THE AGE OF GOLD
SURREALIST CINEMA

CREDITS

THE AGE OF GOLD
Surrealist Cinema
Robert Short
ISBN-10: 0-9799847-0-X
ISBN-13: 978-0-9799847-0-9
Copyright © Robert Short & Contributors 2002, 2008
All world rights reserved
First published 2003 by Creation Books
www.creationbooks.com
This new edition published 2008 by Solar Books
www.solarbooks.org
Design: The Tears Corporation
"Extremities Of The Mind" by Stephen Barber first appeared in *Artaud: The Screaming Body* (Creation Books, 1998/2003)
Film stills by courtesy of The BFI, The Jack Hunter Collection and the author
All rights in the visual works of Salvador Dalí reserved by Fundació Gala-Salvador Dalí, Figueres, Spain

CONTENTS

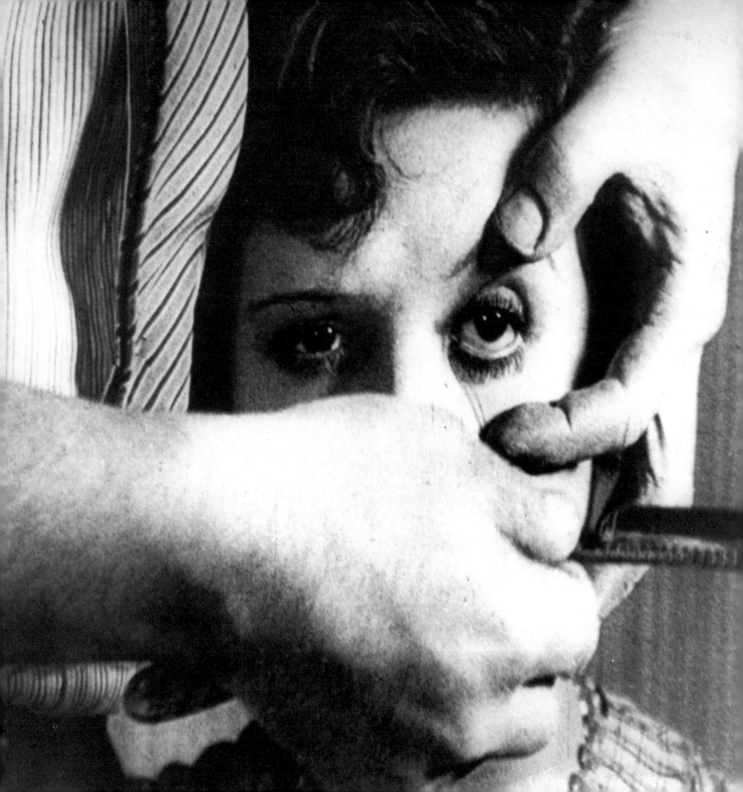

'Now the cinema is, quite naturally, the privileged instrument for de-realising the world. Its technical resources… allied with its photo-magic, provide the alchemical tools for transforming reality' [1]

(René Gardies, 1968)

1. René Gardies, 'Le Cinéma Est-il Surréaliste?', in *Europe,* Nos. 475–476, special number *'Surréalisme'* (1968), p.152.

Battleship Potemkin

Two of the most iconic and celebrated sequences in the history of world cinema climax with the slashing of a woman's eye. In Eisenstein's 1925 *Battleship Potemkin,* the crescendo of violence in the massacre on the Odessa steps culminates with the sword of a mounted Cossack striking a little old lady bloodily blind. Buñuel and Dalí's *Un Chien Andalou* four years later opens with deceptive, domestic tranquillity before the shock of an apparently gratuitous act of mutilation as a man takes a cut-throat razor to the eye of a woman and – in extreme close up – slices it across. The intention of both Eisenstein, the propagandist of fledgling Soviet communism, and Buñuel/Dalí as twin champions of Surrealism, was revolutionary. The assault on the eye of the old lady on the Odessa steps by the Tzarist military calls forth an immediate riposte from the mutinous sailors on the *Potemkin* whose guns destroy the soldiers' barracks – just as the whole film, recalling events of 1905, can be read as calling up the Bolshevik revolution of 1917. The 'prologue' of *Un Chien Andalou* seems to engender the resonant chain of phantasms issuing from the surrealists' unconscious that form the body of the film that follows. Buñuel/Dalí were campaigning for a 'revolution of the

5

mind'. As the works of avant-gardists, both films pursue their provocative ends through the creative use of montage, on the understanding – and anticipating Jean-Luc Godard – that 'political films have to be made politically'.

The nonchalant physical brutality of the opening sequence of *Un Chien Andalou* still provokes even hardened audiences to shudders and gestures of self-protection. They are disturbingly aware that the manifest violence may symbolise some yet more threatening trauma at a latent, sexual level. They feel morally abused also at the breach of contract implicit in this sequence: as spectators attending a cinema performance they have provisionally accepted the film as their reality only to find themselves assaulted in the very faculty which gives conviction to the cinematic illusion. The surrealists always thought of the cinema as a threat to the eye, and, more radically, to the two eyes of the spectator: one eye being the organ of sight, and the second 'I', the viewer's personal identity. But it is soon clear that the mutilation of the eye in *Un Chien Andalou* is meant to be read as the prelude to revelation, not as a terminal blinding. As the film continues, the woman reappears unscathed; and it is her male aggressor, played by the director himself, Luis Buñuel, who, having wielded his blade, is seen no more. As Jean Vigo commented on the slashed eye sequence, which has come down to us the very icon of Surrealism itself: "(it) leaves us with no alternative but to admit that we are committed, that we will have to view this film with something other than the everyday eye!"[2] After all, Surrealism is very much about reversing the conventional connotations of the terms blindness and sight.

What Vigo said of a self-proclaimed surrealist film, André Breton and his group have often claimed for the cinema medium as such. From the inception of the movement in the early twenties, cinema was hailed as the elective surrealist means of expression on account of its power to disturb by betraying the expectations of the 'everyday eye' and its power to inspire by

2. Jean Vigo, 'Un Chien Andalou' in *'Vers Un Cinéma Social'*, as translated by Marianne Alexandre in *L'Age d'Or And Un Chien Andalou: Films By Luis Buñuel*, (Lorrimer, 1968) pp.75–81.

3. André Breton, 'Comme Dans Un Bois', in *La Clé Des Champs* (Editions du Sagittaire, 1953) pp. 241–246, translated by Paul Hammond in *The Shadow And Its Shadow*, (British Film Institute, 1978), pp.42–45.

imposing original visions. In the nineteen-fifties, André Breton wrote that the cinema had been marked out above all other media to promote 'la vraie vie', – though he qualified this by adding that to date it had hardly been equal to the task.[3]

In fact, the promising 'prologue' to *Un Chien Andalou* turned out to be a hard act to follow. The surrealist filmic 'age of gold' was a brief adventure. Set beside the numerous artists and poets in the ranks of committed surrealists over the four and half decades of uninterrupted avant-garde activism presided over by André Breton, only a handful followed Buñuel in using film as their preferred medium of surrealist expression. And their output has been small. The history of surrealist film since the coming of sound is episodic at best. This lack of achievement requires an explanation, especially since expectations of film as a vehicle for the surrealist project were once so high. Something else that needs explaining is why it took nearly six years from the publication of Breton's founding *Manifesto* in 1924 before the movement found its authentic filmic voice in the glory years of 1929 and 1930. Why was surrealist cinema such a long time coming?

4. Perhaps following André Breton in *Le Surréalisme Et La Peinture* (1928), perhaps acknowledging the paucity of 'orthodox' surrealist film product, a number of commentators have opted for the title 'Surrealism And The Cinema' or a similar variant in preference to 'Surrealist Cinema', viz. J H Matthews, *Surrealism And Film* (University of Michigan, 1971); Michael Gould, *Surrealism And The Cinema* (A S Barnes & Co, 1976); Alain & Odette Virmaux, *Les Surréalistes Et Le Cinéma* (Seghers, 1976).

The focus in these essays will be on the small corpus of films that unarguably qualify for the label 'surrealist' in that they were deliberately made in its spirit and earned Surrealism's stamp of approval. We will be asking where *Un Chien Andalou* and *L'Age d'Or* 'came from', how the two films work as cinema and why they have attained such high status both as exemplary Surrealism and as key texts in the development of film language and in our understanding of film effect. But it is also legitimate in this introductory chapter, and necessary in order to contextualise the subject, to extend our treatment beyond the two films of Buñuel and Dalí, beyond 'surrealist cinema' properly speaking, to include the wider agenda that might be implied by an alternative subtitle 'surrealism <u>and </u>the cinema' [see chapter 4].[4] Indeed it would be self-defeatingly purist to do otherwise. First

of all, the surrealists were much more active as film spectators than as filmmakers. We need to take account of their love of cinema for its own sake and of the rather special position they adopted as 'consumers' of film. The psychoanalytic turn in recent film studies towards the film effect has lent a fresh actuality to the surrealists' mode of 'dynamic spectatorship'. From the perspective of Ado Kyrou, the phrase *'le surréalisme au cinéma'* largely means delighted discovery and identification in mainstream cinema of a treasure-house of surrealist moments and motifs whose intrusion into conventional narratives is apparently surreptitious, unconscious or involuntary.[5] Also germane is the issue of film's influence on so much surrealist production in other media, on the shape of their dream narratives, on the modern mythologies that they privileged, on the specific imagery from film that gets quoted in the intertextuality of their writing and painting.[6] Finally and conversely, there is the diffuse but far-flung impact of the surrealist sensibility and practice on a whole swathe of independent – and even mainstream – films worldwide, especially in the last thirty years or so.

A decade before there was surrealist cinema, there was surrealist spectatorship. First generation surrealists were born in the very years that the Lumière brothers presented and popularised their invention. As youngsters, the fledgling poets cultivated the film experience with the unaffected enthusiasm of their mentors, Picasso and Apollinaire. They had their own way of going to the movies. Breton and his friend Jacques Vaché, stationed in Nantes at the end of World War One, used to wander from one picture-house to another, buying tickets without even consulting the programme, entering and leaving on a whim – relishing the visual collage thus put together in their heads as if it were a single film.[7] To poets who believed that revelation came by night, there was so much appeal in the very ambience of picture theatres as caves of significant shadows. Those who passed through 'those muffled doors that give onto the dark' left behind their public selves in the street outside. The cinema induced a mental state half

5. Ado Kyrou, *Le Surréalisme Au Cinéma* (Le Terrain Vague, 1963).

6. For a general survey of the interaction between cinema and modern painting, see, for instance, Germain Viatte ed., *Peinture, Cinéma, Peinture*, (Marseille, 1989); and for a more specific case, my own 'Magritte And The Cinema', in Sylvano Levy ed., *Surrealism: Surrealist Visuality*, (Keele University Press, 1996) pp.95–108.

7. André Breton, op.cit.

way between dream and waking, a kind of conscious hallucination maintained and enhanced by the staccato projection rhythms of the early silent films, the smoky cluster of light beams fixed on the screen and the hypnogogic piano accompaniment. At once passive and voluntarist, the surrealist as spectator put himself in same state of lyrical availability in front of the screen as when, as 'flâneur', he walked through the crowded metropolis awaiting the solicitations of chance or that capital encounter with the 'femme rêvée'. He would convert pulp mass entertainment into a source of private illumination. Aberrant readings, crazy interconnections and delirium of interpretation were the surrealists' 'mode d'emploi' for the movies. Cinema for them was thus the site simultaneously of a cavalier disrespect and a kind of secular worship: 'There is a way of going to the movies as others go to church and I think that, from a certain angle, quite independently of what is playing, it is there that the only absolutely modern mystery is celebrated.'[8]

The modernity of movies was very much part of their appeal to the surrealists. Film was a new form as yet unencumbered with the baggage of an artistic tradition. It had not been 'putrefied' under layers of tradition and aesthetic pretension It was a medium in its infancy and hence, perhaps, in the same condition as Breton claimed for the eye itself, as distinct from the educated mind: 'à l'état sauvage' (in an untamed state).[9] For Aragon, it announced 'a new, audacious aesthetic, a sense of modern beauty.'[10] Even the capitalist, industrial character of mainstream cinema was not seen by them as working entirely to its disadvantage, especially in the early days when the surrealists extolled popular cinema to prick the pomp of their avant-garde rivals. In their early response to cinema one has the feeling that they treated film as they might a found object, as if it were something contingent in the natural world and not an industrial product tainted by capitalism. And unlike poetry or painting, film did not seem as yet to engage their immediate responsibility; it did not commit them to a position because

8. ibid.

9. André Breton, *Le Surréalisme Et La Peinture*, (Gallimard, 1965) p.1.

10. Louis Aragon, 'Du Décor', in *Le Film*, No. 131 (16 September 1918), in Paul Hammond, *The Shadow And Its Shadow*, op.cit., pp.28–31.

it did not compete with them in their own sphere of creativity.

For the surrealists, movies were a perfect 'anti-culture' and their mass appeal was a distinct plus. After all, hadn't Aragon declared that real art 'ought to be read like the morning paper'? Their impatience with good taste and boredom with the academic was matched by the enthusiasm they felt towards all kinds of expression that highbrows dismissed as vulgar – extending from picture postcard fantasy, art nouveau, automata and showroom dummies, to the pulp fiction *Fantômas* serials of Alain and Souvestre. These non-elevated milieux were the most propitious for the eruption of the 'marvellous', for the stimulation of those affective responses that accompanied the disclosure of revelation and the 'insolite'. In part, like Kurt Schwitters with his elegant collages made out of crumpled bus-tickets, their 'dynamic spectatorship' was mimicking the 'grande oeuvre' of the alchemists, converting dross into gold. In part, they were amusing themselves with the pregnant ironies of the art/anti-art game they carried on from Dada. In part, they were highlighting the difference between the latent and the manifest content of any text, a difference which stands out even more sharply where the material is thought to be crude, stereotypical and simplistic. So the surrealists were fans of Hollywood, the very movies that right-thinking people deemed the most stupid – serials like *The Embrace Of The Octopus* about a crime syndicate's takeover of New York – of burlesque comedies and violent melodramas. The poets who, out of contrariness, had given the title *Littérature* to their first anti-art review, denounced the campaigns of Jean Cocteau to have the cinema recognised as 'the seventh art'. Such elevation, they were sure, would lead to the domestication by the ruling system of values of a potentially anarchic medium.

Generations of writers on film, from Jean Goudal in the early twenties to Wendy Everett today, have argued that the cinema as a medium is intrinsically surrealist. The cinema is a splendid dissolvent of the fixed identity of things, revealing them in unfamiliar but nonetheless persuasive

new shapes. It permits exploratory rearrangements of the order of things. The common-sense world of appearances is just the starting point. Cinema is an antidote for what Breton called the prevailing 'cancer of the mind' according to which certain things incontrovertibly 'are', while others that welcomely might be 'are not'. This is because film is naturally ambiguous; all events – the dream as much as the document – can be presented as equally real. No medium appeared more apt to the surrealists for throwing suspicion on the confident dichotomies of the positivist mentality: perception/ imagination; virtuality/actuality; dream/waking life; pleasure principle/ reality principle... all those supposed contradictions whose instability and unreliability the surrealists' mission it was to expose. Describing the impact of film on the basic Cartesian duality between subjective consciousness and the external world, Jacques Brunius wrote: '.... the film enjoys incomparable facility for passing over the bridge in both directions, thanks to the extraordinary and surreptitious solidity that it contributes to the creations of the mind, objectifying them in the most convincing manner, while it makes exterior reality submit in the opposite direction to subjectivization.'[11] And there is no need for fantastic special effects. The surrealising of reality by cinema happens quite naturally. As Wendy Everett has put it recently: 'images that are both real and not real are in the nature of the filmic discourse, as is constant flux and movement which denies these images any stability or certainty and constantly threatens their diegetic status, and the juxtaposition of distant realities which is the natural dialectic of montage, but which can disrupt the spatial and temporal continuity of the narrative as easily as it creates it.'[12]

At the core of the surrealist project as defined by Breton in 1924 was 'the future resolution of these two apparently contradictory states of dream and reality into a sort of absolute reality, or surreality, if I may put it that way.'[13] It has been the fertile and enigmatic resemblance between cinema and dreams – Freud's royal road to the unconscious – that has preoccupied

11. Jacques Brunius, *En Marge Du Cinéma Français* (Arcanes, 1954) pp.107–115, trans. Paul Hammond, op.cit. pp.60–62.

12. Wendy Everett, 'Screen As Threshold – The Disorientating Topographies Of Surrealist Film', *Screen*, Vol.39, no.3, Summer 1998, p.149.

13. André Breton, *Manifeste Du Surréalisme* (Gallimard, 1924) p.24.

Surrealism's engagement with the medium, and, for that matter, surrealism-informed film studies ever since. As Philippe Soupault recalls: 'We thought the film would propose extraordinary possibilities for expressing, transfiguring, and realising dreams. One can think that, from the birth of Surrealism, we sought to discover, thanks to the cinema, the means for expressing the immense power of the dream.'[14] Or to quote Luis Buñuel: 'The cinema seems to have been invented to express the life of the subconscious whose roots penetrate so deeply into poetry. The film seems to be the involuntary imitation of the dream.'[15] In the twenties, when the surrealists probably relied more on dream experience and on self-induced hypnosis than on other forms of automatism to reveal the 'real functioning of the mind', they naturally became film fanatics. Cinema permitted the superimposition of dreams and everyday reality, their suture in a seamless visual experience. In certain respects, film had the edge over the original exercises in verbal automatism with which the surrealist project had been born (via Breton and Soupault's joint texts *Les Champs Magnétiques* in 1919). Had not Freud remarked that dreams remained 'untranslatable in words (and) could only be expressed by means of images'? Jean Goudal made this point in 1925, only a month after the founding publication of the *Surrealist Manifesto*: calling the filmic image ' a conscious hallucination, (utilising) this fusion of dream and consciousness which Surrealism would like to see realised in the literary domain....The objection to method (the difficulty of uniting the conscious and the unconscious on the same plane) does not hold for cinema, in which the thing corresponds exactly to a conscious hallucination (ie. one brought about by the rapid succession of film images). The complete repudiation of logic is forbidden to language, which is born of this logic; the cinema can indulge itself in such repudiation without contravening any ineluctable necessity.'[16]

If film speaks dream, it speaks desire. The constant interaction, back and forth, between the seer and the seen, the self and the spectacle in the

14. Philippe Soupault, in Jean-Marie Mabire, 'Entretien Avec Philippe Soupault', in *Etudes Cinématographiques*, Nos. 38–9, special number: 'Surréalisme Au Cinéma' (1965) p.29.

15. Quoted in Ado Kyrou, *Luis Buñuel*, (Editions Seghers, 1962) p.96.

16. Jean Goudal, 'Surréalisme Et Cinéma', *La Revue Hebdomadaire*, February 1925, quoted in Paul Hammond, *op cit.*, (pp. 49–56). What Goudal said for the filmic image was also prophetic for the subsequent fortunes of the surrealist visual image vis-à-vis the verbal one. Surrealism has earned its currency worldwide, after all, through its painters rather than its poets. The visual image is more direct than the verbal. The word can only 'mean' through a process of 'double articulation' which fatally separates the word from the thing. The word is thus highly vulnerable to the rigidities of cultural codification. The visual image on the other hand, the surrealists held, bypassed the grid of linguistic convention which always hazarded the immediacy of automatic writing. The generative image par excellence for Breton: 'Il y a un homme coupé en deux par la fenêtre' – 'There is a (walking) man cut in two by the window' (perpendicular to his body) – is a palpable vision but a clumsy phrase.

film experience is powered by our desire. The very fact that we are prepared to accept as 'real' the play of shadows on a white surface means that, from the outset, we libidinously collude in a deception. It is our lust to possess a satisfying story that causes us to read the succession of fragments which are a film's shots as if they told a seamless tale. Our desire fills in the cracks and binds up the torn pieces. The content of film is as much of our making as of what's on the screen. Cinema is as much a mirror as it is a window. In *Belle De Jour* (1967), Buñuel doesn't let us see what is making the curious buzzing noise in the box shown by the oriental punter to the girls in the brothel: like the girls, we are invited to imagine 'whatever you want to be there'[17]. Most emphatically of all, cinema speaks of love. Here's Breton again: 'What is most specific of all the means of the camera is obviously the power to make concrete the forces of love which, despite everything, remain deficient in books, simply because nothing in them can render the seduction or distress of a glance or certain feeling of priceless giddiness.'[18]

Paradoxically, it was the cinema's ability to reproduce only the phenomena of external reality – the world of appearances before the lens in all its specificity – that made it the ideal instrument for Surrealism. The joint action of what Walter Benjamin was to call 'the optical unconscious' of the camera and the desiring unconscious of the spectator would be sufficient to bring about that transmutation of mundane reality that the surrealists sought. Film was both mimetic and transformative. You could say that film's proper vocation for surrealists was documentary, not fiction or artifice. Hence their scorn for the special effects so dear to the rest of the avant-garde: their distorting lenses, stop motion, superimpositions, eccentric camera angles....

As Aragon noted as early as 1918, the close-up allows the isolation and 'magnification' of the object, taken out of its usual context, stripped of its utility and rendered over to a world of fantastic connotations: 'On the screen objects that were a few moments ago sticks of furniture or books of

17. Luis Buñuel, *My Last Breath* (Jonathan Cape, 1985) p.273.

18. André Breton, 'Comme Dans Un Bois', op cit.

cloakroom tickets are transformed to the point where they take on menacing or enigmatic meanings.'[19] According to Antonin Artaud a few years later, the mere fact of passage through the lens tangibly changed the world: 'It is certain that any image, however prosaic and banal, arrives transformed on the screen. The smallest details, the most insignificant objects take on a meaning that belongs to them alone. By the fact that it isolates objects, it gives them a life apart which acquires a growing independence and detaches itself from the customary meaning of objects. A twig, a bottle, a hand start to live a quasi-animal existence.'[20] It was precisely the cinema's evocative power in terms of concrete details (Dalí's 'small things') that made it a 'privileged instrument for de-realising the world'.[21] Breton always insisted that the 'marvellous' lay within the fabric of the real. It was a matter of discovering it, not inventing it. Here, for them, lay its difference from mere 'mystery' that was concocted to dazzle us by posturing aesthetes. Buñuel's *L'Age d'Or* has a documentary edge; and he followed it with the archetypal (anti)travelogue, *Las Hurdes (Terre Sans Pain, 1932)*.

　　Wherever they prospected for the marvellous, the surrealists were on the look out for striking images. That they thought the cinema specially promising terrain was only partly explained by their coming to films in the silent era. The poetic figure and its epistemological extension, the analogy, was their alternative principle for re-ordering the world by the light of which they qualified and challenged the hegemonic, rational ordering of the world. They urged that the poetic image – incongruous and fantastic though it might appear – was the indispensable key to classifying experience more satisfactorily. In moments of image hallucination when the frontiers between sense and nonsense were temporarily overrun, the surrealists claimed to have revelations of a reality which transcended that of the positivists' universe, and was in effect more real than it. The very concreteness and specificity of a powerful image produced a shock to the whole sensibility. Such that affective understanding fed by a figured analogy raised hopes that

19. Louis Aragon, 'Du Décor' in *Le Film,* September 1918, in Paul Hammond. ed. op.cit, pp.28–31.

20. Antonin Artaud, 'Cinéma Et Réalité', in *La Nouvelle Revue Française,* No.170, 1927.

21. René Gardies, op.cit.

the divorce between thinking and feeling in the Western mentality could be healed. 'I have never experienced intellectual pleasure except on the analogical plane', said Breton, and 'the veritable revolution will be brought about on the strength of the image.' The cinema seemed the perfect mediator in this process because of both its grip on the whole attention of the spectator and its power to make inert reality assimilable to the imagination. Filmic montage, for instance, was supremely adept at juxtaposing distant realities which, for Surrealism, accounted for the revelatory power of the poetic image. Breton hinted at the surrealist filmic ideal when he imagined a mechanism that could project direct onto the eyelid.

With the enthusiasm of neophytes, the surrealists attributed real power to cinema to change life. While such an estimate may seem exaggerated from a later perspective, they were not alone in it. For Lenin likewise, film – modern, mechanical, popular – was seen as the ideal vehicle for communism and the most potent means of converting the masses to the values of the revolution. And it was because the cinema experience was so totally involving, not merely spectacular. While first generation Bolsheviks sent their agitprop trains puffing across the tundra, Aragon in Paris linked cinema action more delinquently to the traffic in drugs: 'My friends – opium, private vices, liquor organs are old hat; we've invented the cinema.', enthused Aragon.[22] Breton later put it less passively: 'It was precisely a matter of crossing the barrier of the permitted which, nowhere so much as in the cinema, seemed to beckon me towards the forbidden.'[23] Both were extolling the power of film to engage its audience with an unwonted authority. Breton, as usual, had a finer grasp of the surrealist line than his henchman, Aragon: film was to be viewed as tonic inspiration, not opiate compensation. The demand would grow in real life for pleasures hitherto denied by inhibition or taboo. The cinema would lead people to fight in order live their dreams. And this was the hymn-sheet to which a chorus of surrealists sang throughout the 1920s. 'The screen will have produced a

22. Louis Aragon, 'Cinéma Et Compagnie' in *Littérature*, No.4, June 1919.

23. André Breton, 'Comme Dans Un Bois', op.cit.

masterpiece', wrote Robert Desnos in 1923 in his weekly film column for *Paris Journal,* 'when bullets rip the screen when the villain appears and when, sadly utopian as it may seems, the projectionist has to wipe away the traces of kisses left on the silver screen.'[24] And four years later he wrote: 'What we ask of the cinema is the impossible, the unexpected, dreams, surprise, which efface the baseness in souls and rush them enthusiastically to the barricades and into adventures.'[25] It is well known that Buñuel, disconcerted by the blasé response of 'le tout Paris' to *Un Chien Andalou,* insisted that what they apparently found so poetic and so droll was 'in essence only a desperate and passionate appeal to murder.'[26] The group's collective tract in defence of the banned *L'Age d'Or* extolled its 'more than symptomatic role' in the service of the proletariat, and called it 'the indispensable moral complement to stock exchange panics, with an impact which will be specially direct precisely because of its surrealist character.'[27]

Much of this surrealist early rhetoric about movies has been a casualty of time. Par for the course in a period when hyperbole and terrorism were the polemical norm, nowadays such verbal overbidding looks over-egged and over the top. But aside from that, what must have become increasingly obvious in the course of this survey of surrealist statements on the cinema – from 'revelation to revolution' as it were – is their ambiguous fluctuation between the indicative and the optative moods – between the 'this-is-what-cinema-is' and the 'this-is-what-cinema-ought-to-be'. The surrealists always played on this confusion to enhance the provocative effect of their declarations. It put readers in a quandary. And it implied that, even if the 'ought-to-be' is not the 'is', then it could be and must soon be made to be. In other words, the revolution was always imminent and would break out if it was thought and willed enough. This was what Breton meant by: 'The imaginary is what tends to become real' and 'Revolt, revolt alone generates light'. The same strategy was in play when he declared, as previously quoted, that it was in the cinema that 'the only <u>absolutely modern</u> mystery is

24. Robert Desnos, in *Paris Journal,* 13 May 1923.

25. Robert Desnos, in *Le Soir,* 2 April 1927. Georges Godfayn, with an ingenious dialectical twist attributed a revolutionary potency to the very illusoriness of cinema: 'Spectral apparitions are imposed by the cinema with such tangible force that the spectator comes to see himself too as a mere ghost. Fantasy thus helps towards that self-knowledge which is vital to moral astringency in the framework of revolutionary development.' Georges Goldfayn, 'Le Cinema Comme Enterprise De Transmutation De La Vie', in *L'Age Du Cinema* (special surrealist number), August–November 1951, pp.21–24.

26. Luis Buñuel, 'Preface' to the scenario of *Un Chien Andalou,* in *La Révolution Surréaliste,* No.12, 15 December 1929, pp.34.

27. '*L'Age d'Or,* Tract Signed By Thirteen Surrealists', November 1930, in José Pierre, *Tracts Surréalistes Et Déclarations Collectives* Tome 1, 1922–1939, pp.155–184. Elsewhere Buñuel declared: 'It would suffice for the white pupil of the cinema screen to reflect the light which is proper to it, to blow up the universe.' (quoted in Francisco Aranda, *Luis Buñuel: A Critical Biography,* (Secker and Warburg, 1975) p.273.

celebrated'· Yes, the cinema might be that kind of mystery, but only if you had faith. The most banal film could be trans-substantiated into a luminous epiphany if the spectator adopted a stance of 'lyrical attention'. But, even for the surrealists, once initial delight at the novelty of the medium (in its silent period) passed, the prospecting for gold in so much dross seemed like wasted effort. The surrealists' belief that the cinema as a medium was inherently surrealist had its limits. The vast proportion of commercial film entertainment was cretinous and cretinising. The moral outlook propounded in Hollywood movies, whether explicitly or implicitly, was sentimental and conformist. Repetitive and stereotypical, it was poles apart from the spontaneous minting anew that was the surrealist way.

From the mid-twenties, the surrealists' expectations of the cinema were already tinged with incipient disappointment. Significantly, the expression of their first reservations about the medium coincided with their retreat from the position of near solipsism with which the movement started out. In the early days, they had carried their neo-romantic version of 'subjective idealism' to such lengths that a group manifesto could claim that 'a certain agitation in men's minds' was all that was required to start the Revolution. After their introduction to Marx through Hegel and Trotsky, which in turn helped initiate their erratic and unrequited courtship of the French Communist Party, their ideas about the relation between consciousness and material existence – mind and reality – became more dialectical. At the same time as they came to acknowledge the importance of economic conditions in determining consciousness, so – with cinema – they began to pay more attention to the intrinsic qualities of individual films. That is, they began to take a more discriminating account of the form and content of film texts – before, and whether or not, the surrealist spectator's generously redeeming imagination was let loose on them.

Following a parallel track, we will now turn our attention from

surrealism's lyrical expectations of cinema as a bright new medium to the more specific circumstances in French film culture in the twenties that provided the context for their position and helped to determine it.

Surrealism was hardly alone among avant-garde movements in Paris of the twenties in its enthusiasm for cinema. Rather, the position of Surrealism on film needs to be located at the crossroads of debate between Hollywood entertainment cinema and the rich variety of alternatives to the mainstream offered by the contemporary, domestic French film industry and French film culture at the time. The surrealists were by no means alone in looking for alternative forms of cinema to conventional Hollywood mass entertainment with its enlistment of all elements of filmic expression in the service of efficient story-telling, its conservative commitment to nineteenth-century realist narratives and to conventional morality. Cinema in France after World War One – without a studio system, without international stars, without established genres of worldwide appeal – was compelled to do different from Hollywood if it was to maintain a viable niche in the global market. If Hollywood was tied to the aesthetics of nineteenth-century realism and traditional representations, many filmmakers in France in the silent period aspired towards a Modernist cinema that would seek filmic equivalents to pre-war art innovations such as Cubism and Futurism[28].

Surrealism offered just one among a cluster of avant-gardist critical positions jostling for attention, and surrealist cinema was the last of a succession of French avant-gardist film movements in the silent period. In contrast to Hollywood, twenties French cinema presented a confusing variety of production ranging from big budget epics such as *Le Miracle Des Loups* that capitalised on the appeal of picturesque French locations and employed half the army as extras, to experimental shorts like Man Ray's *Retour À La Raison* that were shot on a shoe string. It was an industry of one-off, package productions, of formal experimentation – a director's cinema with authorial independence. Material costs of silent films were low. There

28. Futurism, led by F.T. Marinetti, was perhaps the earliest modern art movement to transpose its ideas to the medium of cinema, although only two films were made by members of the group: *Vita Futurista* by Arnaldo Ginna, and A.G. Bragaglia's *Il Perfido Incanto* (both in 1916).

Il Perfido Incanto

'Cubist' laboratory set designed by
Fernad Léger; from Marcel L'Herbier's
L'Inhumaine.

were no language barriers to their international circulation. Commercial and experimental impulses often intermingled, with directors alternating between the art movie and the entertainment movie, or, like Marcel L'Herbier in *L'Inhumaine* (1924), trying to merge the two.

French silent cinema ran the gamut, stylistically, from abstraction to gritty documentary realism, and, ideologically, from unapologetic art-for-art's-sake to social engagement. Both the industry and the film culture were enthusiastically receptive to foreign films and film-makers, to propagandists for Soviet Communism such as Eisenstein, White Russian exiles such as Kirsanov, and German expressionists alike. There was a significant overlap between film and the fine arts. The prevailing tendency was to privilege visual expressiveness over narrative. Not for nothing was the major French film movement in the early twenties christened Impressionism. Artists like Man Ray, Marcel Duchamp and Fernand Léger sought to render still images in movement, to 'detonate the stasis of painting', making a kinetic equivalent or extension of their painterly or photographic compositions. These avant-gardists looked to analogies between film and the non-narrative arts to challenge the prevailing notion that cinema was uniquely a dramatic and story-telling medium. Employing terms like 'visual music', 'ciné-poème', and 'painting in motion' they experimented with film's potential for abstract expression.

Production centred on Paris which was itself a ferment of radical theorising about the nature of cinema and about the specificity of the medium in its difference from other forms of expression such as theatre and fiction. It was the creative and conceptual liaison between the then silent medium and painting, poetry and music that prompted most research. High-flown concepts like 'photogénie' and 'cinégraphie' were bandied about. There was a network of specialist cinemas ready to show innovative and risky work; film clubs at which new ideas could get discussed, and a press and range of critical reviews to make alternative languages of cinema accessible

to the wider public. In contrast to Anglo-Saxon countries in which cinema was still held in low esteem, in France it enjoyed high artistic status and was, indeed, recognised as 'the seventh art'. Surrealism was just one voice in this raucous chorus of innovation. It was a hospitable context in which Surrealism had no difficulty in making itself understood, but in which, by the same token, it had to struggle to make itself heard. Robert Abel is no doubt right to cut Surrealism down to size by demonstrating that it was only one of many contributors to the richness of discourse on film at the time; nevertheless, it is also the case that the surrealist position proved to the most trenchant and most durably interesting.

To the degree that Surrealism eventually came to dominate the avant-garde scene at large, and thanks to the lasting success of its label, popular film history subsequently has often tended to treat the whole diversity of French experimental cinema in the twenties as 'surrealist'. David Lynch, for example had no qualms about applying the term 'surrealist' indiscriminately to a motley collection of extracts from avant-garde films that he presented in a BBC *Arena* documentary in the eighties.[29] And audiences post-1945 were known to confuse the films of the Dalí/Buñuel collaboration with the work of Jean Cocteau. The problem of classifying avant-garde films in the twenties is complicated by the shifting allegiances of the filmmakers and the intensity of the rivalries between the groups involved. The stamping of this or that film as 'surrealist' or otherwise could be as much a matter of jockeying for position and the marking out of territory as of the intrinsic features of the film in question. The excommunication of Artaud, for instance, meant that *La Coquille Et Le Clergyman,* was definitively excluded from the official canon. Sometimes, as in the eclectic inventory given in the 1938 *Dictionnaire Abrégé Du Surréalisme,* the group included films by Duchamp and Man Ray that preceded *Un Chien Andalou*, with the apparent aim of compensating for the paucity of indisputably surrealist productions and bumping up the roster. At

29. Robert Abel has recently attempted to rewrite the history of French cinema in the twenties assigning only a minor role to Surrealism. Robert Abel, *French Cinema: The First Wave, 1915–129,* (Princeton University Press, 1984) Like him, Ian Aitken has appealed for a more generous re-evaluation of Impressionism.(Ian Aitken, *European Film Theory And Cinema: A Critical Introduction,* (Edinburgh University Press, 2001).

other times, when the motive was intransigent defence of hard core surrealist principles, the inventory was ruthlessly pared down to the Dalí/Buñuel works alone. With the passage of time, the passion invested in fighting these competing claims to intellectual property has subsided, and the finer points of distinction between the rival 'isms' have eroded.

The attribution issue that is most hotly disputed – and most germane to this book's agenda – is between Dada and Surrealist cinema. There is legitimate disagreement here about the decisive criteria. Whether some movies get labelled as dada or as surrealist and the case for arguing for continuity or for difference between them mainly depends on which criteria are privileged. The issue is much clearer with so-called 'Impressionist' cinema, although even here things are complicated by the fact that Artaud's surrealist scenario, *La Coquille Et Le Clergyman,* was brought to the screen by the 'Impressionist' director, Germaine Dulac.

Impressionism was the dominant film movement in French silent cinema immediately after the First World War. The theory and practice of this older generation of filmmakers fell foul of both Dada and surrealist tenets on two counts: on the one hand, it was too 'art-for-art's sake/formalist; on the other, it was too conservative in clinging to out-of-date psychological realism and implicitly reactionary moral values. In the surrealist perspective, the leaders of the so-called 'Impressionist' avant-garde – L'Herbier, Epstein, Delluc – were obsessed with aesthetic problems of technique in an academic sense, not with evoking 'la vraie vie'. Their prime concern was with the properties which they felt to be unique to cinema as an art form in its own right – pure cinema. They prized the autonomy of the visual 'language' of cinema – whereas the surrealists had no interest in any art form for its own sake. As Crevel replied to an enquiry in a contemporary review: 'The cinema, like the rest of the arts, is just another tool'[30]. And Desnos wrote: 'Technical processes not solicited by the action, conventional acting, and the pretence of expressing the arbitrary and complicated

30. René Crevel, reply to 'Enquête Sur Le Cinéma' in *Les Cahiers Du Mois,* 1925.

movements of the soul are the principal characteristics of this kind of cinema, which I prefer to call 'hair in the soup' cinema.'[31] If they were progressive in seeking a filmic language to express complex and sometimes disturbed states of subjectivity (genius, madness, nightmare), in other ways they remained tied to the tradition of psychological drama, reluctant to abandon logical causality in their narration. Impressionism was fatally old hat in the surrealists' eyes because it remained fundamentally loyal to the nineteenth-century traditions of naturalism and symbolism – especially to the Mallarmé 'aesthetic of approximation and the indefinite'.[32] In the spirit of his distinction between 'the marvellous' and 'mystery' (*La Clé Des Champs,* 1953), Breton despised the deliberation behind Impressionism's laboured poetics. Infinitely preferable to Impressionism's contrived magic, were the poetic moments apparently fallen upon by accident in otherwise artisanal films like the serials with Pearl White or Louis Feuillade's action thrillers *Judex, Fantômas* and *Les Vampires.* Finally to the would-be revolutionary surrealists, the politics of the leading Impressionist directors were unacceptable, whether understated, implicitly conservative in the case of L'Herbier, or weather-cock opportunist, or implicitly authoritarian as with Gance (think of his epic paeon to Napoléon).[33]

The surrealists' revolt against the aesthetic of the older generation of French filmmakers prefigured in a number of respects the anathemas which the young, 'nouvelle vague' critics and writers for *Cahiers Du Cinéma* were to heap on the 'cinéma de papa' in the nineteen-fifties. Buñuel had worked as production assistant on a handful of impressionist films before coming to *Un Chien Andalou.* His aggression towards the cinema of elders such as Epstein, Gance and L'Herbier matches that of Truffaut and Godard thirty years later towards the Carné's and Delannoy's of the 'cinéma de qualité' and it had a similar Oedipal ring. Mockery of the solemn tropes of Impressionist cinema was to sustain a whole layer of *Un Chien Andalou*'s parodic intertextuality.

31. Robert Desnos, 'Cinéma Et Avant-Garde', in *Documents*, No.7, December 1929, quoted in Paul Hammond, op.cit., p.36–38.

32. Jean Epstein quoted by Ian Aitken, op.cit., p.81.

Louis Feuillade's *Fantômas* (1913)

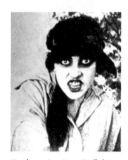

Musidora as Irma Vep in Feuillade's *Les Vampires* (1915–16). 'It is in *Les Vampires* that one must seek the great realities of this century. Beyond fashion. Beyond taste.' (André Breton and Louis Aragon, 1928).

33. See Ian Aitken, op.cit., p.87.

Jean Epstein's *La Chute De La Maison Usher* (1928); Luis Bunuel worked as assistant director on this and Epstein's *Mauprat* (1926), as well as *La Sirène Des Tropiques* (1927) by Mario Nalpas and Henri Etiévant.

If attaching the label 'surrealist' to any twenties avant-garde film prior to *Un Chien Andalou* is contentious at the best of times, in the case of *La Coquille Et Le Clergyman* (Artaud/Dulac, 1928), it is a judgement of Solomon. The following chapter by Stephen Barber devoted to Artaud and cinema is thus fully justified. Artaud had been a founding member of the surrealist group and director of the *Bureau des recherches surréalistes*. As editor of its first house organ, *La Révolution Surréaliste,* Artaud's series of 'Open Letters' to prominent world personalities and institutions were among the most intransigent and compelling of the movement's tracts. Perhaps Artaud had grasped more pertinently than anyone else what a truly surrealist film would be like when he wrote in 1927 that it should be made of 'pure images'.. whose meanings would emerge ….'from the very impact of the images themselves'. This impact must be violent, 'a shock designed for the eyes, a shock founded, so to speak, on the very substance of the gaze.' *La Coquille Et Le Clergyman* has solid claims to be the first surrealist film. Certainly Artaud's scenario with its dream logic and Oedipal inspiration is impeccably surrealist. As is the desperation of the narrative in which the 'clergyman's' desire is constantly thwarted. This 'clergyman' is Everyman. His identity is shifting and fluid; not just priest, but alchemist, and criminal. He can double as a general. Feminisation threatens his masculinity; infantile regression his adulthood. But the adaption for the screen of Artaud's scenario by the well-established Impressionist woman director, Germaine Dulac, betrayed Artaud's vision. Its Freudian scenarios were dramatised with a crying literalism. Dulac addressed Artaud's text with the preconceptions of an Impressionist. She saw it as an account of a dream. It was just the sort of subjective material– suggestive, aberrant, 'poetic' – that Impressionists liked to represent in film as an object of aesthetic contemplation. Hence, the opening sequence where the camera's track down a long, empty hall mimes the psyche's descent into its unconscious. Such devices offered critics and audiences an easy way to dismiss the film as a

mere figment of the imagination and to deflect the anxiety Artaud had intended provoke As Alan Rees puts it: 'The film is located in imaginary and distorted space, but far from Artaud's hyper-aggressive view of film language, or counter-language'[34]. The tragic-comic misunderstandings and mismatch between Artaud and Dulac demonstrate the gap that separates a written scenario from a realised film. Surrealist film had to await a truly congenial meeting of minds in the Dalí/Buñuel collaboration. It was *Un Chien Andalou* a year later that was to deliver on Artaud's promise of 'shock designed for the eyes'.

In the promiscuous politics of the Parisian avant-gardes, the case of *La Coquille Et Le Clergyman* is unique because it confronted two fundamentally antithetical approaches to film – and indeed to the relation between the symbolic and life itself – Artaud's Surrealism and Dulac's Impressionism. *La Coquille Et Le Clergyman* was a one-off. Artaud was never able to make a film (again). As between Dada and Surrealist cinema, however, matters are very different. There is a substantial enough corpus of films – albeit all shorts – for Dada to qualify as a film movement. And distinguishing between something Dada and something surrealist – whether it's a text, an object, an image, or a film – is complicated by the fact that so many of the founding surrealists had been Dadas first. For four or five years after World War One, there was a dynamic overlap between the two movements in Paris[35]. The surrealists inherited much of the spirit animating the likes of Tzara, Picabia and Duchamp: the iconoclasm; the anti-art stance; the debunking, parodistic vein of humour; the taste for scandal and provocation, for chance and spontaneity, for every means under the sun to defamiliarise the world we take for granted. Dalí and Buñuel were not the first filmic iconoclasts among the avant-garde. Dada pioneered many of the filmic strategies for inducing in the spectator that 'anxiety of dislocation' which for the surrealists later, was to be a necessary precondition for any ensuing 'rapture of possibility'[36]. Exploiting a gamut of

34. A L Rees, *A History Of Experimental Film And Video* (BFI, 1999) p.48.

35. There is an extensive scholarly literature which argues the issue of the relation between Dada and Surrealism. The argument for giving everything to Dada is most vigorously made by Michel Sanouillet in *Dada À Paris* (Jean Jacques Pauvert, 1965). Marguérite Bonnet replies for Surrealism in *André Breton: Naissance De L'Aventure Surréaliste* (Librairie José Corti, 1975).

36. See Sidra Stich, *Anxious Visions: Surrealist Art* (Abbeville Press, 1991) p.24.

disorientating devices – fast, slow and stop motion, unmotivated ellipses and parentheses, irrational juxtapositions and graphic matches – Dada films portrayed a world in a state of ludic anarchy. In *Entr'acte,* by a carnavalesque inversion, a funeral is held at the circus. The spectator is not merely disconcerted but aggressed. The audience for *Entr'acte* is first targeted by a cannon fired by Picabia and Satie and then pummelled with boxing gloves. Both Dada and surrealist films attacked the humanist image of the body as an organic whole, 'cutting' it into fragments and 'dissolving' it into fluidity[37]. Confidence in gender difference is confounded by transvestism in *Emak Bakia* and most famously, in *Entr'acte,* by the revelation that the tutu-ed ballerina, filmed through glass from below and, as it were, dancing on the eyes of the spectator, has the head of an hirsutely bearded male. Fernand Léger's *Ballet Mécanique* (1924) had affinities with Dada – if we recall Duchamp's masturbatory chocolate grinder and Picabia's portrait of an American girl as a sparking plug – in its mischievous reduction of human movement to the programmed automatism of machines. And Léger's professed intent to irritate the audience by dint of repetition was also very Dada.

For all that it got endorsed as a surrealist film in the 1938 *Dictionnaire Abrégé Du Surréalisme,* Francis Picabia's and René Clair's playful *Entr'acte* (1924) is unarguably more Dada in inspiration than surrealist – a succession of loosely connected gags and parodies of comic chase sequences. However it reads today, it was intended by Picabia as a vehicle for his nascent, anti-surrealist movement 'Instantanism' and as a riposte to Breton's just published *Manifesto.* The thrust of such films was to deconstruct filmic mechanics for making illusion, while at the same time mischievously pointing to the automatic, mechanical nature of human life and desire. The intent was thus Dada-depreciative rather then surrealist-enhancing. To quote Ramona Fotiade: 'This mechanistic conception of mental processes is radically opposed to the role assigned by Surrealism to

37. Elsa Admowicz, 'Bodies Cut And Dissolved: Dada And Surrealist Film', in J. Williams & A Hughes eds., *Gender And French Film* (Berg 2002), p.19–33.

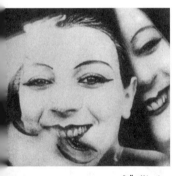

Ballet Mécanique

Entr'acte

imagination in the constant interaction between dream and reality, which makes the subject a real being in the world in so far as its vision constitutes a real order of things rather than a mere simulacrum.'[38] Not only was surrealist film to be more focused in its iconoclasm and revolutionary purpose, *Un Chien Andalou* would replace the anarchic 'informe'/ formlessness of an *Entr'acte* with the logic of the dream.

Dada cinema itself had a many-sided agenda, more richly ambivalent than Dada's tag as a 'great negative work of destruction' suggests. It included abstract artists like Viking Eggeling and Hans Richter – and in their moments, Man Ray, Marcel Duchamp and Fernand Léger – who, as painters, saw 'moving pictures' as a kinetic liberation from the constraints of the static image and as a means of complementing visual with temporal rhythms. In Duchamp's *Anemic Cinema* (1924), for instance, shots of concentric circle designs on flat disks alternate with other disks bearing spirally printed punning sentences. *Anemic Cinema* captures an effect of languorous advance and retreat (phallic/vaginal) as the geometric circles are set in rotatory movement, interspersed with the stubbornly flat effect of the disks with the puns which the movement renders well-nigh illegible. The 'abstraction' of the films of Duchamp – as of Man Ray and Léger – is overlaid with an eroticism that gestures towards Surrealism. But the prevailing tendency of the kinetic in abstract film experiments was towards Constructivism, an autonomous form of art that took pride precisely in not impinging on outside reality. Ramone Fotiade concludes that such movies 'promoted a detached contemplation of images as photographs or abstract painted compositions to which movement is added a purely stylistic device that didn't match the expectations of the surrealists'[39]. By and large, the surrealists agreed with Artaud's dismissal of abstract cinema: 'No one can respond to purely geometric lines which possess no significative value in themselves...'.[40]

The problem of attribution – is it Dada? is it surrealist? – is

38. Ramona Fotiade, 'The Untamed Eye: Surrealism And Film Theory', in *Screen*, Vol.36., No.4, Winter 1995, pp.394–407.

Viking Eggeling (1880–1925) completed only two films: *Orchestre Horizontal-Vertical* (1919) and *Symphonie Diagonale* (1924), whose titles reflect their emphasis on abstract imagery and movement.
Hans Richter (1888–1976) explored similar ideas in *Rhythmus 21, Rhythmus 23* and *Rhythmus 25* (1921–25). *Filmstudie* (1926), *Vormittagsspuk* (*Ghosts Before Breakfast*, 1927), and *Zweigroschenzauber* (*Two-Penny Magic*, 1928) are more obviously Dadaist in nature.

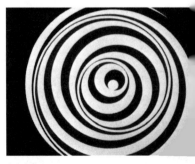

Anemic Cinema

39. ibid.

40. Antonin Artaud, 'Cinéma Et Réalité' in *Oeuvres Complètes*, Vol.III, Gallimard, 1961, p.22.

Man Ray (1890–1976) made four key films: *Retour À La Raison* (1923); *Emak Bakia* (1926); *Étoile De Mer* (1929); and *Le Mystère Du Chateau De Dés* (1929). He also collaborated with Henri Chomette on *À Quoi Rêvent Les Jeunes Films?* (1924), and with Hans Richter on *Dreams That Money Can Buy* (1947).

Retour À La Raison

41. Man Ray, *Self-Portrait*, (Little Brown, 1963) p.274.

Emak Bakia

42. Rudolf E Kuenzli, 'Introduction', in Rudolf E Kuenzli ed., *Dada And Surrealist Film* (Willis, Locker & Owens, 1987) p.4.

especially vexed with the films of Man Ray, not least because the Philadelphia-born artist and photographer had been an affiliated member of Breton's movement since 1925. He had a one-man show at the *Galerie Surréaliste* in 1926. The same year Man Ray set out quite deliberately to make an unequivocally surrealist film in 1926 with his 'ciné-poème' *Emak Bakia,* funded by the wealthy fellow-American, Arthur Wheeler. He was mortified when the finished movie met with a distinctly lukewarm reception from the group. He later lamented: 'I had complied with all the principles of Surrealism: irrationality, automatism, psychological and dramatic sequences without apparent logic and complete disregard for conventional storytelling'[41]. From its opening shot of a film camera in action with Man Ray operating it – the artist's eye reflected in a mirror, filming himself filming – it presents itself as an object lesson in the surrealist belief in the camera's power to transform the familiar world and generate surreality. Correspondingly, the film's last sequence makes play with a woman's gaze in a series of close-ups where what at first we take to be her two open eyes, albeit with a blank look, are revealed to be painted on her closed eyelids. Man Ray could hardly have illustrated more faithfully the surrealist contrast between seeing the familiar world and the dreamer/voyant's 'seeing' with eyes closed. Minus the violence, the sequence anticipates the prologue to *Un Chien Andalou* with its suggestion that it takes a 'blinded sight' to behold the marvellous. No wonder Man Ray was dismayed by the surrealists' lack of enthusiasm. He put it down to his failure to get the group's prior approval for the project. But the same omission on Buñuel's and Dalí's part three years later didn't deter Breton and his cronies from awarding *Un Chien Andalou* their instant accolade. Rudolf Kuenzli suggests that *Emak Bakia* displeased because Man Ray broke 'the cinematic illusion by pointing to the film as a product of the camera' and because his film's 'complete disregard for conventional storytelling' was too radical.[42] Certainly, these self-reflexively deconstructive features linked it more to Dada than

Surrealism. More damagingly from the surrealist viewpoint, the film failed to produce a sense of the marvellous within the everyday. Its material was eclectic, connected in haphazard ways but not according the logic of dreamwork. As if in a spirit of 'anything goes', Man Ray included shots of his own graphic work, such as his 'Rayograms', and animations of small sculptures and other 'objects' of his making. No doubt these jokey self-references by Man Ray irritated the surrealists as much as similar egocentricities on the part of Jean Cocteau in *Le Sang d'Un Poète* (1930).

According to Allen Thiher, *Emak Bakia* and Man Ray's subsequent film *L'Étoile De Mer,* made with Robert Desnos, showed the 'limits of metaphor' for surrealist filmic purposes[43]. From the surrealist perspective, the problem with these films, argues Thiher, composed as they were almost entirely of bizarre and apparently chance juxtapositions (of objects, events, locations, optical effects) was that there was nothing in the flow of the images which the spectator could translate into a readable figure. The encounters were surprising and comic, but what was the connection? Man Ray probably thought that he was obeying to the letter Breton's injunction, paraphrasing Pierre Reverdy, about similes in the 1924 *Manifesto*: 'The more distant and true the relations between two juxtaposed realities, the stronger the image will be – the greater will be its emotive power and its poetic reality'[44]. But according to Thiher, Man Ray misunderstood the difference between verbal similes and film similes, producing weak, uncertain and indefinite meaning. In film, mere juxtaposition by itself doesn't necessarily produce the kind of revelatory image the surrealists sought because film lacks the syntax needed to weld the elements together. In a revelatory, if difficult, verbal image like André Breton's 'Ma femme à la langue d'hostie poignardée ('My wife/woman with a tongue like a stabbed Host') from *Union Libre/Free Union,* the rules of language bind together the seemingly unassociated elements and guarantee a meaning. For metaphors like this to work in film, some kind of syntactic structure equivalent to that of verbal

Rayogram by Man Ray

43. Allen Thiher, *The Cinematic Muse: Critical Studies In The History Of French Cinema* (University of Missouri Press, 1979), p.46.

L'Étoile De Mer

44. André Breton, *Manifestos Of Surrealism* (University of Michigan Press, 1969), p.20.

language is required. This is precisely what Buñuel and Dalí achieved by giving *Un Chien Andalou* a narrative scaffolding and various other 'semanticising' structures. Man Ray had dutifully eschewed story telling because its conventions represented everything the surrealists rejected in traditional realism. Unphased by the risks involved, what Buñuel and Dalí did was to invent a form of narrative discourse that would achieve a sufficient degree of focused meaning without falling back into the trap of bourgeois literalism. Unlike Man Ray and unlike Dada cinema, the surrealist film would restore narrative, character and optical realism but imbue them with the oneiric effects they sought elsewhere through poetry and the visual arts.

Vis-à-vis the rival avant-gardes, Surrealism was a lot more interested in the ethical drive of any work than in its form, and it had to be revolutionary drive. While Dada cinema performed the therapeutic task of demystifying and deconstructing the illusions of mainstream cinema, the surrealists wanted to move on to a cinema that, like Freud's and Jensen's 'Gradiva', 'advanced' in the direction of the unseen and the unknown. As such, it needed to go beyond the necessary and preliminary defamiliarising of reality. It needed to allow the viewer to enter the world of the film, an entry which the wilful incoherence of Dada film denied. Nothing less was required than an unholy pact with Hollywood whose language was precisely so adept at situating 'the spectator in the text' and winning identification. So surrealist film in the hands of Buñuel and Dalí would draw the spectator into the reality produced by the film by offering a range of cues that hold out the promise of a realist text – conventional cinematography, characters, narrative lures[45]. So surrealist film would implicate its viewers, seduce them into a kind of reluctant participation even when teasing, cheating or assaulting them. Thus it emerges that – despite the common ground Surrealism shared with so much innovative cinema in the period, including its roots in the same ferment of film culture – (it is impossible to imagine *Un*

45. From the point of view of avant-gardists for whom breaking the formal frame was the action point of advance, the surrealists' reinstatement of narrative– however fractured and disconcerting– in avant-garde film practice was construed as reactionary. The same criticism was levelled at recourse to figurative imagery in the painting of Dalí, Magritte and Delvaux: in an age of advancing abstraction, it was decried as a retreat back to 'literature'.

Chien Andalou being made outside such a hospitable and comprehensive milieu), the films of Dalí and Buñuel need to be read more as a reaction against abstract cinema and Impressionism, and even Dada, than as developments out of them.

The specificity of the two films by Dalí and Buñuel which are the main subject of the following essays, and the key to their efficacy for the surrealist project lies, no doubt, in the fertile ambiguity of their position between the alternatives of dominant and counter cinema. So perhaps we are talking less about an unholy alliance with Hollywood than about a pact with the devil in which the makers would cheat the devil out of his reward. Surrealist film, says Phillip Drummond, both relates to, and turns away from the classic realism of the mainstream cinematic text, in which clearly identifiable characters act out a human drama in the logical pursuit of clear-cut psychological or material goals.'[46] For Alan Rees, surrealist film sets up a distinct model of avant-garde film 'in which the elements of narrative and acting arouse the spectator's psychological participation in the plot or scene while at the same time distancing the viewer by disallowing empathy, meaning and closure; an image of the disassociated sensibility or double consciousness praised by Surrealism in its critique of naturalism.'[47] Buñuel and Dalí found a filmic way to build that 'bridge' referred to earlier from Jacques Brunius. Facing one way, this meant a way of using film so as to inspire belief in the dream, the marvellous and the unconscious by providing images that were easily perceived, that were clear and straightforward as images even (or especially) if their content was bizarre in the extreme. Facing the other way, it meant a strategy for calling attention to the imaginary nature of the medium such that the apparent pact with mainstream, fiction movies was constantly being undone by the parodic debunking deconstruction and demystification of the fiction film's pretended verisimilitude. In addition to all this, Surrealist cinema would centre on two key areas of life where reason is suspended and the irrational takes over, two

46. Phillip Drummond, 'Domains Of Cinematic Discourse In Buñuel's And Dalí's *Un Chien Andalou*', a paper presented to 'Buñuel 2000: A Centenary Conference', University of Romance Studies, University of London (September 2000).

47. AL Rees, op.cit., p.46.

areas of psychic activity cultivated assiduously by Sigmund Freud: humour and sex. The films of Dalí and Buñuel were to bring the two together: 'two pleasures for the price of one'.[48] In the matter of sexual obsession, where Artaud had been in deadly earnest, the two Spaniards would have a great joke. Their throwing together of vulgar gags and eroticism, high culture and trash, the sober and the infantile, would produce an explosive mixture. Even more unusual in the context of the seriousness of the art film, it would produce movies that were entertaining. It's hardly surprising that *Un Chien Andalou* and *L'Age d'Or* remain far and away the most frequently exhibited of French avant-garde films.

One suspects that a movement so receptive to contemporary innovation, so sensitive to what competing avant-gardes were up to, so determined to be 'ahead of the game', must have been impatient to move on from the stage of imagining movies to that of making them, not least because rivals had already stolen a march on them in a medium that surrealists claimed to be intrinsically 'surrealist'. But until *Un Chien Andalou*, there was no consistent idea among the surrealists about what a specifically surrealist film practice might be. Instead, as we have seen, there was a succession of approximations, of botched efforts that failed for a multitude of different reasons to live up to expectations of the medium for surrealist purposes. Their case was thus very different from that of the young film fanatics writing for *Cahiers Du Cinéma* thirty years or so later who had a very good idea of what a 'New Wave film' would be when they got their chance to make one.

And then *Un Chien Andalou* appeared as if out of nowhere. No wonder it was received so ecstatically and, no wonder that on the strength of it, Buñuel and Dalí won surrealist accreditation so precipitately. The film at last opened up perspectives in a medium the surrealists loved but to which they had yet not found the key. At a moment when the original promise of automatism had gone stale, it exemplified fertile new strategies both for

48. See Jonathan Jones, 'For Better Perverse' in *The Guardian Weekend*, 8 September 2001, pp.34ff.

subversion and the revelatory liberation of discourse which was the movement's *raison d'être*. On top of that, it brought two brilliant recruits into the ranks in a year when the original group was being decimated by schism, excommunications and wholesale defections. The 'age of gold' had arrived!

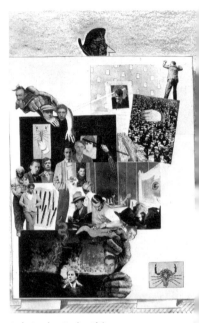

Loplop Introduces Members Of The Surrealist Group (Max Ernst, 1930). Collage of pencils and pasted photographs, including shots of recent members Salvador Dalí and Luis Buñuel.

EXTREMITIES OF THE MIND

Antonin Artaud devoted a great deal of his time to cinema projects in the years between 1924 and 1935, from the ages of twenty-eight to thirty-nine. He wrote fifteen film scenarios in all, and was the only one of the writers associated with the French Surrealist movement to produce a body of theoretical work about the potential of cinema. But despite his expansive engagement with cinema, it is the crucial area of his production which has remained most closed to investigation. To some extent, this is the result of the fragmentary and scattered nature of Artaud's theoretical writings on the cinema, and of the relentless calamities he faced in attempting to make films that could embody his revolutionary theories for cinema. One particular factor in this occlusion has been that Artaud is known as having written the scenario for one of the three great examples of Surrealist cinema, *The Seashell And The Clergyman* (the other two being Luis Buñuel's *Un Chien Andalou* and *L'Age d'Or*), but this is a film which has acquired an ambiguous and contradictory reputation. In contrast to Buñuel's two films, it is very rarely seen. The film baffled most viewers whenever it was screened in Britain and the United States, largely due to the intervention of a disruptive element of chance which would certainly have pleased the Surrealists, if not Artaud himself. When the reels of the film were first sent from France to the United States for distribution, they were re-assembled by error in completely the wrong order. The version of the film which resulted is the one which has been most prominently distributed in the United States and Britain from the

late 1920s to the present. The incoherence of the work certainly contributed to the censorship initially imposed upon the film by the British Board of Film Censors, which used the justification: 'The film is so cryptic as to be meaningless. If there is a meaning, it is doubtless objectionable.'[1]

A further factor in the reputed distancing of *The Seashell And The Clergyman* from Artaud's own intentions lay in the dispute over the gap between text and image that flared up between Artaud and the film's director, Germaine Dulac. The film acquired the reputation in the late 1920s of having been steered away from its original conception by Dulac, to the detriment of the project. Artaud had originally intended to direct his scenario himself, but failed to find the funding to do so. As a result, he deposited the manuscript of the scenario, which he had written in April 1927, at an institute where film producers could look at scenarios with a view to acquiring the rights to film them. Dulac found the scenario there, and decided both to produce and direct the film herself. Dulac was already a legendary figure within experimental film circles – a prolific member of the group of French film-makers known as the Impressionists, which included Abel Gance, and the only female film-maker working in France at the time. Although Artaud had been expelled from the Surrealist movement by its leader André Breton in November of the previous year, his association with what remained at the time an extremely fashionable movement convinced Dulac of the objective challenge to be faced in attempting, for the first time, to make a 'surrealist' film work.

When *The Seashell And The Clergyman* went into production in the summer of 1927, Artaud began to write to Dulac, making insistent demands on her that he should be allowed to collaborate fully on the project, and to edit the film himself. He also wanted to act the part of the clergyman in the production. He was making his living as a cinema actor at the time, appearing in both mainstream and experimental productions, and currently had a role in the Danish director Carl Dreyer's film *The Passion Of Joan Of*

1, *The Seashell And The Clergyman* was distributed in this version by the American company Glenn Photo Supply, which distributed 16mm film copies to Britain. It took until the early 1980s before an American film historian, Sandy Flitterman-Lewis (who was writing a book on the work of the film's director, Germaine Dulac), noticed that the reels were in the wrong order. This discovery appears not to have reached the film's distributors, unless they were oblivious to it, since they continue to use the mis-edited version.

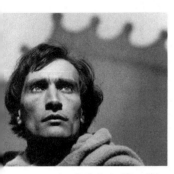

Artaud in *The Passion Of Joan Of Arc* (1928).

Arc, which was being shot in Paris. He persuaded Dreyer to release him from work for the period from 8 to 20 July, in the hope that he could prevail upon Dulac to let him act during those days in *The Seashell And The Clergyman*. Dulac, who clearly had no intention of allowing her directorial independence to be sabotaged by sharing her decisions with Artaud, then delayed the shooting of the film and the editing sessions until August and September 1927, when Artaud was once again fully occupied with his work for Dreyer. Artaud grew increasingly angry, and when the film was screened for the first time, at the Ursulines cinema in Paris on 9 February 1928, he announced that his scenario had suffered unacceptable distortion by Dulac, who, he claimed, had 'butchered' it. Despite his forcible severance from the Surrealist movement, Artaud managed to gain the alliance of a number of Surrealists (and fellow expelled Surrealists) in his protests against Dulac; the Surrealists viewed Dulac as an opportunistic interloper on their preoccupations. The Ursulines screening descended into a cultural riot of the kind which the Surrealists habitually staged throughout the 1920s. At the screening, the writer Robert Desnos initiated a volley of invective and screams directed at Germaine Dulac, and the film projection was abandoned in chaos. Two newspaper accounts gave contradictory accounts of Artaud's own participation in the brawl: in one, Artaud ran wild and shattered the cinema's hall mirrors, crying 'Goulou! Goulou!'; in the other version, he was sitting quietly in the cinema with his mother, and uttered only one word during the glossolaliac uproar: "Enough".[2]

Although Artaud claimed that a manipulative disparity had been opened up by Dulac between the language of his scenario and the imagery of her film, it can be established that Dulac attempted to follow Artaud's scenario with great fidelity.[3] Her changes to the scenario are limited to practical, technical measures that enable the explicit representation of often semi-abstract images. In Artaud's original scenario, a clergyman undertakes a sequence of violent and obsessive actions. The fragmented narrative

2. This account is drawn from a consultation of a series of manuscript letters between Artaud and Germaine Dulac, held in the library collection of the Bibliothèque de l'Arsenal in Paris, together with an archive of newspaper accounts of the Ursulines screening and statements made by Artaud and Dulac to the press about the film.

3. The original manuscript of the scenario of *The Seashell And The Clergyman*, and Dulac's shooting script in its various stages, are in the library collection of the Bibliothèque de l'Arsenal.

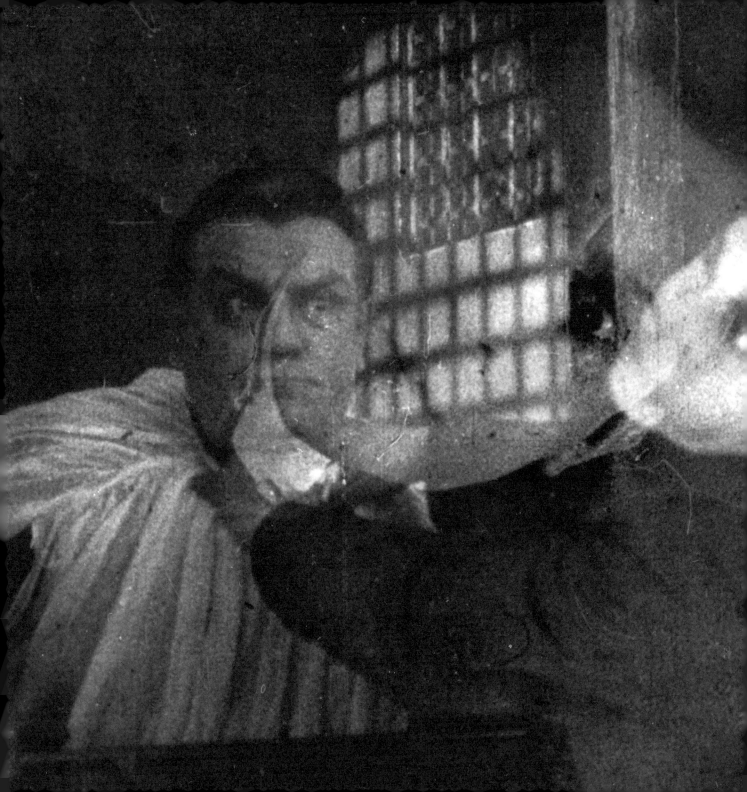

propels the clergyman through a perpetually shifting space of long corridors, crystalline landscapes and narrow city streets. He is sexually tormented in a confessional box by a beautiful woman with white hair, and vents his fury upon the figure of a lecherous military officer. The clergyman's identity collides with that of the officer, and he is constantly surrounded by shattering glass and flowing liquids. His multiple confrontations with the beautiful woman end with her suffering grotesque physical and facial distortions, her tongue 'stretching out to infinity'.

Dulac filmed the images of the scenario with scrupulousness, but, for Artaud, neutralized their virulence by treating them as being simply the representation of a dream. At the beginning of the film, she used the title: *The Seashell And The Clergyman: A Dream*, and gave press interviews in which she announced that she was attempting to find a filmic equivalent for a dream. This infuriated Artaud, who had an intricate theoretical concern with the workings of dream images. He objected also to the way in which the film had sutured together the raw and disjunctive images of his scenario, so that the film flowed easily for the spectator, despite the illogicality of its narrative. Dulac, who was – for that period – a technologically highly advanced director able to execute complex superimpositions of image over image, had used every technical means at her disposal to find cinematic equivalents for Artaud's written images in his scenario, which often gave no indication of the ways in which they should be transposed into cinematic images. It was this very slavishness of Dulac's in following his work which ultimately exasperated Artaud – by duplicating his work, she had distorted and betrayed it – coupled with his anger at being excluded from the film-making process.

As a result of the riot at its première, *The Seashell And The Clergyman* was abruptly taken off the Ursulines programme. The following year, 1929, the film's fragile reputation was entirely overshadowed by Buñuel's celebrated collaboration with Salvador Dali, *Un Chien Andalou*,

which gained the prestige of being the seminal Surrealist film. Buñuel had attended the screening of *The Seashell And The Clergyman* while preparing his own film, and Artaud would claim, three years later, that *Un Chien Andalou*, along with Jean Cocteau's 1930 film *The Blood Of A Poet*, had stolen elements of the hallucinatory imagery, and the strategy of using sudden transitions of time and space, from the film whose scenario he had written. By that time, 1932, Artaud had largely reversed his negative attitude towards *The Seashell And The Clergyman*, claiming it to be a precursor of Buñuel and Cocteau's films. But despite this belated recuperation of the film on Artaud's part, and the objective resemblance between Artaud's written evocation of acts and images in his scenario and their transposition by Dulac into corresponding filmic images, a theoretical abyss separates the scenario and the film. This abyss took the form of Artaud's project for a cinema with far-reaching aims and conception. It was a cinema backed by a theory intended both to exact a radical obliteration of all cinematic history up until that point, and to create a reinvention of spectatorship, by negating the basis of film in the rapport between illusory and pacifying patterns of light and their incorporated, enmeshed spectator.

With the exception of Artaud's ideas, no theory of cinema whatsoever existed among the writers associated with the Surrealist movement at the time. There was, however, a great engagement with cinema in the Surrealist movement, and an enthusiasm for attending numerous film screenings in rapid succession in order to induce a kind of visual delirium or overload in the spectator. With the encouragement of their leader, André Breton, a number of the Surrealists were preoccupied with film as a fertile terrain of psychological investigation; Breton himself envisaged the eventual creation of a world-wide Surrealist cinema with the potential to metamorphose all perception of reality. Several Surrealists, notably Robert Desnos and Benjamin Péret, had written unfilmed scenarios in the form of descriptions

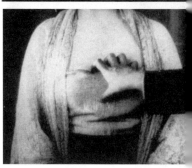

The Seashell And The Clergyman

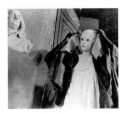

Jean Cocteau's *The Blood Of A Poet* .

4. Antonin Artaud, *Cinéma Et Réalité* (1927), collected in *Oeuvres Complètes*, Volume III, Éditions Gallimard, Paris, 1978, page 19.

of their dreams. But, in direct opposition to such descriptive work, Artaud was proposing an investigation of the systems of dreaming, with the aim of discovering their mechanisms and their collapsing structures (for Artaud, a dream always collapsed into violence and fragmentation). In this way, he intended to formulate films which would reconstitute the violent power of dreaming as a process directly projected into cinematic imagery. This would overrule interpretation or explanation: his stated aim was to "realize this idea of visual cinema where psychology itself is devoured by the acts".[4] Artaud had drawn the images for *The Seashell And The Clergyman* not from one of his own dreams, but from the transcription of a dream written down by his friend Yvonne Allendy; he viewed this distance as imperative for him to launch his attempt to seize what he saw as the visceral emanation of the process of dreaming.

Among the Surrealists, only Buñuel was able to find the finance for a sequence of films (he borrowed money from his mother and, for a time, had a wealthy patron). Artaud negatively associated Buñuel's work with the Surrealist practice of automatic writing, which he detested as creatively passive and antithetical to his own concerns with intentionality and a revolutionary struggle that was to be essentially waged around the human body. But, like Artaud (who was envisaging projects that would document cataclysmic human and natural events), Buñuel was drawn by the documentary form, and included a documentary sequence in *L'Age d'Or*. Before the financial constraints of the new sound cinema at the beginning of the 1930s terminated his film-making activities for nearly twenty years, Buñuel would make the sardonic documentary *Las Hurdes, Tierra Sin Pan / Land Without Bread* (1932), about what he perceived to be the ignorantly self-inflicted poverty of an isolated Spanish community who threw away food and medicines because they failed to understand their uses. But Buñuel's cinema was avowedly non-theoretical: it engaged to some extent with issues of psychoanalysis, but took its own creativity as enforcing

a wilful blindness towards any system of thought, however revolutionary or deviant that system might be.

Artaud developed his theory of cinema around the many other scenarios which he was writing at the time of *The Seashell And The Clergyman*. His theory of cinema appears at the intersection between the images of the scenarios and the preoccupations in language which impelled them. And to some extent, his theory of cinema emerges in direct tension with many of these scenarios. The subject matters of Artaud's scenarios – some of which were clearly written at great speed – vary very widely, and in style they range from oblique chains of unconnected images to highly accessible and cogent plot descriptions of characters engaged in physical struggles. One reason for this latter quality of accessibility in some of Artaud's scenarios was that he was always extremely short of money in the 1920s and 1930s; his theoretical concerns often clash incongruously with the need for his ideas about cinema to help to generate an income for him. For example, one of his scenarios, entitled *Flights*, was an entirely commercial project intended to connect into the increasing popular interest of the time in long-distance aviation, reflected in extensive media coverage. The plot revolves around two competing attempts to accomplish a long and difficult journey, with the protagonists affiliated to the mutually exclusive qualities of "romance" and "villainy" that prevailed in the commercial cinema of the time; after numerous trials, Artaud's romantic heroes win the aviation race in triumph. Artaud was also prepared with his scenarios to plagiarize cinema genres without compunction, and he attempted to interest the German Expressionist cinema and its offshoots in Hollywood with a horror film scenario he had written, *The 32*, which closely resembled work on the theme of the mass-murdering vampire by directors such as F.W. Murnau. As with *Flights*, *The 32* has an upbeat ending, with the vampire redeemed and society saved from further destruction. Artaud sent another of his horror film projects, *The Monk*, to the founder of the Italian Futurist art movement, F.T.

The Seashell And The Clergyman

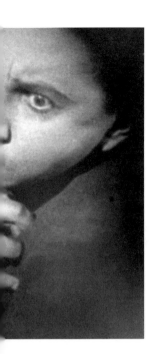

Marinetti, who by this time had become an official poet of Mussolini's fascist régime and an influential figure in mainstream Italian cinema. (Artaud's project, and his request to be employed to direct films in Italy, were ignored by Marinetti.) Many of Artaud's commercial scenarios of the second half of the 1920s give the impression of a futile attempt to ingratiate himself with the formulaic mainstream film culture of the time, though each of them also contains an intermittently startling imagery of the body in extreme crisis. *The Seashell And The Clergyman* was the third of Artaud's scenarios, which number fifteen in all. By far the most extraordinary of all of the scenarios is the very last one, *The Butcher's Revolt*, which Artaud again intended to direct himself and for which he drew up an intricate – though, in its mathematical calculations, completely inaccurate – budget.

 The Butcher's Revolt was written early in 1930, at the crucial point of crossover between the end of silent cinema and the innovation of sound cinema. The scenario possesses a far more cohesive narrative than *The Seashell And The Clergyman*; it even takes place in a specific location, around the Place de l'Alma in Paris. The principal figure in the scenario, introduced with irony by Artaud as "the madman", is in a dangerously obsessive state. While waiting to meet a woman in the street, he watches a carcass of meat fall from a speeding butcher's truck and becomes fascinated by the rapport between the texture of the meat and that of human flesh. He immediately provokes a brawl in a nearby café, and then takes part in a sequence of headlong chases (recalling those from Hollywood silent comedy films) which culminate in his arrival at a slaughterhouse and his humiliation there at the hands of the police. As with *The Seashell And The Clergyman*, the identity of the protagonist is volatile, and he experiences extremes of sensation, from joy to paralysing despair. The action of the scenario is powered by sudden transformations of space, punctuated by occasional outbursts of words, screams and noises.

 In all of his scenarios before *The Butcher's Revolt*, Artaud had

conveyed an adamant opposition to the introduction of sound into his film work. This was the moment of heated debate throughout Europe about whether the new technology of sound in cinema should be resisted or welcomed. In a lecture which he had delivered on 29 June 1929 at a cinema specializing in experimental work, the Studio 28 in Montmartre, Artaud declared: "There is no possible identification between sound and image. The image presents itself only in one dimension – it's the translation, the transposition of the real; sound, on the contrary, is unique and true, it bursts out into the room, and acts by consequence with much more intensity than the image, which becomes only a kind of illusion of sound."[5] Sound, for Artaud, would have to be separated from the image, in order for the image to maintain its own, autonomous resonances and impact. But the following year, with *The Butcher's Revolt*, Artaud attempted to come to terms with the growing inter-relationship of sound and image in cinema; he now viewed the element of mutual destructiveness which he perceived within this relationship as potentially valuable to his aims. He allowed a number of isolated and obsessive phrases (such as: "I've had enough of cutting up meat without eating it") into his scenario, typographically emphasizing them and enclosing them in black-bordered boxes. The words served as a way of imparting an abrupt emphasis to the visual imagery, which would, he believed, rebound from the image/sound collision with greater ferocity. The tense interaction of image, word and sound extended to Artaud's presentation of the scenario's content and its implications for spectatorship. In a note preceding the publication in June 1930 of his scenario in the literary periodical *La Nouvelle Revue Française*, Artaud summarised the content of the imagery: "eroticism, cruelty, the taste for blood, the search for violence, obsession with the horrible, dissolution of moral values, social hypocrisy, lies, false witness, sadism, perversity..." – all of this would be made explicitly visible for the spectator with "the maximum readability".[6] The vision of horror would itself become a visceral but disciplined language.

5. Antonin Artaud, extract from lecture (1929), *Oeuvres Complètes*, Volume III, page 377.

6. Antonin Artaud, untitled note (1930) accompanying *La Révolte Du Boucher*, in *Oeuvres Complètes*, Volume III, page 54.

Artaud's strategy for sound in *The Butcher's Revolt* prefigures that used in his recording for radio, *To Have Done With The Judgement Of God*, eighteen years later. There, the sound effects – screams and rhythmic, percussive beatings – became inserted into Artaud's recited language of expulsion and refusal, with an immediate incision. In the recording, the violent physical gesture of the scream cuts across the escalating rush of the language's imagery in the way that, in Artaud's plan for *The Butcher's Revolt*, noise would have vitally lacerated the flow of the visual images. Similarly, in Artaud's notebook drawings of the mid-1940s, the entangled arrangements of texts and images are often seared by a sudden gesture of obliteration – a pencil stroke that abruptly makes its trajectory across the page, simultaneously reinforcing the powerful visual emanation of language and image as it cancels them.

In *The Butcher's Revolt*, the primacy accorded by Artaud to the image and its spatial presence broke with the predominant film style of the time, which consisted of a kind of filmed theatre that emphasized psychological dialogue and the passage of time. In his note about *The Butcher's Revolt*, Artaud stressed the spatial quality of the reinforced sound which he would employ: "The voices are in space, like objects."[7] Space is a crucial element in Artaud's conception of film. There is a constant preoccupation with expanding and manipulating the spatial dimension while erasing or reducing time. The passage from film frame to frame is an especial danger in Artaud's perception; each image must be emphasised to such intensity that the intervening passage of time between the images can be suppressed to its maximum degree. In his "Theatre of Cruelty" of the early 1930s, there is a parallel concern with spatial movement: the actor's gesture must burn itself out into space with unique immediacy and impact, and must not be repeated in time. The very first of Artaud's film scenarios, *Eighteen Seconds*, from 1924, evokes the thoughts of an actor during the period of eighteen seconds between the moment at which he looks at his watch and the moment

7. ibid, page 54.

at which he shoots himself in the street. A complex sequence of images and spatial mutations is arranged into a condensed period of time, which would then have to be expanded to an hour or two of cinematic duration. Since the process of representation operates for Artaud on a temporal level, on which sound and image are repeated and disseminated, his determination to introduce a spatial rather than temporal element into film sound signalled a denial of the movement towards diminishment and repetition which any completed, represented art object makes. In Artaud's conception of cinema, the presence of the human body in which the film has its axis must be immediate and dense. It is likely that Artaud was aware of a precedent to this aspect of his theory, in the form of the Italian Futurist film manifesto of November 1916, which had demanded "polyexpressiveness" and proposed "filmed unreal reconstructions of the human body".[8] With a scenario such as *The Butcher's Revolt* that projected the amalgamation of diverse, volatile physical elements into a spatially flexible and eruptive structure, Artaud was envisaging a cinema which – like all of his subsequent visual and aural work – was acutely resistant to representation.

Despite prolonged efforts, Artaud failed to find the money to finance the planned production of *The Butcher's Revolt*. He abandoned writing scenarios and his theoretical work on the cinema tailed off at the same time, while, for the next five years, he was forced to continue acting in films – an occupation which he viewed as menial and humiliating.[9]

An innovative and extreme theory of cinema emerges from the short series of texts which Artaud produced at the same time as writing his scenarios. Artaud's theory of cinema is a theory of fragments. It is an oblique, tangential theory with an impulse towards self-cancellation. To some extent, Artaud's theory of cinema serves directly to disassemble and negate the practical attempts which he was making simultaneously to create film works.

8. Film manifesto entitled "The Futurist Cinema", originally published in the journal *L'Italia Futurista*, Rome, issue 9, 11 November 1916, and reproduced in part in the catalogue *Film As Film*, Hayward Gallery, London, 1979, pages 79–80.

9. Artaud's film-acting career had started well, with his part in the director Claude Autant-Lara's experimental first film *Fait Divers*, produced in the same year as Artaud wrote his own first film scenario. In *Fait Divers*, Artaud plays a suave, lipstick-wearing adulterer with sperm-stained trousers who is strangled to death by his lover's irate husband. Claude Autant-Lara was only twenty-three years old when he directed *Fait Divers*. The film's aura of compulsion and obsession, together with its intricate superimpositions and slow-motion sequences, all prefigure those in Germaine Dulac's *The Seashell And The Clergyman* (particularly the erotic scene of Artaud's slow-motion strangulation, which parallels the throttling of the lecherous military officer in Dulac's film). Autant-Lara went on to become a successful mainstream film director, but the attacks of the French "New Wave" critics on what they saw as his "archaic, bourgeois melodramas" contributed to the premature end of his film-directing career at the beginning of the 1960s; however, he began a prominent new career at the end of the 1980s, aged almost ninety, as an extreme right-wing Member of the European Parliament.

Artaud in *Fait Divers* (1924).

Artaud's theoretical film writing, like all of his work, exists in a state of constant flux, with points of abandonment followed by points of resurgence. Artaud writes with the greatest degree of vision and theoretical acuity about film projects which he has already definitively abandoned. His proposals for the cinema are often best seized, in their ephemerality, on the margin of overlap between his theoretical texts and the letters he wrote about his theories, to figures such as the magazine editor Jean Paulhan. The form of the letter was always a privileged site for Artaud in the dissemination of his theoretical work – a form in which polemical exhortation could be allied to direct address. For Artaud, the letter had the effect of imparting confidential or urgent information in the form of a kind of written contract; once the addressee had received the letter, they were involuntarily and compulsorily bound into Artaud's project as a supporter. In Artaud's acutely heterogeneous "letters of theory", as they might be called, the content oscillates wildly between individual obsession and an objective interrogation of wider subject matters, such as the origins and processes of dreaming. In exploring the potential of Artaud's theory of cinema, then, what needs to be pinpointed is the space of intersection between his avowedly theoretical fragments, his letters of theory, and the scenarios that sought visually to form a counterpart – simultaneously interlinked and deeply divisive – to his linguistic preoccupations with the cinema. A final element in this conglomeration of material is Dulac's *The Seashell And The Clergyman*, with its superficial but loyal attachment to Artaud's images.

In Artaud's theory of cinema, representation is perceived as an abyss. From his earliest writings, such as his correspondence with Jacques Rivière on the nature of poetry, Artaud had spoken of a dual trap, within which all of his attempts to create language fell apart. Firstly, he was faced with the dispersal of his language through inarticulation – the intractable slippages which his mental images suffered as they were brought into a textual form. And secondly, on the occasions when he was finally able to

assemble a text, he was immediately faced with its loss into representation, which he perceived as the stealing-away of the unique or original relevance which his language had possessed to his physical presence. In Artaud's work, the body is everything: to transform or transmit the body is the intention of all his work. His incessant hostility towards the process of representation – as the power which assimilates and sabotages this intention – endured throughout his work, and would become most angrily forceful in his approach to his drawings and recordings of 1946–48. By the time he came to work on his final project, *To Have Done With The Judgement Of God*, Artaud would conceive of representation as being inextricably and maliciously linked to social and religious institutions, writing in 1947: "there is nothing I abominate and execrate so much as this idea... of representation,/that is, of virtuality, of non-reality... attached to all that is produced and shown, as if it were intended in that way to socialize and at the same time paralyse monsters, to make the possibilities of explosive deflagration which are too dangerous for life pass instead by the channel of the stage, screen or microphone, and so turn them away from life."[10] Artaud's theory of cinema is one of the primary points of origin for this unique rage against representation, since the essential focus of his rage at this time is the gap of representation between language and image. That gap is what impairs the transmission of his imageries of the human body. For Artaud, the arena of cinema is made up of intangible plays of light, of temporal delays and spatial wastelands, all of which constitute the dead zone of representation.[11] Representation works to deny his conception of a filmic work in direct contact with the human body; the image is always stripped of its imminence. But, at the time of his film work (in contrast to his later work in drawings and recordings), Artaud still recognized that the element of mediation is inescapable in the cinema, and that it had to be both ambushed and worked with. His film theory, then, formulates a confrontation with representation, with the aim of tearing the image away from representation, to transplant it

10. Antonin Artaud, working notes (November 1947) towards *Pour En Finir Avec Le Jugement De Dieu*, in *Oeuvres Complètes*, Volume XIII, 1974, pages 258–259.

11. By way of a contrast, the celebrated French film director Robert Bresson's approach to representation is exactly the inverse of Artaud's in formulation, but is strangely similar in intention and result. Where Artaud wants to refuse representation but project everything (that is, the body), Bresson declared that his sparse, condensed kind of cinema is "the art, with images, of representing nothing". Robert Bresson, *Notes Sur Le Cinématographie*, Éditions Gallimard, 1975, page 20.

directly into the film spectator's ocular nerves and sensations.

Artaud aimed to make his film images dense – and so resistant to the temporal process of representation – by emphasizing their existence in space and their sense of perpetual movement. Around these images of the body, all of the other elements in his scenarios are articulated only to the extent that they are then immediately suppressed, destroyed or subtracted from his filmic world. His film language becomes one of dissolution, with an arrhythmic narrative, and with images pounded down to compact visual sensation. He wrote: "search for a film with purely visual sensations in which the force would emerge from a collision exacted on the eyes".[12] (The constant emphasis on an ocular attack upon the spectator in Artaud's film work necessarily recalls the literal eye-slitting, with its own implications for spectatorship, which is staged at the opening of Buñuel's *Un Chien Andalou* – a film that, as noted earlier, the director was preparing at the time he saw *The Seashell And The Clergyman*.) For Artaud, the concentrated impact which his film would exert on its spectator's perception would result from the disjunctive but accumulating force of his images, amassing to produce a dynamic and essentially spatial inscription of his concerns. With a project such as *The Butcher's Revolt*, the imagery's sensory charge would be accentuated still further by its juxtaposition with elements of noise and with verbal outbursts.

Artaud's conception of cinema moves away from the dominant film fiction of the time – with its attempt to invisibly integrate the new sound technology with the image – towards a more jarring interaction of elements of control and chance. In inviting a disruptive element of chance into his otherwise rigorously formulated work, Artaud was engaging to some degree with the documentary film form, in which directorial intention was ostensibly always subject to being over-ruled by the random emanation and perverse occurrences of reality itself.[13] All of Artaud's scenarios project an atmosphere of darkness, blood and shock at the boundary between intention

12. *Cinéma Et Réalité*, page 19.

13. There are notable exceptions to this. In Luis Buñuel's documentary, *Land Without Bread*, for example, the film's voice-over describes how things are so bad and backward in the poverty-stricken Spanish village which is the subject of the film that the villagers' livestock voluntarily commit suicide by jumping over a cliff. The film shows the animals doing this. But when the image is studied closely, it's just possible to see the film crew pushing the animals over the cliff.

and chance. This is the point where opposites meet and collide – divisions between reality and fiction, and between the individual and an engulfing society. Artaud's film theory delineates a conflict staged upon borderlines, spatially charting the trajectories of what he calls "the simple impact of objects, forms, repulsions, attractions".[14] The borders of image and language inhabited by Artaud's film work are the sites of these multiple collisions, most notably between the subjective and social realities which he would later interrogate in his recorded work. His obstinate traversal of textual and visual borders always implies a negative push: the image stays in the domain of the image, or else risks annihilation. In this relentless collapsing of borders, Artaud's film theory move towards a fall into catastrophe – in fact, towards a zone in which the filmic counterpart to the theory is desired but impossible. And in this theory, the image aimed for and the spectator aimed at would be in a dangerous state of interaction.

14. *Cinéma Et Réalité*, page 20.

Artaud's film theory intends to force its spectators into a position of subjugation to its imageries, with its visual flood of disintegration and disaster; but, at the same time, the theory espouses a violent unleashing of the spectators' senses – those spectators remain alertly grounded in the tactile world, aware both of what the film is subjecting them to, and also incited to react, in simultaneously physical and revolutionary ways. Artaud's theoretical writings and his scenarios possess and maintain their own relentlessly self-annihilating logic which is never transgressed, and moves toward the act of demonstrating images of the insurgent human body at their most stripped-away and condensed – and thereby, in Artaud's conception, at their most resistant to the process of representation. His scenarios are expelled under great internal pressure from his obsessions, and are pitched to explode in the spectator's eyes – directly conveying "the convulsions and jumps of a reality which seems to destroy itself with an irony where you can hear the extremities of the mind screaming."[15]

15. ibid, page 20.

For Artaud, the cinema was literally a stimulant or narcotic, acting

16. Antonin Artaud, *Sorcellerie Et Cinéma* (1927), *Oeuvres Complètes,* Volume III, page 66.

The Man With The Movie Camera (Dziga Vertov, 1929). Vertov (1896–1954) was part inspired by Futurism when formulating his theory of Kino-Eye, a 'means of making the invisible visible, the obscure clear, the hidden obvious, the disguised exposed'.

directly and materially on the eyes and the senses. He called his film projects "raw cinema"[16], and though they were designed initially to investigate the mechanisms of dreaming, they came to demand a more immediately physical contact between the cinematic image and the spectator. Like Artaud's "Theatre of Cruelty" of the mid-1930s, this was a language of film that could work only once – taking the form of one unique film and, in theory, one sole and unrepeatable screening and one set of spectators. It avoided to its extreme limit the process of signification and representation, using instead an imagery compacted together from control, chance and the body's projection.

Artaud's project for the cinema is, in historical terms, lost. It aimed to divert the future course of cinema (and to cancel out cinema's pre-existing course) at a moment of great transformation – that of the coming of sound – when it appeared possible that film could be sent into an unknown direction with the potential for a new relationship between the film and its audience. Many other extraordinary experiments and theories of cinema were being formulated at the same time as Artaud's plans. In the Soviet Union, Dziga Vertov's polemics about spectatorship and revolution were, in their way, as visionary and radical as Artaud's. But, where Vertov was able to direct his film *The Man With The Movie Camera*, Artaud produced nothing. Artaud's vision of cinema, not least because of its integral self-cancellation, cannot stand on the strength of its celluloid imagery (which goes no further than the first, directionless step of *The Seashell And The Clergyman*). Where Buñuel's films gained an aura of enigma through the consistent theoretical reticence of their maker, Artaud's cinema is all theory and written images, and no films. Like his drawings of the mid-1940s, it is in raging flux between imagery and commentary. As the history of cinema transpired, the meshing together of sound and image which Artaud had protested against in 1929 also effectively terminated the first headlong rush of Buñuel's cinema, and brought to an end the great experimental decade of European cinema.

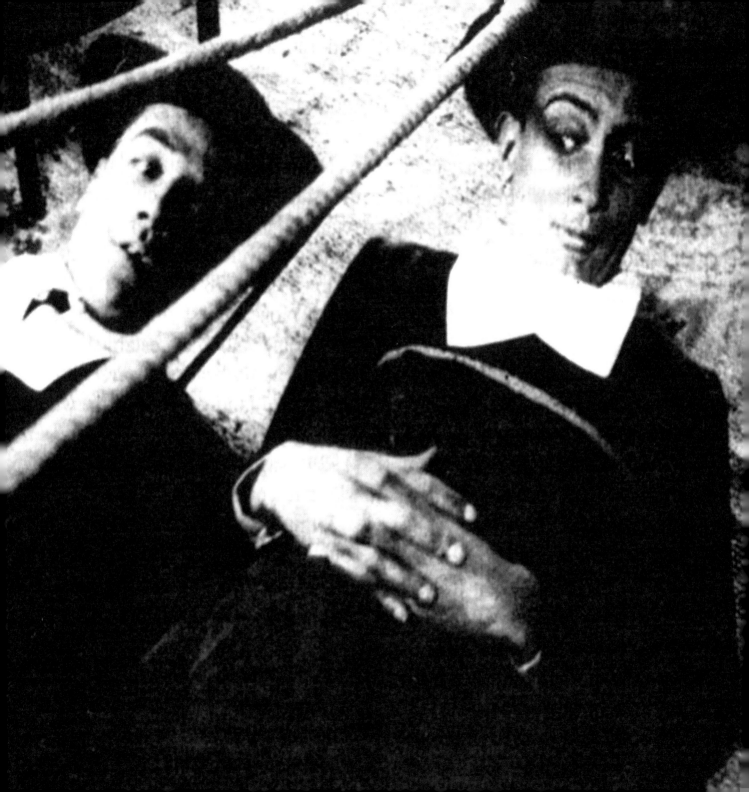

Was there more than a hint of opportunism about the Surrealists' instant appropriation of *Un Chien Andalou* and their equally speedy recruitment of its two makers into the ranks? Certainly the film and the brilliant Spanish duo provided a much needed fillip for the movement that in 1929 was badly depleted and uncertain of its future direction. However, there was nothing unusual about the group's – or more specifically, Breton's – recognition of a kindred spirit 'after the event' as it were. This often happened with artists from the provinces and abroad. Hans Bellmer, for instance, had been at work constructing and photographing his notorious dolls in his native Germany several years before they were brought to the attention of the Paris group and immediately embraced as iconic surrealist objects. Thanks particularly to its achievements in the visual arts, as distinct from its less accessible writing (in French), the movement itself was on the threshold of becoming international. By the late twenties, the outreach of Surrealism was continental, even worldwide. As the newest 'avant-garde' – dare one use the word in this context? – Surrealism shared in the 'rayonnement' enjoyed by the modernist movements of the 'école de Paris' in general at this time. So it was not that extraordinary that a little movie by a pair of young Spaniards hitherto just about unknown to the Paris group should be hailed as the first, totally authentic, surrealist film.

Hans Bellmer's doll, which first appeared in photographic form in the surrealist review *Minotaure*, Number 6, 1934, under the title 'Variations On The Construction Of An Articulated Child'.

Where did *Un Chien Andalou* 'come from'?

Before looking at the film itself, it is worth taking a step back to

examine the varied and complex forces that were at work in its far from immaculate conception: a genesis, indeed, that the Spanish authority Agustin Sanchez Vidal has called 'an endless enigma'.[1] Part of the puzzle centres on the issue of the 'Spanishness' of its creators' inspiration as distinct from the input of Surrealism. How does their specifically Spanish background inform the film? What bearing did their earlier experience, individual and shared, have on the film? These questions are not academic because the lives and the work were so profoundly enmeshed – as with surrealists generally – that knowledge of the one is a key to understanding the other. As for a second part of the puzzle: which of the two – Buñuel or Dalí – contributed what to the collaborative effort? – we'll reserve that until we've taken a closer look at both *Un Chien Andalou* and *L'Age d'Or*.

The Buñuel/Dalí duo of 1929–30 had earlier been – and for six or seven years – the Buñuel/Dalí/Lorca trio. These were the terrible triumvirate of the 'Generation of 1927', each with a formidable destiny before him: Juan García Lorca was to become the most important Spanish dramatist of the century; Salvador Dalí was to become, at any rate as far as the general public is concerned, the personification of Surrealism both in his work and in his life; and Luis Buñuel, long after his partnership with Dalí broke up, was destined to be a supreme exemplar of European post-war 'art cinema' alongside Bergman, Fellini, Antonioni, Godard and Truffaut.

What so impresses observers of the Dalí/Buñuel/Lorca, milieu in the early twenties is the depth of the complicity which existed between them and the degree to which the shared imagery, themes and obsessions of their later careers can already be spotted in the student culture of their Madrid years.

The threesome met up at the Residencia des Estudiantes, Madrid's equivalent of Oxbridge. Buñuel was the first to arrive, in 1917, registering for an agronomy degree but switching to philosophy. He was keen on sport, especially athletics, boxing and arm wrestling. He was a prankster who would climb up the façade of the Residencia for a dare, and have his friends

1. Agustin Sanchez Vidal, *Buñuel, Lorca, Dalí: El Enigma Sin Fin* (Barcelona, 1988). This book has not yet been translated into English. But a good idea of its argument can be had from Vidal's chapter titled 'The Andalusian Beasts' in Ian Gibson et al. eds, *Salvador Dali: The Early Years* (South Bank Centre, 1994) pp.193–208.

Lorca and Buñuel, 1925.

2. The main source for this material on Buñuel's and Dalí's early years is Luis Buñuel, *My Last Breath* (Jonathan Cape, 1984, chapter 7).

jump on his stomach to test his muscles. He had a reputation for telling tall stories – like the one in which he claimed to have given street directions to the King of Spain without raising his hat. Lorca arrived in 1919 and the two became instant friends. Lorca had already published his first collection of poetry. Hugely gifted as a poet, painter, musician and later playwright, Lorca, with his shining, dark, Andalusian eyes, was also a magnetic personality.

A year later, in 1920, they were joined by Dalí, the most single-minded of the three at this stage, who enrolled in the Academy of Fine Arts. He dressed provocatively, sporting enormous hats, huge ties, a long jacket that hung down to his knees. They nicknamed him 'the painter from Czechoslovakia'. He also behaved provocatively, scuppering his chance of completing his course at the Academy by shouting at the panel of examiners: 'No one has the right to sit in judgement upon me. I'm leaving'. Buñuel recalls, 'Along with Lorca, he became my closest friend. We were inseparable; Lorca nurtured quite a grand passion for Dalí, but our Czechoslovakian painter remained unmoved.'[2]

Dalí was the son of a successful lawyer from Figueras in Catalonia, Lorca came from a well-to-do land-owning family from near Granada in Andalusia, and Buñuel's father in Aragon had made a fortune dealing in Cuban sugar. So the 'three musketeers' at the Residencia could live the life of reasonably well-heeled señoritos. It was a round of drinking bouts, practical jokes, improvised happenings, brothels and jazz sessions late into the night. Buñuel founded 'The Order of Toledo' in 1923 with ranks of caballeros and escuderos. To become a caballero you had to love Toledo without reservation, drink there a whole night long, and enjoy wandering through the city with no destination in view (just as the surrealists did in Paris). The little band elaborated shared rituals, mythologies and bestiaries. They invented the 'putrefact', an Ubuesque figure who stood for philistinism and 'bourgeois' crassness. Putrefaction was the sentimental, the decaying,

the formless; the opposite of Dalí's favoured clarity and dispassion. They planned to produce a 'Book of Putrefaction' to rival Flaubert's *Dictionary Of Received Ideas*. Yet the 'putrefact' became shot through with ambivalence as Buñuel and Dalí moved towards Surrealism; the intimacy of attraction and repulsion vis-a-vis rottenness is evident enough in the Dalí/Buñuel films. Another object of their common mythology was Saint Sebastian, the tutelar of homosexuals and sado-masochists, and, since Mantegna's painting, a favourite icon of Christian and erotic martyrdom. Ever paradoxical, Dalí had the Saint stand for objectivity, the power to control emotion, and patience in extreme agony. According to Ian Gibson, in September 1926, Dalí mischievously asked his friend Lorca if he had noticed that, in the representations of the martyr, there was never any suggestion that the arrows pierce his buttocks – a teasing allusion, to anal intercourse and the poet's attempts to possess him.[3]

Common to all three, it seems, was an extreme form of adolescent anxiety about sexuality – in the forms at once of uncertainty about their own gender, fear of women and of impotence, along with a residual sense of the sinfulness of sex.

Buñuel describes in his autobiography how the tight association in his mind between sex and death dated from his childhood in Aragon. 'As in the Middle Ages, death had weight in Calanda; omnipresent, it was an integral part of our lives. The same was true of faith. Given this heavy dosage of death and religion, it stood to reason that our *joie de vivre* was stronger than most. Pleasures so long desired only increased in intensity because we so rarely managed to satisfy them. Despite our sincere religious faith, nothing could assuage our impatient sexual curiosity and our erotic obsessions. In the end we were worn out by our oppressive sense of sin, coupled with the interminable war between instinct and virtue'. Buñuel wonders why Catholicism had such a horror of sexuality and goes on: 'It seems to me that in a rigidly hierarchical society, sex – which respects no

Lorca and Dalí, 1927.

3. Ian Gibson, *The Shameful Life Of Salvador Dalí*, (Faber & Faber, 1997) p.142.

barriers and obeys no laws – can at any moment become an agent of chaos. Ironically, this implacable prohibition inspired a feeling of sin which for me was positively voluptuous. And, although I'm not sure why, I have always felt a secret but constant link between the sexual act and death.'[4]

4. Luis Buñuel, op.cit. p12 & 15.

Before moving on to issues specifically of cinema, it is worth noting two further, but rather different, factors that contribute to Vidal Sanchez's 'endless enigma'. One stems from the nature of avant-gardism in Spain at this time. Buñuel, Lorca and Dalí belonged to a milieu immensely hospitable to the new, but one in which the avant-gardes from abroad were received as it were in the game of 'Chinese whispers'. And it was some years before Buñuel and Dalí gravitated towards Surrealism specifically. There was a snag for the Madrilenas. While there was, of course, a strong native input – the three were inevitably influenced by the generation of writers Spain produced at the turn of the century: Ortega y Gasset, Valle Inclan, Galdos and by the younger Ramon Gomez de la Serna – nevertheless, the capital of the world avant-garde in the twenties, as it had been since the belle époque, was unchallengeably Paris. For the generation of 1927, the relation Paris/Madrid was metropolis/provinces. As a corollary of provincialism, the movements that proliferated in the Spanish capital were highly eclectic and syncretic. It was more difficult to distinguish one 'ism' from another than, say, in France. They often overlapped. Much of the activity of the avant-garde in Spain was an occupation conducted in clothes borrowed from abroad. Spanish avant-gardists took off the peg the literary and artistic 'isms' fashioned for the most part beside the Seine.[5]

5. Derek Harris ed., *The Spanish Avant-garde* (Manchester University Press, 1995), Introduction.

A second complication was that both our men were only in their twenties and still very much in the process of finding themselves. Buñuel took a long time to discover his vocation as a filmmaker. If Dalí knew very well that he wanted to be a painter, it was six or seven years before he found his definitive style. All of this is easy to see in Dalí's paintings and artistic manifestos between 1923 and 1928, when he seemed to be working through

all the possibilities of modern art. This working through, however, was always challenging and critical. You could almost call it a sort of post-modernist pastiche.[6] It seems as if Dalí reworked in his own way – and worked his way through: cubism, neo-classicism, new objectivity, metaphysical painting, and even expressionism. Dawn Ades suggests that he was trying out identities, searching for the clothes that would finally fit him.[7] He quoted from Picasso and Miró in an attempt to be at their level, just as while an adolescent he vied with Chardin and Leonardo. If he was initially suspicious of Surrealism, then perhaps it was out of narcissism. He seems to have played a game of love-hate with Surrealism in order to try to bring it under his control. As for Buñuel, he was more or less connected with the Ultraists who claimed to be the furthest ahead of the game as it was played in Madrid: they were admirers of Dada, Cocteau, Marinetti and Apollinaire. Buñuel published his early poetry in the *Ultra* review.

It is no wonder that, from their earliest years in the University residence, just like 'provincials' everywhere, Buñuel and Dalí longed to 'monter vers Paris'. Buñuel left Spain for Paris in 1925 after his father's death, returning several times in the next four years to bring news – and avant-garde films to show in Madrid – from the French capital. Like Miró, Picasso and Juan Gris before them, these Spaniards only made their major contributions to European modernism once they had moved to Paris. Writers like Lorca, however, were bound by the limitations of their native tongue, unless they chose to abandon it in favour of French. The achievements of the Spanish literary avant-garde was therefore muted in the European context.

By 1927, Dalí's paintings exhibited the burgeoning influence of Surrealism, particularly of the oneiric landscapes of Giorgio de Chirico and Yves Tanguy, and to a lesser degree, Max Ernst and Dalí's fellow Catalan, Juan Miró. In October, Dalí justified the role of the unconscious in the creative process behind his recent, dream-inspired paintings and admitted 'the intervention of what we would call the poetic transposition of the purest

6. Marc J LaFountain, *Dalí And Post-modernism* (State University of New York Press, 1997) passim.

7. Dawn Ades, *Salvador Dalí* (Thames & Hudson, 1982) pp.14–15.

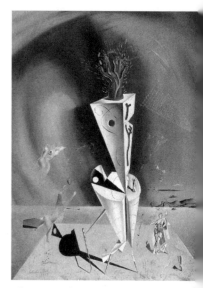

Dalí's *Apparatus And Hand*, 1927.

8. *L'Amic DeLles Arts*, October 1927, quoted in Dawn Ades, op.cit, p.34.

9. Viz 'Salvador Dali, 'Photography: Pure Creation Of The Mind' (1927) in Dawn Ades ed, *Salvador Dali: The Early Years*, op.cit. See Robert Radford, *Dali,* (Phaidon, 1997) pp.77ff.

subconscious and the freest instinct.[8] But the position taken in his March 1928 'Catalan Anti-Artistic Manifesto' shows that he still harboured reservations about making a full commitment to Surrealism. His reasons were theoretical; not just tactical nor the consequence of geographical distance. His long-held predilection for clarity, precision and objectivity led him to distrust what he called ' the murky subconscious processes' associated with Surrealism's founding procedure, automatism. To provoke new thought, he was now saying , you needed simply to look afresh at the external world. His watchword, 'To look is to invent' was to take him briefly away from automatism, in fact away from painting as such, and towards photography. Dalí's quarrel with the 'putrefacts' – aesthetes, mystic and sentimentalists who relied on academic theory and inherited notions of good taste – and his early quest for a new, lucid, objective art, inevitably led him to consider in a very positive light the role of the camera.[9] He became increasingly dissatisfied with painting in 1928 and turned to photography – with 'its infinite figurative associations to which it submits our spirit' – to reveal the hidden facets of reality. And from the photo, it was only a step towards film and...*Un Chien Andalou.*

It might seem surprising that these developments in Dalí's thinking were to bring him closer to Surrealism rather than continue to distance him from it. For they were coincidental with shifts within Surrealism itself where automatic methods were revealing their limitations by the later 1920s and Breton was casting about for fresh alternatives to re-energise his movement. Dalí's 'innocent eye' approach chimed with Breton's recent declaration that 'the eye (existed) in an untamed state'. Just as Breton insisted that reality and surreality were mutually contained within one another, so Dalí urged that the givens of reality are the basis of all intimations of surreality. It seems that Dalí was particularly taken by the documentary character of Breton's latest book, *Nadja,* (1928), which supported its clinical observation

of 'facts belonging to the order of pure notation' with accompanying documentary photographs. It can never be sufficiently emphasised that Surrealism is not about a flight from the real – not a wishful escape into some Never-neverland of the imagination. Just the reverse, it is about an intensification of our experience of the real. This helps explain the surrealists' precocious interest in the camera, both for photography and cinema. Approaching by a different path, Dalí found himself on the same route.

Meanwhile Buñuel in Paris was making his own way into the orbit of Surrealism. He was to remain faithful to its tenets until his death. Buñuel later said that he was first seduced by the snapshot of Breton's henchman, Benjamin Péret, insulting a priest in a 1926 number of *La Révolution Surréaliste,* and later by the frankness of the group's survey on sexuality – both unthinkable in his native Spain. For him and Dalí too, as for so many others who, unbeknownst to each other, were already practicing instinctive forms of irrational expression, Surrealism came like a recognition rather than a discovery. Buñuel came to treasure Surrealism because it gave access to the dark depths that held such fatal attraction since his childhood. It respected the essential mystery at the heart of things. Just as important, it was a vehicle for revolt, playful and insolent (unlike dour Communism) and dedicated to fighting everything that was punitive in conventional wisdom. Surrealism's appeal to Buñuel always remained moral: for existing values it substituted a richer ethic whose tenets were passion, humour, occultation, insult, cutting loose and the risks of an imaginative life on the edge of the abyss.

As far as cinema was concerned, while at the Residencia, Buñuel and Dalí had thought of film only as entertainment, not as a new form of expression. Not yet even dreaming of making films, and just like the surrealists in Paris, they were passionate film-goers. Their favourites were American comedies, especially those of Buster Keaton and Harry Langdon.

More than eighty-per-cent of the movies exhibited in Madrid at the time were made in Hollywood. By 1927, Dalí was taking cinema more seriously. He listed film among the defining features of modernity – along with gin cocktails (Buñuel's choice) and sports cars – in his personal manifesto 'Saint Sabastian' in *L'Amic De Les Arts* in July. This was a forerunner of his key article 'Art films and anti-artistic films' for *Gaceta Literaria* of December that year which he dedicated to Buñuel.

Buñuel's entry into cinema came about almost accidentally. He had gone to Paris in 1925 with the idea of becoming a career diplomat. He had been invited to help launch a putative Society for Intellectual Cooperation under the aegis of the League of Nations. When the project stalled, Buñuel was adrift. He passed the time going to the pictures. A recommendation from a friend got him work on the set of Jean Epstein's screen adaption of George Sand's novel *Mauprat*. Bit parts in films such as Jacques Feyder's *Carmen* followed. He gravitated towards the avant-garde and had personalised notepaper headed 'Luis Buñuel: Metteur en scène cinématographique'. But the jobs he hustled for in film production were irregular and hardly prestigious. He fell back on film criticism. Sending his copy from Paris, Buñuel was reviewing films regularly for the Madrid *Gaceta Literaria* from January 1927 and he also wrote for the Paris-based *Cahiers d'Art*. Many of Buñuel's ideas were in fact borrowed from the film criticism of Parisian surrealists such as Aragon and Soupault and from surrealist fellow-travellers such as Jean Goudal in his seminal article 'Surréalisme Et Cinéma' published a month after Buñuel arrived in Paris in January 1925. In promoting an image of himself back in Spain as a fully fledged cinéaste, Buñuel could capitalise on the mystique surrounding Paris in the eyes of the Madrilenas and on flattering rumours about his own success in the Paris film world which he did nothing to deny. In truth his apprenticeship in the film industry was hardly glorious. By late 1928, he had not risen higher than assistant on the set, albeit to notable directors such as Jean Epstein, Marcel

L'Herbier and Maurice Dekobra. He was not an easy colleague. He ruined his chances of working further with Epstein, for instance, by bad mouthing the even more highly respected Abel Gance. But, in early 1927, Buñuel at least enhanced his reputation at home by bringing a programme of avant-garde Paris films – it included Clair/Picabia's Keatonesque *Entr'acte* – to screen at the Sociedad de cursos y conferencias. He was after all just about the only Spaniard with any professional experience in the cinema. It may well be that Buñuel was seeking via film – in which his career had not as yet taken off – to keep pace with the growing reputations of Lorca in writing and Dalí in painting The degree of jealousy between Dalí and Buñuel is revealed in Buñuel's letters to their mutual friend, José 'Pepin' Bello complaining about Dalí's and Lorca's absence from his moment of glory, and in Dalí's letters to Lorca resenting Buñuel's 'triumph' and querying its worth.

As 1928 progressed, Buñuel's and Dalí's ideas about cinema grew so close as to become indistinguishable. They also echo in almost every respect the critical positions – and the robust sympathies and antipathies – of the surrealists. They were at one, for example, in their love of Hollywood and their corresponding denigration of France's art cinema. In 'Art films and anti-artistic films', Dalí criticises artistically inclined filmmakers for bringing to the medium the worst affectations of the old lyrical or literary culture and for showing no awareness of the inherent technical qualities of the medium. Indeed, it is the 'anti-artistic' Hollywood producer who, in working like a naïve artist, reflects the subconscious fantasies behind popular imagination: 'He films in a pure way, obeying only the technical necessities of his equipment and the infantile and strikingly joyful instinct of his sporting physiology.'[10] Since January 1927, Buñuel had been singing to the same hymn sheet in his reviews for *Gaceta Literaria*. Like Dalí, his main concern was with the poetic possibilities of the medium, albeit in an 'anti-artistic' vein. It is in the films of Harry Langdon and the cross-eyed Ben Turpin that he finds 'the finest poems that cinema has produced'....The

10. Salvador Dalí, 'Film-arte, Film-anti-artistico' *Gaceta Literaria*, (Madrid) No.24, 15 December 1927, translated in Ian Gibson et al. eds, *Salvador Dalí: The Early Years* (op.cit., pp. 219-220).

11. Luis Buñuel, in *Gaceta Literaria,* No.56, 15 April 1929, translated in *An Unspeakable Betrayal: Selected Writing Of Luis Buñuel,* (University of California Press, 1995) pp.123–4.

12. Salvador Dali, *Oui, 1,* (Denoël, 1971) p.40.

13. Haim Finkelstein, *Salvador Dali's Art & Writing, 1927 To 1942 – The Metamorphosis Of Narcissus* (Cambridge University Press, 1996) p.84.

14. In *L'Amic De Les Arts,* March 1929 quoted by Finkelstein op.cit, p.84.

equivalent of Surrealism in cinema can be found only in those films, far more surrealist than those of Man Ray.'[11]

Of course, Dalí and Buñuel were being deliberately provocative in these reversals of the canons of respectable taste. Their anti-art film campaign is of a piece with Miró's aim to 'assassinate painting', Ernst's claim to have gone *Beyond Painting'* and Aragon's *Painting Defied.* If anything, Dalí's anti-art position on the cinema was more radical than Buñuel's in so far as he was ready to jettison what he called 'anecdote' altogether, declaring the poetry of film lay in 'little things', 'the villain's mask, his movements, his manner of dressing, the hand knocking at the door'.[12] According to Haim Finkelstein, 'Dalí's totally non-dramatic conception consisted of two basic directions. One relied on the standardisation and constant 'signs' of the American commercial cinema; the other partakes of the fantasy inherent in the simple recording of the facts and objects of the external world.'[13] But it was still difficult to tell from the writings of either Dalí or Buñuel, prior to the making of *Un Chien Andalou* what they thought a 'pure' surrealist film might be like. In a published interview by Dalí in March 1929, Buñuel replied that the only kind of film they could advantageously aspire to might be 'a succession of surrealist images' and 'oneiric scenarios'.[14] But even with these precautions, Buñuel was still worried that such a film might fall into the avant-garde trap of artiness.

Jealousy and rivalry notwithstanding, the winter of 1928–9 was the period of Dalí's and Buñuel's greatest intimacy. By the spring of 1928, the crystallisation of Dalí's ideas about international modernism was separating him more and more from Lorca. Already in 1927, Dalí had misgivings about the ornate, folkloric side of Lorca's *Mariana Pineda,* a play which so upset Buñuel he stormed out. Another milestone in the deteriorating relationship was the publication of Lorca's *Romancero Gitano* in 1928. It was a crying example of that very outworn localism that Dalí had just denounced in the 'Catalan Anti-artistic Manifesto'. Buñuel's star waxed with Dalí as Lorca's

waned. It was no coincidence that this intimacy followed hard upon Lorca's efforts during a stay with the Dalís at Cadaquez in the June 1928 to consummate his physical love for Dalí. The Catalan had firmly resisted these attempts at sodomisation, protesting vehemently he wasn't homosexual.[15] These personal dramas suggest that the sexual preoccupations of the imminent film – complexes of infantilism, castration, gender ambivalences – were very close to home. And perhaps soliciting Dalí's collaboration on the film was another stratagem on Buñuel's part to woo Dalí away from Lorca.

At the start of 1929, Buñuel's career in French cinema was still marking time. It seems that, as a last throw, he had prevailed on his mother to advance him the substantial sum of five thousand douros – about a hundred and forty thousand French francs at the time – to make a film of his own. It was money that would have come to him eventually in any case, being an equivalent to his sisters' doweries. This was in the autumn of 1928 and Buñuel's idea was to make a film based on the short stories about city life by their much admired older friend from Madrid, the modernist writer, Ramon Gomez de la Cerna. Dalí, however, had been unimpressed by Buñuel's outline and sent back some ideas of his own jotted down on the lid of a shoebox.[16] Dalí himself did not have either the discipline or the experience needed to make a film on his own, nor to make the leap from the written figure to the moving, film image. Thus *Un Chien Andalou* came at an opportune moment for both of them, given that Dalí was increasingly disenchanted with painting in the winter of 1929 and was putting much more faith in the photographic image to achieve the osmosis he sought between reality and surreality. To quote Naim Finkelstein again: 'For Buñuel, a committed film maker who was ready to undertake almost any project, and Dalí whose views of film are quite removed from any considerations of practical realisation, *Un Chien Andalou* was the common ground on which they both met.'[17] For the first time a director truly sympathetic to Surrealism was available – as was the necessary cash.

Two of Lorca's poems, 'La Casada Infiel' and 'Prendimiento Ee Antoñito El Camborio', were recited in Justo Labal's short 1937 film tribute *A Federico Garcia Lorca*. The first film version of Lorca's play 'Bodas De Sangre' (*Blood Wedding*) appeared one year later, directed by Edmundo Guibourg.

15. Ian Gibson, *The Shameful Life Of Salvador Dali* (Faber & Faber, 1997) pp.164-5.

16. Or so Dali claims: see Salvador Dali, *The Secret Life Of Salvador Dali* (Vision Press, 1949) p.206, and Ian Gibson, op.cit., p.192.

17. Haim Finkelstein, op.cit,, p.84.

(Buñuel has claimed that he made *Un Chien Andalou* for only half what he'd been given, and that he spent the rest in Paris night clubs.) All that was needed now was a script.

Whether or not Dalí had written 'a very short scenario' or not is still uncertain. No record of it has survived. But it does seem that on the strength of Dalí's promise of something 'that went completely counter to the contemporary cinema'[18,] Buñuel took the train from Paris in January 1929 to meet him in Figueras where they worked together on their screenplay for a week. This is how Buñuel in his autobiography recalls the genesis of the scenario:

'A few months later, I made *Un Chien Andalou,* which came from an encounter between two dreams. When I arrived to spend a few days at Dalí's house in Figueras, I told him about a dream I'd had in which a long, tapering cloud sliced the moon in half, like a razor blade slicing through an eye. Dalí immediately told me that he'd seen a hand crawling with ants in a dream he'd had the previous night.

'And what if we started right there and made a film?' he wondered aloud.

Despite my hesitation, we soon found ourselves hard at work, and in less than a week we had a script. Our only rule was simple: no idea or image that might lend itself to a rational explanation of any kind would be accepted. We had to open all doors to the irrational and keep only those images that surprised us, without trying to explain why. The amazing thing was that we never had the slightest disagreement; we spent a week of total identification.'[19.]

And in conversation with Turrent and de la Colina, he went further:

'We were so attuned to each other that there was no argument. We wrote accepting the first images that occurred to us, systematically rejecting those deriving from culture or education. They had to be images which surprised us, and which we both accepted without discussion. Only that. For

18. Salvador Dali, op.cit., p.206.

19. Luis Buñuel, *My Last Breath,* (op.cit, 1984) pp.103–4.

example: the woman grasps a tennis racket to protect herself from the man who wants to attack her. Then he looks around for something with which to counter-attack and (now I'm talking to Dalí) 'What does he see?' 'A flying toad.' 'Bad!' A bottle of brandy.' 'Bad!' 'Well then, two ropes.' 'Good, but after the ropes, what?' 'He pulls them and falls, because they're tied to something heavy.' 'Ah, then it's good for him to fall.' 'On the ropes are two big dry marrows.' 'What else?' 'Two Marist Brothers.' 'That's it, two Marist Brothers!' 'Next?' 'A cannon.' 'Bad!' 'A luxurious armchair.' 'No, a grand piano.' 'Terrific, and on top of the grand piano a donkey....no, two rotting donkeys. Fantastic!' That's to say, we encouraged irrational images to well up, unexplained.'[20]

20. Tomas Perez Turrent & Jose de la Colina eds., *Conversations Avec Buñuel* (Cahiers du cinéma, 1993) pp.30–31, trans. in Ian Gibson, op.cit, p.193.

This account of the gestation of the filmscript is impeccably surrealist. The film was born of a 'chance encounter' between images and follows the 'logic' of dreams. Though irrational, the unfolding of the script is not arbitrary but obeys the orders of a compelling complicity between the two men. Though conscious choice intervenes in the script and, obviously, will do so in the practical realisation of the film itself, *Un Chien Andalou* is engendered by an act of automatism. Its material is not so much invented as discovered. The encounter of the images plays the role of a surrealist 'incipit': that fecund 'found' phrase that Aragon claimed was the starting point of so many of his surrealist writings. The iconic example is the phrase – accompanied by a weak visual representation – that 'knocked on the window' of André Breton's consciousness one evening at the onset of sleep: 'Il y un homme coupé en deux par la fenêtre'.[21] (There is a man cut in half by the window') – the famous 'fenêtre qui fait naître'.

21. André Breton, *Manifestes Du Surréalisme* (Jean-Jacques Pauvert, 1962) pp.34–35.

The origin of the title, *Un Chien Andalou,* has been much debated. Several alternatives had been bandied about between Buñuel and Dalí, including *Don't Lean Inside The Window,* a twist on the warning in French trains: 'Défense de se pencher au-dehors'. It was a clunky joke, but indicative of their burlesque intent. *The Priest With The Crossbow* was also set aside when the pair joyfully settled on *Un Chien Andalou.* It had earlier been

intended by Buñuel for a collection of his then unpublished poems. Perhaps *Un Chien Andalou* was chosen precisely because there are no references at all to dogs in the film, Andalusian or otherwise. Magritte also, like most surrealists, preferred titles that bore no rational relation to his pictures. According to Aranda, Andalusia was the butt of amiable derision for Residencia students from northern Spain, in much the same way as Mallorca in *L'Age d'Or*. They applied the name 'Andalusian dogs' to anti-modernist poets still in thrall to folklore and lyricism. And according to Buñuel, Lorca did feel personally attacked by the film and suspected that he was indeed the 'Andalusian dog' in question.[22] Given that Buñuel and Dalí had come to identify modernity with maleness, was not Lorca also perhaps the impotent cyclist in the feminine frills? Ian Gibson has pointed out that the idea for the male protagonist dressed as a chambermaid falling off a bicycle is taken directly from 'Buster Keaton's Outing', a brief text by Lorca done in 1925 which is itself full of references to the cinema. The Batcheff character's anxiety about breasts and lust for buttocks is another unkind, likely allusion to Lorca's homosexuality.[23]

Un Chien Andalou was shot in a fortnight, as rapidly executed as the script itself, to which Buñuel kept faithfully. He hired a studio at Billancourt, a cameraman and two professional actors. The opening credits for the film are sparing: after Buñuel for direction and Buñuel/Dalí for the scenario, only the principal actors are named – Simone Mareuil and Pierre Batcheff, and the cinematographer, Duverger. There is no mention of Buñuel as razor man, nor of Dalí as Marist Brother, nor of any of the mutual friends who took walk-on parts gratis. Simone Mareuil was a professional actress of modest notoriety who appeared in twenty or so mainstream French films between the wars. She was to commit a spectacular suicide in 1954 by setting fire to herself and running in flames through the woods. Batcheff was to kill himself too, only three years after *Un Chien Andalou*. In 1929, he was far better known than his screen partner, and for that matter, than Buñuel

22. Luis Buñuel, op.cit., p.157.

23. Ian Gibson, op.cit., p. 195.

65

or Dalí. In fact, he was something of a matinée idol and had worked with many of the most highly rated French directors of the silent era: Gance, Clair, Epstein, L'Herbier, Cavalcanti…. He apparently played more than an actor's part in the actual realisation of the movie. Maybe it was hoped his star quality would ensure big takings at the box office launch. Fano Mesan was cast as the hermaphrodite; she used to dress *à la garçonne* and occasionally accompanied Buñuel and his friends in the cafés of Montparnasse. The main actors were paid – a little – but they were paid. Buñuel was his own producer for the first and only time in his life.[24] He never showed the scenario to the actors. He would just say to them: 'Now you're looking through a window; there's an army marching by' or 'Over there two drunks are fighting'. As for Dalí, he travelled up to Paris – it was his second visit since a brief first stay in 1926 – but he was present on the set only for one of the last days of the shoot. According to Buñuel, Dalí spent most of that day preparing the corpses of the two donkeys on the grand pianos, covering them with treacly glue, gouging out their eye sockets and exposing their teeth, so as to make a graphic match between them and the ivory piano keys.[25] It seems that Dalí, as a painter first and foremost, was more interested in *mise-en-scène* than in any other elements of the film-making.

 The two Spaniards had a great deal riding on *Un Chien Andalou*. Though a profit would have been a bonus, for Buñuel, a critical success counted more because this was perhaps his last chance to break through into a career in films. For Dalí, it promised the notoriety he craved in Paris where it mattered most. Finally, it could be a passport into the surrealist group. That both men were now totally aligned with Breton is clear from the last March 1929 'surrealist' issue of *L'Amic De Les Arts* edited, and mostly written by Dalí. Buñuel recalls that he was apprehensive about how their film would go down with its first night, by invitation only, 'tout Paris' audience at the prestigious Left Bank art cinema, the Studio des Ursulines

24. Tomas Perez Torrent and Jose de la Colina, op.cit., p.32.

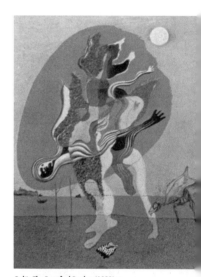

Dalí's *The Putrefied Donkey* (1928); rotting or skeletal mules figure in his work since the epochal *Honey Is Sweeter Than Blood* (1926).

25. Robert Radford, *Dalí* (op.cit), p.91.

on 6 June 1929. 'Everyone' was there including Picasso, Le Corbusier, Cocteau (although the latter denied seeing their film prior to making his own *Le Sang d'Un Poète* a year later) – and probably a good few members of the surrealist group. Fearing the worst, Buñuel, who was working the backstage gramophone – which played the soundtrack of Argentinian tangos alternating with the Liebestod from Wagner's *Tristan And Isolde* – had filled his pockets with stones to throw at the audience if there was a hostile reception.[26] He needn't have worried. The film was greeted enthusiastically and went on to have a successful eight-month run at Studio 28, a commercial/experimental cinema on the slopes of Montmartre. On the strength of their film, Buñuel and Dalí were – as they had so hoped – swiftly enrolled into Breton's group and Buñuel was charged with the role of advancing Surrealism's project through cinema. Paradoxically, the very commercial success of the film got Buñuel into hot water with the surrealists, arousing their hatred of the cash nexus. Another early blip in the relationship followed Buñuel's agreement for the scenario to be published in the commercial magazine, *La Revue Du Cinéma,* before it appeared in *La Révolution Surréaliste.* But good feelings were restored when the director used the group's house-organ to excoriate the film's complacent admirers, insisting that it was not poetic or beautiful but 'nothing other than a desperate, a passionate, appeal to murder'.[27] His words chimed exactly with Breton's notorious declaration in the same number that 'the simplest surrealist act consists of dashing down into the street, pistol in hand, and firing blindly, as fast as you can pull the trigger, into the crowd'.

So, what are we <u>shown</u> – and what do we <u>see</u> – in *Un Chien Andalou?*

What exactly happens during this densely packed seventeen minutes of silent film. And what might we begin to make of it? Given all that has been said so far, it will be clear enough that a synopsis of *Un Chien Andalou* as if it were a normal movie with a logic of causality governing the customary unfolding of the story is bound to betray it completely. Nevertheless, some

26. Luis Buñuel, op.cit., p.106.

27. Luis Buñuel, Note introducing the scenario of *Un Chien Andalou, La Révolution Surréaliste*, No. 12, December 1929, p.34. As for Dali, he wrote later: 'The film produced the effect that I wanted, and plunged like a dagger into the heart of Paris as I had foretold. Our film ruined, in a single evening, ten years of pseudo-intellectual post war avant-gardism. That foul thing which is figuratively called abstract art collapsed at our feet, wounded to the death never to rise again, having seen a girl's eye cut by a razor blade….' Salvador Dali, op.cit., p.212.

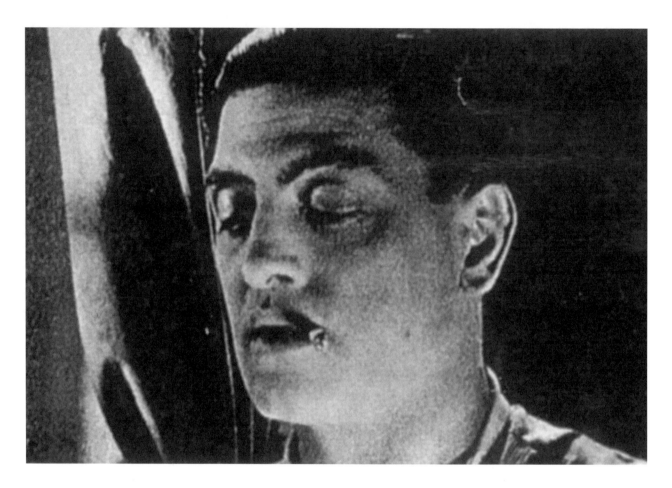

sort of map of the film establishing the principal landmarks of its elliptical love story is indispensable if one is to find one's way around in the following discussion of how it works, why it is made the way it is, and what it might mean.

'Once upon a time', reads the intertitle with which the film begins: the inviting and reassuring first words of bedtime stories since the world began. We are led to expect the unfolding of a straightforward, chrono-logically arranged storyline, the stuff of fairy tale and pulp fiction that has

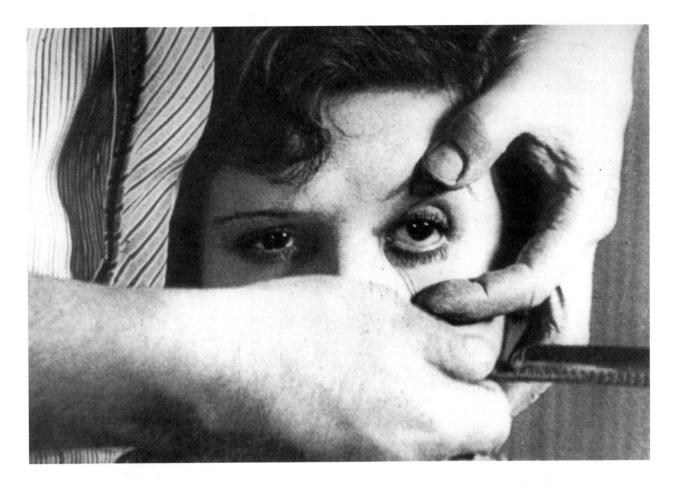

become the staple of movie entertainment. A familiar vehicle of narrative logic has been set in motion and we are on board. But that this might be a disquieting kind of fable is signalled by the following shot – a close up of a man sharpening a cut-throat razor on a leather strop. It is the director, Luis Buñuel, who tests the blade on his thumb. He steps out onto a balcony. Shots of him looking upwards alternate with shots from his point of view of a wisp of cloud approaching the moon against a dark sky. Cut to a close up of a woman's face, staring straight into the camera lens. The fingers of the man's

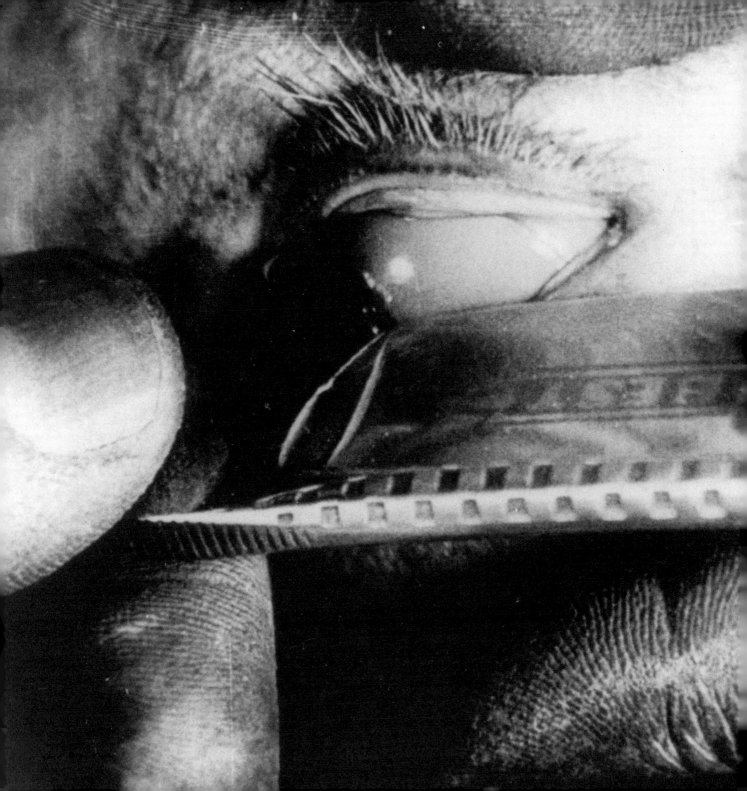

hand part the lids of her left eye, while the hand holding the razor moves into shot and towards the eye. Cut to a shot of the horizontal cloud passing across the surface of the moon. Extreme close up of the razor slicing the eyeball and drops of gelatinous liquid oozing out.

More has been written about the opening sequence of *Un Chien Andalou* than any other two-minute sequence in the history of film. And the image of the slashed eye is one of the icons of Surrealism. It is worth looking again at the reasons for its celebrity. They boil down, I think, to three: the almost unbearable impact of the action that produces a physical shock which does not diminish even after many viewings; the figural density and poetic resonance of the visual elements brought into play together with the complex way they are strung together; and the challenge the sequence delivers to us as spectators to think again about the satisfaction we get from watching films.

It is profoundly shocking. Nothing prepares us for this gratuitous attack. The effect is exacerbated because, unusually for cinema, the woman's eye is looking directly out at the audience – returning our gaze – implicating us. We grasp that is ourselves who are also the intended victims of this visual assault. To quote Allen Thiher: 'Buñuel commits a violent transgression against our desire to protect our privacy. With seeming impunity, (he) forces upon the spectator a visual rape'[28]. And the cool tranquillity with which the unspeakable act is committed is another twist of the knife in the spectator's unease. Denying us shots of anticipation or reaction on the part of either the aggressor or the victim, it a grotesquely cool exercise in clinical objectivity. No wonder Buñuel has been dubbed 'the surgeon of the look'.

Of course, as Hitchcock famously said: 'Cutting is the best way' He meant it was the best way for a murderer to do a killing, and the best way for the film director to manipulate his audience. Buñuel, who had just published an essay extolling 'découpage' as the key to expressivity in film,

would have agreed. It is he, the director on the screen, who engenders the film – by a cut. Cutting is symbolically appropriate also because a central preoccupation of the film is sexual desire, and sexual anxiety, including more specifically for the male, the fear of castration. Complexes about castration also lead to fetishism. The fetishist substitutes as the object of his desire a part of the thing for the whole. Fragmentation therefore reigns in *Un Chien Andalou* because the film deconstructs the sexual subject and opens up contradictions within desiring in the exchange of looks, the circulation of fetishised objects and body parts.[29] Mutilation of the text matches mutilation of the body. The initial act of physical violence is directly related to the textual violence that will follow. The thumbnail on which Buñuel tests the sharpness of the stropped edge is about the size of a 35mm frame, and the razor stands in for the guillotine on the editing rostrum. It is significant, perhaps, that Buñuel disappears from his own film having accomplished the act of cutting. The characters who follow and who 'persist', on the other hand, fail to reach their goals. This tells us something about the power and responsibility of the filmmaker (again like Hitchcock, the clock repair man in *Rear Window)* winding up this 'infernal machine'.

And that's it. The story moves on. How can we place what we have seen? Where did the woman come from? The slicing is an effect of montage; of course it's not the actress's eye that is cut up but a dead calf's with the surrounding hide depilated. It's all down to the Kuleshov effect and Eisenstein's 'montage of attractions', the conditioned reflex of shot-following-shot that we learn with the first films we ever see and which thereafter assumes an implacable persuasiveness.

And yet the editing that created the effect is itself full of inconsistencies. From one shot to the next, the wrist of the razor-wielding man loses its watch, and his neck acquires a striped tie. The filmic effects which construct the story simultaneously undermine it.

What kind of relation can there be between a cloud passing across

28. Allen Thiher, *The Cinematic Muse: Critical Studies In The History Of The French Cinema* (University of Missouri Press, 1979), p.27.

29. Robert Abel, *French Cinema: The First Wave, 1915–1929* (Princeton University Press, 1984), p.485.

30. In terms of the inventory of figures of speech available to a maker of text whether verbal in poetry, say, or visual in cinema, a metaphor links two elements on the basis of some sort of resemblance (a cut-throat razor blade looks like a wisp of cloud, for example) while a metonymy acts by contiguity between the two elements (the cow and the double bed in *L'Age d'Or* share the same space, for example).

the moon and a razor slicing an eye? It's convincing as a graphic match, of course, and as some kind of visual metaphor.[30] (Such figures belong to a form of rhetoric designed to make an image speak for or connote a richer meaning than it baldly states or denotes. By and large, cinematic metaphors are difficult to read, draw attention to themselves and disrupt the narrative flow and are found mostly in avant-garde and experimental films. Metonymies are unobtrusive and they may well accomplish their work without being recognised as figures at all. Thus we find more metaphors in *Un Chien Andalou* than in *L'Age d'Or* because Buñuel was more concerned with narrativity in his second film, and also because the addition of sound contributes to a sense of contiguity between images.) But common sense quickly reduces it to the status of an illusory figure. Yet at the same time, we have willed the connection between the two. It's as if we want the eye to be broken. It is our desire that the cloud passing is a cause and the razor slash an effect.

How can this sequence be part of a proper story when the same woman reappears a few shots later, eyes palpably undamaged. And what a relief! Even though the earlier mutilation cannot be denied. (Instead, it is Buñuel who disappears from the film!) We have been given a succinct but pointed lesson on the way film works on our imagination. Film studies calls the process involved 'suture'; it's one of the ways audiences make meaning out of what they see. The film starts the process up but the spectator does more than read the text and collude; each of us fantasises our own scenario.

And it seems that, if we consciously egged the film on towards a mutilation, we may at the same time have unconsciously willed it towards a rape. Enough has probably been said about the spectator's masochistic identification of his/her own vision with the severed eye. But by the sadistic side of the same coin, the razor slash is even more obviously the film's symbolic deflowering of the woman. The moon is a traditional symbol of virginity after all. The implied vagina symbolically completes a triad with

the moon and the eye. Just as the implied penis completes a phallic triad with the cloud and razor. So the prologue not only indicates the kind of spectatorial responsiveness that will be subsequently be expected from the audience; it also prefigures the chains of sexual motifs that will recur and ramify in the sexual obstacle race to come, even if Buñuel and Dalí are gleefully laying on the Freudianisms with a parodic trowel. The graphic forms and patterns deployed in this opening sequence will inform the rest of the film that follows, constantly recurring and resonating one with another at the same time as they disrupt the smooth unfolding of a story. In regard to circular forms, we will participate in a game of echoes and repetitions – alternately concave and convex – that takes in the thumb nail, the moon, the eye, the hole in the hand, the armpit, the sea urchin, the puckered mouth etc. And we will observe a corresponding series of linear forms that includes the razor, the cloud, the striped box, the tie ... which doubles analogically with the geometric recurrence of diagonals and phallic shapes.

The chains of correspondences evoked in this sequence really do stretch away 'as far as the eye can see' (Breton must have sighed with delight).[31] Multiple connotations are implied by the simple invocation of the moon: feminine-gendered eye of the night; the virgin planet that presides over love and transgression. In seeming to engender the eye of the woman, the moon also links macrocosm to microcosm and, in the same spirit as the opening caption, confers on the story a universal dimension.

At the psychoanalytic level, the eye which is the instrument of desire becomes the symbol of desire and its concomitant anxieties. The slicing episode relates to the act of castration – another metaphor that remains implicit – and contains most of the rest of the film in a nutshell.[32] All of these different metaphoric levels are subsumed in the physical and ancestral horror produced by aggression upon an organ already so symbolically saturated with meaning. There is the mythical dimension also. The eye is the icon of sight and by extension of enlightenment. It is also the organ that

31. *Vide* André Breton, 'As In A Wood' in Paul Hammond, op.cit, p.45.

32. Claude Murcia, *Un Chien Andalou, L'Age d'Or, Luis Buñuel: Étude Critique* (Nathan, 1994), pp.75ff.

Oedipus struck out of his own head – (by displacement?) – in his anguish at having (unknowingly) killed his father and married his mother. The prologue can also be read as an archetypal surrealist image, juxtaposing entities from distant orders of reality on the model of Lautréamont's 'Beautiful as the chance meeting on a dissection table of an umbrella and a sewing machine'. This was the prototype 'explosive' figure that Breton celebrated as making an affective impact on the psyche like an electric shock. And both Lautréamont's simile and the prologue feature male and female entities with the latter menaced with surgical intervention.

Linda Williams has queried perceptively why an attack on the eye is so obsessively terrible for us.[33] Since *Un Chien Andalou*, she reminds us, scenes of damage to the eyes: pecked out in Hitchcock's *The Birds,* stuck with pins in Argento's *Suspiria,* forced open with calipers in Kubrick's *A Clockwork Orange*…..have been rehearsed again and again as standing for the worst kind of hurt to the person we can conceive of. Damage to the eye seems to be at the limit of what audiences can tolerate because it is the image most immediately felt as visual violence done to the spectator. Why do such scenes unfailingly affect us? Is it the thrill of watching something that 'goes too far', that breaks a taboo? We are extremely ambivalent about the eye because of its power to deliver injury as well as its susceptibility to harm. The voyeur's eye gives him the sadist's power over the object of his gaze. For Sartre, it is their punishing gaze that makes 'other people' our Hell. Looks can kill. So, we know that the eye can be a weapon, but what about when it is a target – the 'bull's eye' of violence? Do we respond so strongly because the eye masochistically invites injury, like the bully's victim in the schoolyard, so pathetically vulnerable, so soft, so prone to tears? In the looking, are we the eye that is broken, or the hand that wields the knife? How do scenes like these plot the movement of the spectator's reaction? As Georges Bataille wrote in his 1929 essay 'Eye' partly inspired by *Un Chien Andalou,* the repulsion of the violated eye is inseparable from its

33. Linda Williams 'An Eye For An Eye', *Sight And Sound,* April 1994, pp. 15–16.

seductiveness, for 'extreme seductiveness is probably at the boundary of horror'.[34] Clearly, it's too much to expect a simple answer to the question: why does the sliced eye fascinate so much?

The shocked spectator has barely had time to recover from the 'branded eye'[35], when – 'Eight years later' – reads the second intertitle. Once again, the lure of a story in prospect lulls our aroused distrust to sleep – we've been conned already by 'Once upon a time' – but the pleasure stories give always wins out over 'once bitten twice shy'. The trick fools us again and, against all the odds, we'll do our best to read what follows as a logical, chronological tale. It's what spectators do! Now we have been transported to a sunny Paris street. A young man cycles along wearing an outfit of frilly cuffs, a cap with white wings, a collar and a frilly skirt over a dark suit. Round his neck hangs a striped box on a cord. Is it a gift he is delivering to his lover? Fade to the interior of a room (the same room as in the prologue?) There's the same woman again, wearing the dress she had on in the first sequence. She's intently reading, so her eyes must be intact. As if interrupted by a noise from the street outside, she throws down the book. It falls open on a reproduction of Vermeer's *The Lace-maker*. From the window, she sees the rider tumble off his bicycle into the gutter, still astride his machine whose front wheel goes on idly turning. Apparently, torn between irritation and solicitude, the woman rushes out of the apartment block and kisses him passionately as he lies, eyes still open, against the kerb. This was a rider who 'fell off' at the moment of 'arrival'; is it a matter of death, or just a 'petite mort' of premature ejaculation?

We've only caught a glimpse of the reproduction of *The Lace-maker*. Vermeer's masterpiece is rich in intertextuality, famous as an image of quiet contemplation, focusing on inner experience in the midst of the world of things. The painting had been the object of a delirious interpretation by the young Dalí when a similar copy of it in his father's study provoked in him the

34. Georges Bataille, 'Oeil', in *Documents*, No.4, September 1929, p.216 and in *Oeuvres Complètes*, I (Gallimard, 1970) p. 187.

35. 'The Branded Eye' is the title of Giulia Colaizzi's translation of Jenaro Talens's *El Ojo Tachado* (University of Minnesota, 1993).

Jan Vermeer van Delft: *The Lace-maker* (c.1665).

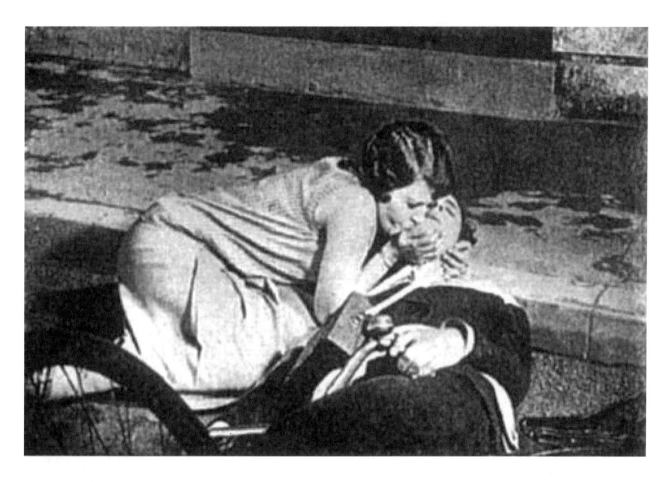

36. Salvador Dalí, op.cit., p.127.

Dalí's 'rhinocerontic period' – exemplified by his 1954 painting *Young Virgin Auto-sodomised By Her Own Chastity* – is documented in his memoir *Diary Of A Genius* (Creation Books, 1995).

hallucinatory vision of a rhinoceros horn.[36] Dalí found it a thing of convulsive beauty because everything in the painting, including all the mental concentration of the seamstress, converges on her needle, which itself is not depicted but only suggested. Dalí said he felt the sharpness of the absent needle in his flesh. The woman in the film has been gazing at a painting of a woman gazing at her lace-work. Simone Mareuil is looking at the Vermeer with the kind of sexual desiring with which surrealists approached all works of art. She stares at it obsessively as if it were her

private fetish. But her total absorption is interrupted by what we infer is a noise from the street below. She throws down the book and goes out, as if preparing to exchange one object of desire, the narcissistic mirror of art, for another, for life and a man.[37] Alas, this new, interpersonal object of desire – the infantile, feminised cyclist – will fail her. He will only recycle the same stalled mechanism of desire.

Buñuel makes a lot of play in these sequences with camera angles and eyeline matches, dissolves and superimpositions, gently mocking the stylistic clichés of the Impressionist films in which he had served his technical apprenticeship. In L'Herbier's *Feu Mathias Pascal*, a high angle shot dramatically announced some great revelation; in *Un Chien Andalou*, it's just the absurdity of a chap inexplicably falling off his bike. More of the same follows as the woman, who is now back in her room, takes a striped tie from the man's striped box and places it, along with his collar and all his frills, on a bed in such a way as to form the outline of the vanished – presumed dead – cyclist. She sits down with an expression of determined concentration on her face as if she's trying to will the lost man back to life – a parody perhaps of Usher's raising his dead wife from her tomb in Jean Epstein's *La Chute De La Maison Usher* (1925, on which Buñuel had worked as assistant cameraman)[38]. But instead of being restored upon the bed – only his tie by an elementary piece of trick photography knots itself in place – our cyclist contrarily reappears standing on the other side of the room, quietly contemplating a little colony of ants that are busying themselves around a deep hole in the palm of his open hand.

Here is another 'putrefying' piece of mise-en-scène – a lugubrious figure for some kind of psychic infestation – obsessively interesting to our hero because its repulsiveness vies with its unhealthy but undeniable power of attraction. Our exhausted hero's blood is up again. 'Ants in the legs' is the French phrase for 'pins and needles' and, by extension for feeling horny. Ants figured in several of Dalí's key canvases from 1929 onwards. Buñuel had his

37. Paul Sandro, *Diversions Of Pleasure: Luis Buñuel And The Crises Of Desire* (Ohio/Stete University Press, 1987) p.46.

38. Apparently, among these striking effects, all the lap-dissolves were done in camera to save money, not on the editing rostrum. No doubt misled by the sobriety of Buñuel's very functional and pared down film style in his later, post-1945 films, many commentators (eg. Maurice Drouzy, *Luis Buñuel: Architecte Du Rêve,* [Lherminier, 1978, pp.41–2]) have claimed that in *Un Chien Andalou* he was very sparing with special effects, superimpositions, extravagant camera angles, slow motion shots … typical of the twenties French art film. But, in fact, the film abounds with all sorts of trick shots and camera 'magic' precisely because Buñuel and Dali had set out to satirise the elaborate effects employed by the rival avant-gardes.

Detail from Dalí's *The Enigma Of Desire* (1929).

filmed insects sent from Spain in a metal box containing a mini-habitat of rotting wood; he found the red heads of these particular ants especially photogenic, even in black and white.

There follows a vertiginous chain of lap dissolves: from ants in the hand; to the hairy armpit of a woman sunbather; to a sea urchin with spines waving in the tide; to a cluster of people in the street outside viewed from above (within an iris); and finally (and back) to a severed hand lying on the road.

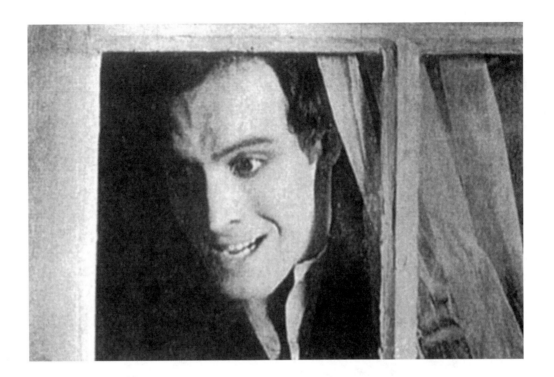

We're on the street again, carried there by the bizarre logic of this foregoing series of graphic matches, a truly delirious eruption of irrational visual and mental associations. The severed hand lies on the ground and a young person with close cropped hair and of indeterminate sex, wearing the striped box on a cord around her neck, is poking at the and with a stick. The meat of the truncated wrist yields obscenely beneath the pressure of the ferule. A crowd of onlookers gathers round, evidently excited by the scene. A considerate policeman retrieves the hand and puts it in the striped box that we now know so well and hands it back to the androgyne. Clutching it to her breast, she stands uncertain and alone in the middle of the road as traffic goes by on either side. Inevitably – hadn't we been wishing it to happen? – she is eventually run over by one of the passing cars. The couple have been watching all this from the apartment above. Our cyclist hero is even more

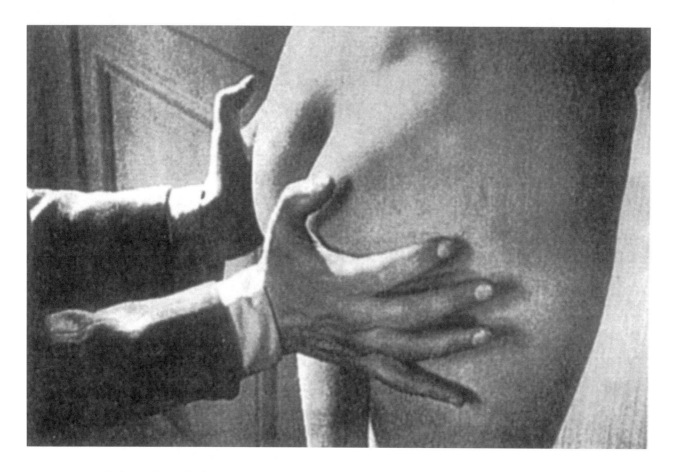

aroused than the onlookers down below by the implicit onanism followed by sado-masochism of the scene just witnessed. Or is he just thrilled to recognise his fetish striped box again? In any case, he starts lecherously pursuing the woman around the room. As he caresses her body, another sequence of dissolves reveals her breasts and buttocks alternately clothed and bare, the limbs in question also showing a disconcerting propensity to merge one with the other. In close up, Batcheff's eyes roll back convulsively and blood trickles from the corner of his mouth. The woman breaks away in disgust – and well she might – as his mouth now puckers into the shape of

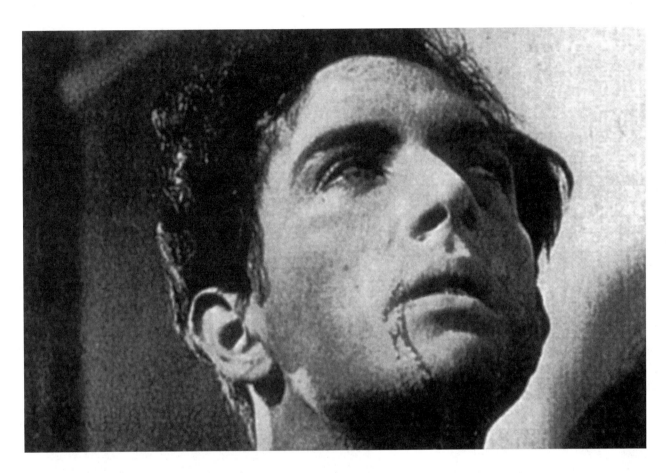

an anal sphincter.

Mareuil beats a retreat to a corner of the room and fends off Batcheff with a tennis racket. His assault is hampered when he picks up two ropes and starts to pull on them. The burden that holds him back is then revealed in all its absurd grandeur: it's that famous assemblage – as much installation as surrealist object – composed of a pair of prostrate, struggling priests (the players change in the montage, but they are consistent in standing for the prohibiting function of religion), a pair of grand pianos (ossified, academic culture) each one adorned with a rotting donkey

(stultifying labour), and other assorted flotsam and jetsam. The woman makes her escape into the next room and tries to slam the door in the man's face. He follows and this time his insect-infested hand gets caught in the door – another 'frame', another 'severing'. But then we see that the woman

is really standing in the same room. And the man is there too, lying quietly on the bed where the frills of his cycling costume had earlier been laid out.

'Towards three in the morning' reads the next caption. An impatient stranger has rung the doorbell (two hands through a wall agitating a cocktail shaker stand in for this).[39] The visitor bursts into the room and orders our fully-dressed hero out of bed. He confiscates his paraphernalia, comforters, – box and all – and throws them one by one out of the window. This seems to be a further joke at the expense of *Feu Mathias Pascal* for here too the eponymous hero comes face to face with his old identity in the form of his challenging double and, striving to rid himself of his past, attempts to kill his former mocking self. In a simple exercise of parodic trick photography, the unwonted visitor – the double of our hero but as energetic and self-assured as the cyclist is languid and hesitant – makes the cyclist stand in the corner like a dunce.

Another intertitle states: 'Sixteen years before', but this is belied by fact that the physical appearance of the two selves of the bifurcated hero are unchanged. Now the double takes a pair of books from a schoolroom desk and gives them to his less mature version. But the books turn into pistols and the double is shot down, Western movie style. Would-be one-to-one readings of meaning in the film have been especially flummoxed and at odds with each other over this episode. Not everyone agrees that the two men are doubles. Some commentators take the caption at face value and see it as a dispute between an older and younger self. Others see the shooting as a rebellion (illusory, of course) against a tyrannical super-ego. 'I am suffering a conflict' gets a literal rendering as one half of the conflicted personality guns down the other!

As the dying double collapses, a dissolve carries him into a sunlit park. In his fall, the back of his trembling hand grazes the naked back of a statuesque young woman seated on the grass beside him. Desire is fulfilled only *in extremis*. Her image fades away leaving his body stretched out face

39. Another joke at the expense of 'regular' movies of the period: according to silent film convention, a shot of an actual bell signified a bell ringing; Buñuel and Dalí replace this with one of two hands vigorously shaking a cocktail shaker.

down on the ground. Another little crowd gathers, all men this time, and not notably concerned at this turn of events. They form a makeshift funeral cortège and bear the corpse off into the distance – all to the (excessively) appropriate strains of Wagner's *Liebestod*.

We're back again with the woman who is now alone in the familiar room. A sequence of dissolves reveals that a spot she is looking at on the opposite wall is a death's head moth. Under this sign of death, Batcheff reappears. What seems to be a lover's quarrel ensues with all the typical shot/reverse shot alternations you'd expect in a regular movie. The difference is that the cut and thrust of their row – it's like a tennis-match rally – is represented by images not words (and only partly because it's a silent film) from an irrational, subjective world. It's your everyday melodramatic bust-up but represented in terms of unconscious impulses.

The man puts his hand to his face and boastfully reveals to the woman that there is no hole where his mouth should be. This sealing of the mouth reverses the earlier opening of the eye, perhaps. It may remind us of how earlier he had apparently horrified the woman by contracting his lips into the shape of an arsehole. She replies by emphatically painting in her own mouth with lipstick. The man's mouth in turn has now sprouted (pubic) hair. And she discovers that the hair he's grown on his mouth is the hair she's lost under her own armpit. (All these vagabond body parts seem to prefigure René Magritte's 1934 painting *Le Viol*.) Defiantly assuming the initiative, she sticks her tongue out at him – twice for good measure – no doubt teasing him for his impotence.

Magritte's *Le Viol*.

Finally, in exasperation, she opens the door and walks – match on action – straight onto a windswept beach. It's as if she's making a break at last out of a perverted 'huis clos' interior into the airy space of freedom. Another boyfriend (he looks reassuringly upright and uncomplicated) has been waiting for her there. They wave to each other familiarly. He points impatiently to his wrist watch, the composition of the close-up 'severing' his

hand. She smiles as if to reassure him that all we've just seen going on is past history. Arm in arm, the newly formed couple stumble away across the shingle. They come across the cyclist's frills and ubiquitous box, all wet and muddy at the water's edge. They pick them up for inspection one by one, and discard them contemptuously. The couple walk on 'into the sunset', perhaps to 'live happily ever after'.

Not so! – even if a final caption, positioned at the top of the frame of the concluding shot, reads 'In the spring'. It seems to promise a new beginning and fertile regeneration. But the image itself, a kind of still life, reveals the couple – now 'putrefacts' – buried up to their chests in sand, burned by the sun and crawled over by huge insects. Both victims have hollowed-out eye-sockets. The effect is of a 'painted tableau with real people stuck in the sand like dead flowers'[40]. It is difficult to tell from the film print whether the man is the new lover or the cyclist, nor does the film script help resolve the issue.

And while the words announce a new 'beginning', the image tells us that it's the end of the romance. This time, there will be no new re-envisioning after the blinding for this is the blindness of death. There is no poetic redemption. The stasis will persist, just as it will do in *Happy Days*, Samuel Beckett's post-war play which the final shot uncannily anticipates. A film that began with a trauma ends with a kind of torture. It's a culminating act of aesthetic violence on the part of Buñuel and Dalí. According to Paul Sandro: '(The characters) have left the fetish objects of their story behind only to become fetish objects themselves. In death, they are stripped of whatever autonomy they had as characters and their function is explicitly acknowledged at last: they have all along been the objects of our desire, existing only for our pleasure. And for a moment we are held reciprocally in an image of their subjugation.'[41]

So much for what we see. But how should we read *Un Chien Andalou*? And what does it mean?

40. Linda Williams, *Figures Of Desire*, op.cit., p.99.

41. Paul Sandro, op.cit., p.50.

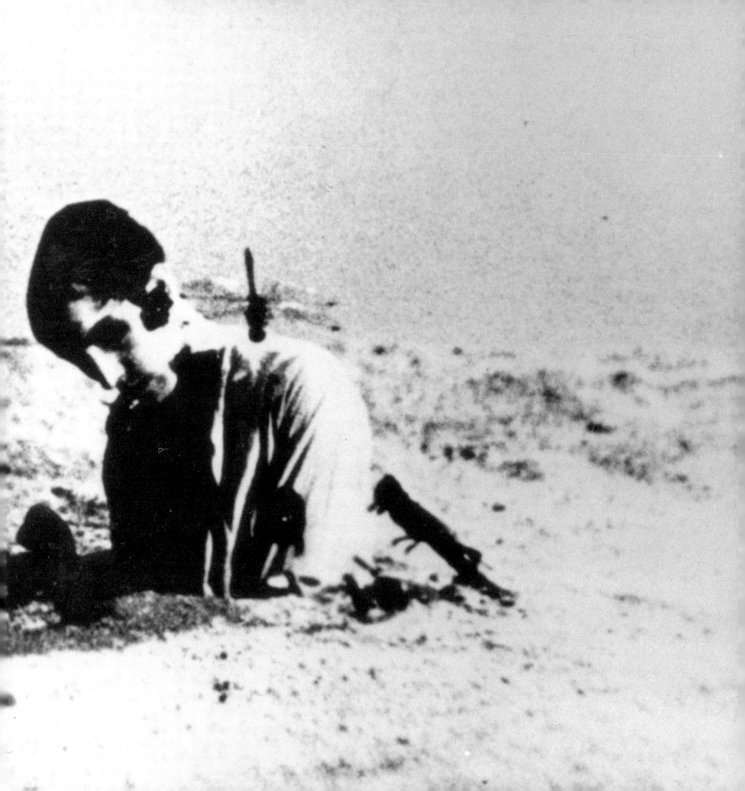

At a certain level, there ought to be no problem. It is, after all, a love story. Ostensibly, the plot's trajectory is the classic Hollywood (and folktale) one of 'the formation of the couple' (Raymond Bellour) It's that old chestnut about obstacles on the path to 'they lived happily ever after'. Yet the tension never lets up between this hyper-familiar, reassuring, anecdotal line and the perversely irrational content that undermines its causal chain. And it's with this incongruity that the problems start.

Audiences even today are often uncertain how to take it and squirm nervously when taxed about their reactions. Are they being taken for a ride? Is it, after all, just a tissue of self-indulgent nonsense, a farrago of non sequiturs? Is it an exercise in a symbolism so arcane as to be intelligible only to the initiated? According to Freddie Buache: (we'd) 'be wrong to see in this only the convulsions of a pair of vagabond imaginations.'[42] So let us assume that, like Robin Wood on Hitchcock, we should treat Buñuel and Dalí seriously – perhaps as 'logicians of the unconscious'.

There are compelling reasons for reading the film psycho-analytically, as has been implicit throughout the preceding synopsis. Indeed, this has always been critics' and interpreters' preferred approach. Faced with the film's enigmas, they have been encouraged in this by Buñuel himself who famously commented that the 'only method of investigation of the symbols would be, perhaps, psychoanalysis'.[43] Both Dalí and Buñuel had steeped themselves in Freud in the year previous to collaborating on the film. The fact that the film was immediately qualified as surrealist and that Surrealism itself since Breton's 1924 *Manifesto* had located itself on Freudian maps of the psyche is further support for a psychoanalytic reading. Breton had long before noted the affinities of the poetic figures like the metaphor and analogy with the work of condensation and displacement in Freud's picture of the mental processes. If the imagery of the film is to be approached metaphorically, then the eye-mutilation sequence blatantly solicits such a reading, followed as it is by a combination of male and female signs in a pattern of assertion and denial of the presence of the phallus which

42. Freddie Buache, *Luis Buñuel,* (Editions L'Age d'Homme, 1970) p.13

43. Luis Buñuel, 'Notes On The Making Of *Un Chien Andalou'*, in Joan Mellen ed., *The World Of Luis Buñuel: Essays In Criticism* (Oxford University Press, New York, 1978) p.153.

seems to illustrate the castration anxiety discourse of the unconscious. The work of displacement going on here may be read as transferring interest from the genitals to the eye, for instance. Condensation, which might entail the placing of the male and female symbols in a single ambivalent signifier, can be seen at work, for example, in the figure of the befrilled cyclist.[44]

But a psychoanalytical reading need not mean the search for an exclusive one-to-one equivalent between an image in the film and some specific psychosexual thing. Early critics such as François Piazza, Mondragon and Pierre Renaud all assumed that the film contained an allegorical master narrative which recounted the sexual development of a single hypothetical (male) protagonist.[45] It was about adolescent sexual development or sexual frustration, starting with an invocation of the castration complex or the sexual act, and continuing with the sexual pilgrim's progress through phases of infantile narcissism, mother fixation, homosexuality, sado-anal eroticism, impotence and much else besides. Each of these exegetes seemed equally confident of having lit upon the unique key to the film. Yet no two interpretations have ever agreed on the specifics of the psychosexual allegory they unearthed. Almost certainly this was because they closed their eyes to elements in the film that did not fit their particular story and ingeniously filled in 'the gaps left by the evident fractures of the film'.[46] Typical was Mondragon, the flavour of whose ingenious reading can be gauged from this opening extract: 'Once upon a time there was a small child who is conceived (corresponding shot: the razor stropped on leather); when the pregnancy is reaching its end (full moon); he is born (cf. the slit eye). Then he grows up, learns how to walk (which Buñuel illustrates with the character on a bicycle wearing a bib); but his steps are unsteady, he falls and needs his mother to get up again. Although he loves his mother, he also loves himself, seeking pleasure from his own body (cf. the hands with holes where ants are swarming) and finds amongst his companions someone whom he can love (ie. the androgyne filmed in the road)'[47].

If they did not interpret *Un Chien Andalou* as a sexual allegory, early

44. Laura Oswald, 'Figure/Discourse: Configurations Of Desire In *Un Chien Andalou*', *Semiotica*, No.33, 1981, pp.118–119, quoted in Haim Finkelstein, op.cit., pp.91–92.

45. François Piazza 'Considérations Psychanalytiques Sur *Un Chien Andalou*', *Psyché*, janvier-février 1949, pp.147–156; Mondragon, 'Comment J'ai Compris *Un Chien Andalou*', *Revue du Ciné-club*, Nos. 8–9, juin 1949; and Pierre Renaud , 'Un Symbolisme Au Second Degré: *Un Chien Andalou*', *Etudes Cinématographiques*, Nos. 22–23, May–June 1949, pp.147–157.

46. Phil Powrie, 'Masculinity In The Shadow Of The Slashed Eye: Surrealist Film Criticism At The Crossroads', *Screen*, Volume 39, no.2, Summer 1998, pp.153–163.

47. ibid., p.157.

critics equally reductively, if understandably, tended to see it as the representation of a dream. This repeated Germaine Dulac's gaffe which so incensed Antonin Artaud when she described *La Coquille Et Le Clergyman* as a dream. *Un Chien Andalou* is not a filmed dream nor even, despite Buñuel's account of its inception, the record of a series of his own and Dalí's dreams. It is more fruitfully read as a filmic exploration of how the mind dreams and of the processes by which 'dream creates its meanings'.[48] Desire, argues Williams is less a subject-content than a form – a structural process in which the work of the image is central.[49] Relating the language of film to psychoanalysis, one might suggest that 'mise-en-scène' corresponds to the exercise of projection, while editing corresponds to the work of the Freudian censor.[50] *Un Chien Andalou* is more about the form of the unconscious in its processes than it is about the content of any particular dream. The unconscious is not so much a pre-existing hidden treasure-house of symbolic content waiting for the artist to loot it – as Cocteau, for one, on the evidence of *Le Sang d'Un Poète* (1930), seems to have thought. It is rather a psychic activity, better viewed as a process by which desire expresses itself. This helps explain why this little film has assumed so much importance for more recent film theory. Following Metz, recent approaches have stopped asking 'What does this film mean?' in favour of 'In what position does this film place the spectator?'

The contradictoriness of successive rival 'core narrative' readings of the film, combined with their selective inaccuracy and distortion of what we actually see on the screen, has by and large discredited attempts to interpret *Un Chien Andalou* as either the dream of a unified subject (the hypothetical hero) or as the allegory of the hero's sexual development.[51] More recent approaches have emphasised the ways in which the film opens up possibilities of meaning, rather than containing meaning through a series of one to one symbolic equivalents. In this, they have been in tune with the spirit of Breton who repeatedly warned about single and exclusive interpretations which inevitably limit the generation of meanings essential

48. Wendy Everett, op.cit., p.151.

49. Linda Williams, op.cit, p.15.

50. See Jean-Michel Bouhours, 'La Mécanique Cinématographique De L'Inconscient', in the catalogue for the exhibition, *La Revolution Surréaliste*, (Centre Pompidou, 2002) pp.381–385.

51. Phil Powrie, op.cit., p.158, crediting the pioneering article by Philip Drummond, 'Textual Space In *Un Chien Andalou*', *Screen*, Vol.18, No.3, 1977, pp.55–119.

52. Wendy Everett, op.cit., p.144.

to the surrealist process.[52] Instead of glossing over or seeking to resolve the fractures in the film which have frustrated so many earnest efforts to tease out a unifying narrative, recent psychoanalytically-based criticism has seized on these very disruptions and argued that the discontinuities and the undermining of the story telling are the very point of the film. Linda Williams has put it very clearly: 'Unconscious desire, if it is to be present in film in the way that it is present in dreams, cannot be 'represented' there as a subject: it must be perceived, as the unconscious desires of dreams are perceived, through the transgressions of a more familiar discourse.'[53]

53. Linda Williams, 'Prologue To *Un Chien Andalou*', *Screen*, Vol.17, No.4 1976–7, pp.24–33.

For surrealists, following Freud in this, the workings of desire are primarily unconscious. By what means, then, could one hope to represent something that was unconscious? On the face of it, the task was impossible. You could try minting a brand new language, perhaps, like the 'Edenic' alphabets invented by architects of Renaissance Utopias to circumvent the confounding formulae of existing languages tainted by original sin. The downside of this is that no one could understand what you were trying to say. Breton initially claimed that automatic writing directly tapped into psychic activity in its primitive state, innocent of cultural contamination. There was a nostalgia here for a lost Golden Age that was never specified but implicit, an age in which the divide between the self and the world – word and life – had not yet opened up. Surrealism was thus initially about breaking out of the institutional rigidities that paralysed language – and setting words free. As time went by, however, claims for the pristine naturalness of automatic writing met with increasing suspicion. In the 1960s, textual critics such as Michel Riffaterre persuasively argued that automatism was just another form of rhetorical discourse, albeit more adventurous, suggestive, elliptical and 'fast' in the associations of ideas in which it trafficked than other rhetorics.[54]. Post-Freudians like Jacques Lacan have undermined Surrealism's ambitious claims from another direction, contending that even the primary processes of mental activity are penetrated from the very outset

54. Michel Riffaterre, 'La Métaphore Filée Dans La Poésie Surréaliste, *Langue Française*, No.3, 1969.

by symbolic structures akin to those at work in conventional language. There is thus no escape from language's 'prison house'. As scepticism grew about the surrealists' aspiration to overcome the divide between word and thing, so the reverse side of their project came to the fore. Unpersuasive finally in its claim to have discovered a language that was the direct transmitter of thought, the ultimate outcome of Surrealism's practice with automatism and dream has been to expose the arbitrariness of all forms of language. In a word, and this is hardly surprising, Surrealism has been much more successful as a demolition job than it has been as heir to the grand aspirations of Romanticism. While persisting doggedly in its founding mission as the vehicle of revelation about unity within the Surreal, holding out the lure of identification with that higher unity, the project has been far more convincing as a vehicle for demonstrating rupture and duality. *Un Chien Andalou* (and *L'Age d'Or*) – classic texts of desire's frustration, not its fulfilment – are early avatars of this fate.

Buñuel's and Dalí's solution to the problem of how to represent unconscious psychic processes was via the transgression of more familiar discourses. *Un Chien Andalou*'s shocks and disorientations are not random. They are predicated on a systematic breaking of the frame of traditional narrative and thus come across as parodies of the conventions of both the mainstream and the art cinema of the time. In mainstream cinema, an impression of reality or verisimilitude is usually assured by apparent fidelity to the audience's experience of time and space. The audience's belief in what is seen comes from spatial continuity and the logic of cause and effect. It is these logics that *Un Chien Andalou* mocks and largely defies. In terms of the ordering of the film, it is in the cuts – the very points at which classical narrative montage strives most for continuity – that the body of the film is dismembered. The signs of narrative logic and continuity that we are used to are present: shot/reverse shot alternation, eyeline matches, cuts on action, and so forth. As spectators, we therefore assume that a logic of causality links the successive shots because the conventional cues are visible.[55]

55. Or, should we stubbornly persist in reading them as continuous, they can represent only a madly self-contradictory and grotesque world. The film's intention is probably to provoke such confusion that we respond in both these ways, before perhaps reaching the conclusion that what is going on here is also a parody the codes films generally use to make meaning and to tell stories and that what is being demonstrated here is the arbitrariness of these conventions. Buñuel argued that such shock tactics were not gratuitous but necessary to put the spectator in the state of mind to accept the free association of ideas that is Surrealism's *raison d'être*.

56. Phillip Drummond, op.cit., p.89.

But the mutually inconsistent images montaged together by Buñuel and Dalí refuse to be read as continuous. The time axis is repeatedly disrupted in ways that both poke fun at narrative film conventions and enhance the spectator's sense of temporal confusion. Thus, the misleading intertitle 'Sixteen years before' follows 'Towards three in the morning'· Similarly, abrupt changes of setting achieved through montage confound our sense of the integrity of space. For example, there is continuity of action across cuts between unrelated locations when the murdered double starts his death fall indoors and completes it in a park, or when the woman makes her insulting departure in the Paris flat but exits out the door onto a windy beach. Conventionally, when a shot of a character staring at something is followed by a dissolve, we read the sequence as announcing a fantasy. But in *Un Chien Andalou* this isn't necessarily so, and we are left with no way of being sure whether what comes next has the status of reality or fantasy.

So, as Phillip Drummond has observed, the film works by the fragmentation of traditional linkages rather than by their tressing as in conventional narrative codes.[56] The whole film is an assemblage of incongruities typified, perhaps, by the trundling apparatus of ropes, cork boards, pianos, priests and donkeys that burdens the hero – at once archetypal surrealist installation and 'bachelor machine'. Likewise, at the level of characterisation, there is neither psychological nor physiological consistency. Batcheff plays three characters: the cyclist, 'himself', and his double. Characters – Buñuel the razor man, the androgyne and the new lover – are inserted into and ejected from the story with equal arbitrariness. Bodies endure the transfer of hair and the erasure of a mouth. The normal frontiers of the human form are blurred as an eye is broken and yet miraculously restored, and as breasts transmogrify into buttocks……

But 'even hell has its laws'. And *Un Chien Andalou* substitutes alternative patterns of ordering for the conventional ones that it subverts. In compensation, it makes all sorts of connections between the otherwise disjointed episodes via its many repetitions, pairings and doublings, which

also confer on the film the obsessive character of a dream. There is the proliferation of graphic forms that echo the forms of the prologue. The gouged out eyes of the piano-borne donkeys remind us of the sliced eye of the prologue, just as they prefigure the empty eye sockets of the half-buried lovers in the final shot. *Un Chien Andalou* is a perpetual movement between opposing poles of signification. Just as the prologue is ordered on alternating figures based on presence and absence, so the film that follows is patterned on symmetrical oppositions between assertion and denial: sight versus blindness; regeneration versus lifelessness; attraction versus repulsion; horizontal lines versus circular shapes, and, – dare one say it? – male versus female.[57]

What was the point, in the end, of all this wilful flouting of classic film form? Dadaist delight in confounding expectations? Comic effect? The pleasurable sense of freedom that comes from doing things different? All of these certainly; and more besides. The subversion of the pretended orders of logic has an ethical thrust. These forms claim, after all, to represent reality. Simply to transgress them is to make a start on cleansing the Augean Stables of received wisdom. There was every reason why a surrealist would want to put a bomb under established fiction film conventions. By 1928, the language of silent films had evolved to a degree of sophistication and expressivity that could rival that of novels. And it was precisely here, from a surrealist point of view, that the trouble lay. All this elaborate syntax achieved was the transposition to the screen of the narrative discourse of the nineteenth-century novel. And the latter was the ultimate vehicle for just that realist credo that Breton trashed when he set out the position of Surrealism in the 1924 *Manifesto*[58].

Recent studies of *Un Chien Andalou* have focused on its strategies for frustrating the spectator's identification with what is seen and for laying bare the differences between the film image and the 'reality' it supposedly reflects. For Allen Thiher, it is the self-consciousness of these strategies that makes the film archetypally modernist: 'a reflexive form of creation in which

57. ibid., p.85. There was a musical accompaniment at the performance of all 'silent' films and *Un Chien Andalou* was no exception. The 'order' of the music track helps hoodwink the spectator into believing that the image track also is delivering a coherently unfolding story. The choice of music (it was almost certainly selected by Buñuel, not Dalí) employs the strategy of the close encounter of opposites that we find everywhere in the movie, and which was pervasive in surrealist art. Buñuel chose to alternate the *Liebestod* from Wagner's *Tristan And Isolde*, with some Argentinian tangos: 'brothel music' that was then all the vogue in the Paris nightclubs. These two kinds of music were the inverse of each other: 'high' and 'low', noble and vulgar, romantic and popular, sublimated and desublimated.

58. Allen Thiher, op.cit.

the work is endowed with indices that constantly point to the work as an artefact'.[59] Linda Williams concurs that the film's modernism lies in the way 'the *matter* of language is brought into play at the expense of the reality that is represented'.[60] Such readings fit with Surrealism's joyful subversion of all fixed forms of representation. They put Buñuel/Dalí are on the same tack as Magritte with his painting, *This Is Not A Pipe*. Objects can't be fully covered by the signifiers that claim to represent them. Shifting from the semiotic to the psychoanalytic (and they are inextricably entwined in *Un Chien Andalou*) – what goes for Magritte's pipe goes also for our sense of identity. The regular movie promotes an imaginary, narcissistic mis-recognition of the nature of the self. It confirms the conventional notion of the unity of the self – a major source, indeed, of the comfort people derive from watching films in the first place. Unconcerned about displeasing, Buñuel and Dalí take their cue from Breton's existential question that opens *Nadja*: 'Whom do I haunt?' – and deny that identity has such cosy coherence. Their film is about bringing home to us the fact of our perplexing duality and uncomfortable conflictedness.

Instead of narrative, the unfolding of *Un Chien Andalou* presents us with a succession of repeated displacements of the same structures of desire – the eternal return of Freud's 'repressed'.[61] Instead of pursuing the usual goal of storytellers which is to inspire belief in their fiction, the illogical succession of images that compose *Un Chien Andalou* focuses our attention on the unconscious properties of the related images themselves. And the more precise their denotation, the more unsettled and unsettling their connotation. But these repetitions-with-difference do not overwhelm the text in such a way as to stultify altogether the movement of a narrative. The lineaments of characterisation and time reference that a story needs are present at least in tantalising filigree. And if the characters have no names and next to no anchorage in everyday reality, they do have goals. It is on account of this persistence of story, however exiguous, that Surrealism is probably the only avant-garde <u>within</u> the parameters of narrative cinema.

59. ibid.

60. Linda Williams, *Figures Of Desire*, op.cit., p19.

61. Paul Sandro, op.cit., p.47. Surrealism is probably at its best when making the everyday strange – defamiliarisation disorientating us in the most familiar of surroundings – as the popularity of Magritte's pictures attests. The operation keys in with Freud's description of the 'uncanny', which dwells not on the fantastic as such but rather on the routine horrors of daily life. Freud defined the uncanny as 'that class of the frightening that leads us back to the known and the long familiar'. It involves metamorphoses that make us see the familiar as strange and project unconscious fears and desires onto our surroundings and the people around us. Freud explicitly refers to the 'return' of the repressed. The repressed returns not just once but again and again, which helps account for the obsessive repetition of the same figures throughout the film. Not for nothing is the hero introduced as a cyclist – for these psychic scenarios require constant 'recycling'.

And it is their residual storylines that almost certainly help account for Surrealist films' perennial popularity over the other avant-gardes.[62]

We have seen how psychoanalysis gives privileged access to *Un Chien Andalou*. The whole film bathes in an atmosphere of latent sexuality and deploys the symbolism of Freud's *Psychopathology Of Everyday Life*. But this does not mean that the language of psychoanalysis is spared the subversive treatment that Buñuel and Dalí mete out to other institutional discourses, pilloried for their arbitrary conventionality. The very literalness of the Freudian tropes in the film points to the knowing irony behind their enlistment. *Un Chien Andalou* is a play not only <u>of</u> the Freudian paradigm but <u>with</u> it. That psychoanalysis was fundamental to Surrealism did not mean that it was exempt from criticism. After all, the surrealists never went the whole way with Freud. They had major reservations about the therapist Freud for whom to cure patients was to reconcile them to the prevailing 'disorder of things'. They distanced themselves from the conservative moralist who was prepared to pay too high a price in 'discontents' for the rewards of 'civilisation'. And what was the Freudian doctrine if not late flower of that positivist ethos that was so consistently a target for Surrealism's irrational detonations? So, on this score, psychoanalysis was just one more categorical discourse due for subjection to Buñuel's and Dalí's caustic and hyper-self-conscious scrutiny.

Many early viewers took *Un Chien Andalou* very seriously indeed. Jean Vigo was one such, as we have seen. Another was Cyril Connolly (Palinurus) who saw it as a sort of unholy rite and recalls leaving a Paris screening 'with the impression of having witnessed some infinitely ancient horror, Saturn swallowing his sons'.[63] But to dwell exclusively on the terroristic violence is to miss the humour, however dark, that pervades the film. We have to see the part of play in all this. To 'take seriously' and at face value the unspeakable event in the prologue, for instance, is not an option. As spectators, we'd surely have to quit the cinema. If we're going to stay with this film, we have to put a certain saving distance between ourselves and the

62. The persistence of narrative is critical to the issue of Surrealism's status within modernism. Authorities on modernism such as Clement Greenberg were misled by Surrealism's apparent return to the conventions of figurative art jettisoned by Cubism into dismissing it as 'marginal', 'literary' and 'reactionary'; they missed the point that Surrealism, far from being illusionism's dupe, only pretends to create the illusion of real space. Perhaps it was only in relation to the radical non-representational efforts of the avant-garde champions of 'cinéma pur' that Surrealism appeared to be content-obsessed (as suggested by Linda Williams, op.cit., p.26).

63. Palinurus (Cyril Connolly), *The Unquiet Grave* (Grey Arrow, 1961) p.118.

things we're seeing. Allen Thiher is eloquent on the significance of the ironic perspective that this movie requires of us. It is one, he argues, that 'converts the unthinkable act into an object of contemplation and, by its humour, of pleasure'.[64] The concept 'black humour' is a typical surrealist oxymoron, of course – a figure for 'the one in the other'. If we find it less trouble to favour alternately the one or the other term in such a figure, Surrealism is about attending to them both at once. Black humour converts the pain that necessity inflicts on the self into pleasure and thus brings about a kind of liberation. It's a mental lightning conductor that de-dramatises the tragedy of human life.. For Breton, it is 'a superior revolt of the mind'[65] and 'a value in the ascendant'. Unlike solipsism which pretends that fate and contingency are unreal, black humour acknowledges the force of these 'accidents' and yet asserts the superiority of the self over them. It claims a spiritual victory over circumstance. It thus preserves the surrealist from the de-energising anguish that assails the existentialist when confronted by the absurdity of man's fate. Instead, it provokes a kind of intoxicating desperation. Black humour is the last redoubt of the vanquished but unbowed – the recourse, for example, of the prisoner condemned to execution on a Monday who mounts the scaffold declaring: 'A good way to start the week'.[66] And it would be hard for a surrealist such as Buñuel to do without black humour given his conviction that the conflict between what the individual wants and what society will let him do is irresolvable, and given that our very own impulses are at war with each other. It is the play of black humour in *Un Chien Andalou* that contributes to its tonic effect upon audiences. The film is indeed about frustration and defeat – confronted head on – but in such an exhilerating way that defeat is turned into a kind of victory.

We gather from Buñuel that the spirit presiding at the script stage of *Un Chien Andalou* was one of joyous irreverence. He wrote to a friend in the spring of 1929: 'The title of my present book is *The Andalusian Dog*, which made Dalí and me piss with laughter when we thought of it.'[67] Humour can never be far from Surrealism because the kind of surprise that

64. Allen Thiher, op.cit., (also in *Literature Film Quarterly*, 5.1 1977, pp.38–49).

65. André Breton, Preface to the *Anthologie De L'Humour Noir* (Jean Jaques Pauvert, 1966) p.16.

66. Although Breton did not formally theorise the concept of black humour until the later thirties, the surrealists were familiar with a similar notion in Freud. And the strategies adopted by black humour are fully recognised by the surrealists in the 'Manifeste pour L'Age d'Or' (1930). Black humour gets Surrealism off the hook of the charge that it is a sucker for a kind of Pollyanna-ish optimism on which recent critics have tried to hang it (to the advantage of Breton's rival, Georges Bataille, especially). These two movies are having fun. Buñuel took an instant dislike to Bataille, by the way, because he 'had a hard face that looked as if it never smiled' (Luis Buñuel, *My Last Breath*, op.cit., p.122).

67. Franciso Aranda, op.cit., p.59.

is provoked by the incongruous encounters they loved in any image is always on the cusp between the comic and poetic revelation. By and large, Surrealism has lasted so well because of its gift for laughter rather than its earnest romanticism.

There are several dimensions of ludic mischief in *Un Chien Andalou*. Some have stood the test of time better than others. Audiences in the silent era would have been more alert than we to the parodying of contemporary, rival, avant-garde film practice. Some parodic devices of editing and cinematography have already been noted earlier in the synopsis of the film. Agustin Sanchez Vidal has claimed that there is hardly an image in *Un Chien Andalou* that cannot be traced to a cinematographic precedent.[68] Maybe Buñuel was taking his revenge for the five years he had spent on the margins of French cinema as studio assistant and general dog's body – the humble apprenticeship whose prestige he had always exaggerated to his friends in Spain. In a similar vein, passages in the script indicate that Buñuel and Dalí meant to ridicule the exaggerated acting style of Impressionist films: hence, the man 'now looking like the villain in a melodrama'stares at the woman 'lustfully, with rolling eyes'etc...Several in-jokes were being cracked when they decked out in frills the romantic matinee idol, Pierre Batcheff, 'the French James Dean of the twenties' and cast him in a role 'modelled on Chaplin'[69].

Non-French-speaking audiences may miss out also on the word-and-image play that underlies and motivates much of what we see. Stuart Liebman has made an inventory of the film's many literal translations of figures of speech into visual images. – visualising verbal metaphors, making visual puns.[70] For a number of the film's otherwise unfathomable enigmas, Buñuel and Dalí drew on that aspect of dreamwork that transforms latent verbal thought into manifest visual images – a kind of psychic reformulation that circumvents repression. – a verbal disguise. They were evidently intrigued by the filmic possibilities opened up by such a process. They wanted us to hear the murmuring speech beneath the spectacle. So much of

68. Quoted in Ian Gibson, op.cit., p.195.

69. Phillip Drummond, op.cit.

70. Stuart Liebman, '*Un Chien Andalou*: The Talking Cure', in Rudolf E. Kuenzli ed., op.cit, pp143–158.

the imagery of the film is tied to the French language, not least its slang, forbidden, and base variants. These figures add yet another dimension of meaning to *Un Chien Andalou*'s play with registers of popular discourse. The 'illustration' of clichés and puns exposes the arbitrariness of the linguistic original and makes a kind of nonsense of them. The harmless figural phrase for a glance, 'un coup d'oeil', motivates the literal slicing of a real eye. The ants-in-the-hand shot doesn't just reprise the guilty, masturbating hands – similarly enlarged, similarly 'severed' at the wrist – in Dalí's paintings of the time. It also illustrates the French phrase for pins and needles – 'avoir des fourmis (dans la main)', which doubles for 'feeling randy'. And the repeated composition of close-ups in which the frame cuts off a hand at the wrist evokes the age-old paternal threat to sons found masturbating: 'Je vais te couper la main.' The sequence with the grand pianos – 'pianos à queues' – seems wittily to conflate a pair of readymade expressions: one relating to marriage (*se mettre la corde au cou*), and the other related to cuckoldry (*elle a fait des queues à la barbe de son mari*). These are all examples of a kind of trope – a turn of phrase or shifting of sense – that gives us a pleasurable surprise and makes us laugh – linguistically, a logical twist that gives the two elements of any sign (the signifier and the signified) a new relationship to each other.

L'AGE D'OR

de luis bunuel
scénario de
luis bunuel et salvador dali

interprété par
gaston modot · lya lys
caridad de laberdesque
lionel salem · max ernst
madame noizet · liorens artryas
duchange · ibanez

CHAPTER THREE
"L'AGE D'OR"

The warm reception of *Un Chien Andalou* by 'le tout Paris' was both a blessing and a curse for Surrealism. While not going as far as to court martyrdom, the movement was ambivalent about success, especially commercial success. The film's long run in Montmartre was gratifying to Buñuel and Dalí, but also disquieting. Its popularity implied that it was too easily recuperable despite its authors' best provocative efforts. And indeed its fate – among the diversity of the movement's production – has been to suffer particularly badly from the subsequent 'museumification' of Surrealism. As the visual superseded the verbal in public recognition of Surrealism, and then as the moving audio-visual experience won out over the static image, so *Un Chien Andalou* has become the ideal 'vade mecum' for explaining the movement. Exemplary and entertaining, its seventeen minutes make it user-friendly in any art history/pedagogical context just as they agreeably satisfy expectations of generic avant-garde film practice. *L'Age d'Or*, by contrast, has proved much more resistant to recuperation. If *Un Chien Andalou* can be dismissed as a dream, *L'Age d'Or* is stubbornly unclassifiable. At just over an hour, it fits neither with the arty short nor with the conventional feature film. While *Un Chien Andalou* became part of any self-respecting film society's annual repertoire, *L'Age d'Or* was banned within three months of its release. Acquiring the glamour of the forbidden, its very invisibility for half a century – until 1980 when the censors finally relented – enhanced its prestige as the ultimate weapon in Surrealism's

arsenal. Hearsay and rumour inflated its spectral menace, as did the overwrought recollections of those few who had got to see it. If *Un Chien Andalou* stands as the supreme record of Surrealism's adventures into the realm of the unconscious, then *L'Age d'Or* is perhaps the most trenchant and implacable expression of its revolutionary intent.

It is thus ironic that this desperate and sustained revolutionary declaration was funded by a wealthy aristocrat. The opportunity to make a second film arrived hot on the heels of the success of *Un Chien Andalou*. It came in the form of an invitation to Buñuel and Dalí in mid-November 1929 from the Vicomte de Noailles to make a sequel – this time a longer film, and a talkie – to commemorate the birthday of his wife, Marie-Laure. In the capital of world art that was Paris in the later Third Republic, there was nothing unusual about scions of the aristocracy, even from the most venerable families, playing Maecenas to the avant-garde. Noailles had already dipped his toe in the waters of film production, having recently commissioned Man Ray's semi-home-movie, *Le Mystère Du Château Du Dé* (1929), shot at the couple's art déco holiday residence in the Midi. In July, the Noailles had enthused over *Un Chien Andalou* after a private screening at their Paris mansion (they had installed their own cinema equipped for sound) on the avenue Victor Hugo. Marie-Laure was a modernist poet in her own right. She was also a direct descendent of the Marquis de Sade, a qualification which stood her in good stead with Buñuel who had recently been enjoying *Les Cent-Vingt Jours De Sodôme* in a clandestine edition lent him by Robert Desnos. While it might seem inconsistent, to put it mildly, for a surrealist, would-be Communist to accept the backing of an aristocrat, the private commission suited Buñuel very well because, as an intending professional filmmaker, he needed to build on the reputation established by *Un Chien Andalou,* while as a surrealist, he couldn't make a blatantly commercial movie.

Initially, it seems that *L'Age d'Or* was meant to be another short film,

employing some of the 'gags' that had not gone into *Un Chien Andalou*. Its status as a sequel was signalled in its original working title, *La Bête Andalouse*. The novelty was to be in the soundtrack, making it, with René Clair's *Sous Les Toits De Paris*, one of France's first talkies. Noailles had intended to have Stravinsky compose the musical score. But the author of *The Rite Of Spring* was vetoed by Buñuel for being 'Catholic' and too aesthetic. For his lead roles, Buñuel chose Gaston Modot and Lya Lys. He had met Modot while they were both working on Feyder's *Carmen* in 1924. Modot had been a friend of Picasso before the First World War. Acrobat, gag-writer, singer, Communist – Modot even directed his own short movie in 1928 and as an actor was a fixture in inter-war French cinema, commercial and avant-garde alike. Paul Hammond has this to say of the Modot character in *L'Age d'Or*: 'With his spiv moustache and brilliantined hair – a toupée that the Catalan mistral endangered – Modot was the lantern-jawed double of Adolphe Menjou, the Hollywood actor Dalí and Buñuel lionised, and of Dalí himself.'[1] Lya Lys (real name Natalia Lyech) was more problematical – a Russian émigrée with no acting experience, she needed much coaching before Buñuel secured the Louise Brooks-style performance he sought. They later became lovers and Lys accompanied him to the United States, where she stayed on to become a starlet, appearing in numerous minor roles throughout the thirties. During the winter of 1929/30, the script of what was eventually titled *L'Age d'Or* grew exponentially – with the generous compliance of his noble sponsor – to justify the final sixty-three minute feature. It came out way over Noaille's original budget, at about eight times the cost of *Un Chien Andalou*. *L'Age d'Or* was shot in a day under three weeks at the same Billancourt studios – filmed, it was claimed, in 'a state of euphoria, enthusiasm and destructive fever'.

The contentious issue of the respective contributions to Buñuel and Dalí to both our films will be fully discussed at the end of this chapter. Suffice it to say here that their relations during the preparation of *L'Age d'Or*

1. Paul Hammond, *L'Age d'Or*, (British Film Institute, 1997) p.21. I have to acknowledge a big debt throughout this chapter to Paul Hammond's breezily infectious essay for the BFI Film Classics series. His little book is a mine of information, and makes accessible without fuss most of the recent, often ponderous, theoretical writing inspired by the film.

were less harmonious than with the earlier film. Dalí's input was not as significant, though it was greater than early commentators allowed. According to Kyrou and Aranda, the collaboration was limited to a single session. But we now know that Buñuel and Dalí spent a week together at Cadaques between 29 November and 6 December 1929 working on the script. They met again in Paris during the first ten days of the following January. Although they tried to conjure up the original rapport, a variety of factors frustrated any repeat of the meeting of imaginations that had worked so well for the earlier film. Although Dalí forwarded ideas – perhaps a whole filmscript – to Paris, the film as realised in terms of its narrative structure and ideological position was largely the work of Buñuel alone. It seems that Dalí's mind was elsewhere. Gala had recently come into his life. Buñuel loathed this universal surrealist muse, who was still married to Paul Eluard, with a jealousy matching that he had earlier shown towards Lorca. Financial difficulties following the bankruptcy of his main dealer, Camille Goemans, forced Dalí's absence from Paris during the shooting. He was not even able to participate in the filming of the sequences at Cadaques. Dalí's father, incensed by news of a recent inscription on a painting by his son worded *Sometimes I Spit For Pleasure On My Mother's Portrait*, had threatened to have him arrested if he so much as set foot in Catalonia[2]. For want of surviving records, it is difficult to gauge the precise input of Dalí into the first version of the script. In the introduction he wrote to the synopsis in the programme leaflet which the surrealists published for the release of the film, Dalí claimed initially: 'My general idea when I wrote the script for *L'Age d'Or* was....' Breton made him change it to: '.....when I wrote the script of *L'Age d'Or* with Buñuel'. All the accounts agree that Dalí played no part in the actual shooting of *L'Age d'Or*. After their quarrel, Dalí disowned the film altogether on the grounds that Buñuel had totally betrayed his intentions, replacing his own 'authentic sacrilege' with a 'primary' anti-clericalism and an over-explicit political message.'[3]

2. Robert Radford, op.cit., p.98.

3. Salvador Dali, *The Secret Life Of Salvador Dali* (Dial Press, 1942) p.282.

Whether Dalí liked it or not, *L'Age d'Or* is a textbook, almost a catechism, of the cardinal tenets of the surrealist movement in perhaps its most incandescent period. In the years immediately following Breton's *Second Manifesto,* the group's urge to marry up opposites was at its keenest and, likewise, the tensions between them: occultation and proselytism; the cult of love and the lure of abjection; utopian aspiration and black humour; rhythmic automatism and the 'photographing' of the irrational. *L'Age d'Or* faithfully delivers on the surrealist agenda of the day. In the frankness of its eroticism, for instance, it coincides with the group's 'researches' into sexuality in the course of which no less than eleven sessions were held between 1928 and 1932.[4] While keeping faith with Breton's dictum that the surrealist 'erotic' should be 'veiled', *L'Age d'Or* sails very close to the wind of pornographic explicitness that Aragon and Péret were essaying, in words and under pseudonyms – in *Le Con d'Irène* and *Les Rouilles Encagées* respectively – and with Man Ray in a plaquette of photographs titled *1929*. *L'Age d'Or* chimed also with the group's most dedicated efforts to reconcile the world views of Marx and Freud in terms of their shared diagnosis of an incipient 'cracking' beneath the surface limpidity of the bourgeois order.[5] (It was the Communists' demonising of Freud and Aragon's assent to it that eventually precipitated Aragon's rupture with Breton and, consequent upon that, Buñuel's own departure from the group.) This was also the year in which the group's house-organ was relaunched as *Le Surréalisme Au Service De La Révolution* in the hope of dispelling the comrades' suspicions of surrealist insubordination and dilettantism. Finally, in its ambivalence towards desire (damning, or redemptive?), *L'Age d'Or* can be read as a document of the schism in Surrealism between the transcendence-seeking Bretonians and the 'old mole' oppositionals who rallied round Georges Bataille and his rival review, *Documents*. Hence, unlike its predecessor, *L'Age d'Or* received the group's imprimatur before rather than after the event. Their collective declaration saluting the film's release read: 'This is

4. The first two were published in *La Révolution Surréaliste,* no 11, 15th March 1928. The minutes of all of them are available in translation by Malcolm Imrie in José Pierre ed., *Investigating Sex: Surrealist Discussions, 1928–1932* (Verso, 1992). It is worth noting that woman seem to have participated only in the seventh, eighth and ninth sessions.

5. Surrealism's most sustained essays in 'Freudo-Marxism' were probably André Breton's *Les Vases Communicants* (Editions des Cahiers Libres, 1932) and Tristan Tzara's *Grains Et Issues* (Denoël et Steele, 1935).

the indispensable moral complement to stock exchange panics, whose effect will be very direct, precisely because of its surrealist character'.[6]

While at the antipodes of Communist propaganda, *L'Age d'Or* was meant and understood at the time to be a call to revolution. For once, Surrealism found itself taken seriously, perhaps as much because the political climate was changing as for the incitement of the film itself. At the start of thirties, with the Wall Street Crash and the mounting threat of Nazism in Germany, the 'après-guerre' gave way to the 'avant-crise', and successive French governments bore down hard on the Communists and their fellow-travellers. Life was being made more difficult in all sorts of ways not only for militants but also for irksome poets. A fully paid up surrealist adherent by now, Buñuel seems to have been determined to banish all equivocation about his demoralising intentions in the second film. This was to be no rebus susceptible of endless possible re-readings. It was to deliver a message that no one could misconstrue. As Buñuel later said in his conversations with Max Aub, ... 'it's a clear, straightforward film, with no mystery. Nothing of the sort. Very surrealist, of course, but there's no mystery to it. My ideas are clear to see. Well, not mine, the ideas of the surrealist group. They're perfectly evident. Everything that's anti-one thing or another: – anti-family, anti-country, anti-religion, anti-everything – is very clearly, and very violently expressed.[7] Clarity, method and calculation presided over the preparation of the scenario; with little or no automatism and at the expense of spontaneity and dream. Correspondingly, the film style of *L'Age d'Or* is largely functional and unobtrusive with limited camera movement and little trick photography – as if to give it the authority of a documentary. Out go the iris effects and slow motion shots of *Un Chien Andalou*. Avant-garde fast cutting – the average shot length in *Un Chien Andalou* was three seconds – gives way to a more normal take-length of five and a half seconds.[8]

If *Un Chien Andalou* plays on the opposition between sight and

6. *L'Age d'Or*, signed by thirteen surrealists in Maurice Nadeau, *Documents Surréalistes*, (Editions du Seuil, 1946) p.177.

'As-tu Froid?', photograph by Luis Buñuel showing his anti-clerical stance, published in *Le Surréalisme Au Service De La Révolution*, July 1930.

7. Max Aub, *Luis Buñuel: Entretiens Avec Max Aub* (Pierre Belfond 1984) p.159.

8. Leading Dali to pay Buñuel the back-handed compliment: 'It looks like an American movie' (Luis Buñuel, *My Last Breath*, op.cit., p.116).

blindness, then the corresponding duality in *L'Age d'Or* is between gold and shit. The psychoanalytical and age-old linkage between the basest and the most precious of substances is the most likely key to the film's title. Those who sell their souls to the Devil find that the gold he gives them in exchange eventually turns to excrement. Dalí wrote in the summer of 1930: 'We learned long ago to recognise the image of desire behind the simulacra of terror, and even the reawakening of the "ages of gold" behind ignominious scatological simulacra.' [9] It is a title of epic pretension. It seems certain that it was lit upon out of surrealist contrariness, by 'anti-phrase'. It is a contrary title in another sense also: for the argument of the film seems to be that each age of mankind's history repeats the same clash between impulse and inhibition. Time unfolds repetitively and cyclically and never releases us from the vertigo of our desires. Thus, the film's leaps across time are no longer gratuitously surprising as in *Un Chien Andalou*; they are about relating a historical past to the present. The deliberate flattening of temporal perspective emphasises that this is a film about our condition in the here and now.

Both films tell the story of thwarted love affairs and explore the mechanisms that cause love to fail. Both films have 'bookend' opening and closing sequences – prologues and epilogues – from which some or all of the main protagonists are absent – sequences that bracket the central narrative and comment metaphorically upon it. The films represent two complementary fables. And *L'Age d'Or* differs in many important respects from its predecessor. If the 'McGuffin' of both is heterosexual love and its frustrations, the second film stretches its canvas way beyond the fated romance of a single couple to reach out to the world at large and the cultural history of the west. It takes in both the internal struggle between Eros and the death instinct, and the external one between the imaginary world of desire and the social order. The targets of its satire are explicitly social, even if the root causes of the dysfunctions examined may still lie in

9. Salvador Dali, *La Femme Visible* (Editions Surréalistes, 1930) p.18, quoted by Paul Hammond, op.cit., p24.

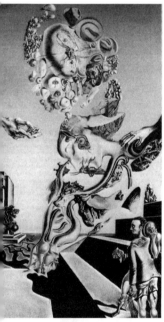

Dali's *The Lugubrious Game* (1929), with its scatological imagery which caused some concern to the surrealists, especially Breton. It was Georges Bataille's psychoanalysis of this painting which led to Bataille's break with the surrealist group. Dali's other paintings in this ultra-provocative phase included *Portrait Of My Sister, Her Anus Red With Bloody Shit.*

maladjustments of the individual psyche. Linda Williams has remarked that, if *Un Chien Andalou* deconstructs the illusory unity of the self, then *L'Age d'Or* does the same for society.[10] From the standpoint a 'surrealist revolution', the nagging question that has hung over *L'Age d'Or* is whether the supreme egotism of the sexual drive we see in action (at once frustrated and destructive) is specific to a society in decomposition – one that revolution might cure – or an ineradicable feature of the human condition. Does our corporal finitude and our conflicted psyche ensure the disappointment in advance of all our aspirations towards a Golden Age? Is desire destructive because it inhabits a structural double bind; or is it contingently frustrated by a specific historical, and iniquitous, culture? If *Un Chien Andalou* affirms the first; *L'Age d'Or* makes a stand on behalf of the second contention. There's a shift too from ambiguity about gender and from denial of sexual difference to a more straightforward bi-polarised sexuality. It's almost as if the passage between the two films imitates the intellectual journey of Sigmund Freud as his theorising moved out from the pre-first-world-war confines of the consulting room and neuroses of the individual patient on the clinician's couch, to the bold post-war social speculations about taboo, monotheism, the sources of art, aggression, civilisation and its discontents.

It has been noted that *L'Age d'Or* lacks the formal unity of its predecessor and comes across as something of a 'heterogeneous collage'.[11] Certainly, there are striking shifts in mood between lyricism and derision, romantic exaltation and abjection, that anticipate the narrative liberties taken by the nouvelle vague. And the film wilfully mixes genres: fiction and documentary, pseudo-historical reconstruction and contemporary melodrama. It 'travels' between diverse geographical locations as prodigally as a James Bond movie – from the rocky shores of Cape Creus, to a putative Imperial Rome (which is really modern Paris) and finally to the cardboard gothic castle of a debauchee out of the Marquis de Sade. But it would be a mistake to dismiss *L'Age d'Or* as just a collection of disparate gags. The

10. Linda Williams, *Figures Of Desire*, op.cit., p.109.

11. Paul Hammond, op.cit. p.9.

microstructure may be disconcerting but the there is an order to the thematic and ideological macrostructure. There is a powerful internal logic behind *L'Age d'Or*'s juxtaposition of contraries. Once again, privileged images – hanks of hair, agitated fingers – recur. Patterns of opposition and reversal, along with repeated strategies of interruption and delay, all serve to hold the film together. As in *Un Chien Andalou*, but on a bigger scale, the discrete parts resonate together, share a consistent ideological texture and express a singular, overall, 'cruel' vision. And again, as in *Un Chien Andalou,* the spectator can learn a lot from the 'prologue' about the how to read the film that follows.

The clinically distanced position which the film will take towards its human protagonists – lovers and love's enemies alike – is established from the start. Only episodically, and the better eventually to confound us, are we going to be invited to identify with the characters. Nor is there any 'Once upon a time' to lull us into fairy tale receptivity. The opening segment borrows entomological, factual footage recording the behaviour of scorpions from a pre-First-World-War popular science documentary, along with its silent movie captions. The old film stock is fuzzy and the framing erratic but, by the same token, it is true to Buñuel's and Dalí's anti-artistic impulses. It places all that is to follow in a framework of 'natural history', 'image-fact' and 'small things'. The sequence may not equal the prologue to *Un Chien Andalou* in the direct physicality of its impact but its provocative significance ramifies cumulatively as the film progresses. We see the scorpions fighting among themselves and repelling an intruding rat. It is immediately clear from the laconic intertitles – they are direct quotes from the entomologist Jean-Henri Fabre whom Buñuel had read enthusiastically as a student in Madrid – that what the documentary identifies as the instinctive behaviour of the scorpion – its venomous aggression, its survival capacity, its treachery to its own species – applies equally to humankind. The scorpion is the zodiac sign that governs the genitals and the anus. As such,

it is the symbol of sex, excrement and death. It introduces the ambivalent dynamic that powers our impulses of attraction and repulsion alike, and officiates at the alchemical marriage of excrement and gold. The scorpions prologue, like its equivalent in *Un Chien Andalou,* is also the avatar for the startling diegetic ruptures which the film has in store. It warns us that the film itself will behave like a scorpion and mimic the shape and function of the scorpion's tail: 'formed of a series of five prismatic articulations' ending 'in a sixth vesicular joint, the poison sac'. The film too is 'an organ of battle

and information'. It too will deliver its most provocative thrust – secrete its venom – in its last segment.

Originally, Buñuel wanted to make the transition from the scorpions prologue to the second sequence of the film featuring bandits in one shot, a simple tilt from close-up on arachnid to distant outlaw-figure over the same barren landscape. Spatial contiguity would thus have made a metonymic link between men and insects. Practical difficulties with the shot meant he had to be satisfied with a cut and a metaphorical connection via a linking

intertitle: 'Some hours afterwards' (that could have come straight out of *Un Chien Andalou*).[12] A brigand lookout, clambering among rocks, espies four bishops, robed and mitred, seated on the cliff below and intoning prayers. The crooks of their crosiers recall the shape of the scorpion's tail. The bandit sentinel staggers away, to rally his gang and repel the intruders (called the Majorcans or Mallorcans), much like the scorpion who 'sees off the meddler who disturbs his solitude'. But if the fast and efficient scorpions give a lesson in survival of the fittest, the bandits are drained of vitality. Their knives don't cut. They use their rifles as crutches. They march the wrong way. One called Péman plays a lacklustre, onanistic game with a 'bachelor machine', made of pitchforks and rope, complete with 'umbilical cord'. These tramp-like figures could be rural anarchists or primitive rebels. They are certainly the wretched of the earth. Like the scorpions, they quarrel among themselves and resent intruders. Could they represent a primal stage of human evolution, before authority was internalised and when life was instinctual but devitalised? Is Buñuel suggesting already that, in the double bind that is the human condition – unlike the scorpion condition in this respect – there is no vitality without repression? Is this an eccentric take on Freud's scenario in *Totem And Taboo* of social life before the primal crime? Alternatively, the bandits' gear, with its accordion and paintbrushes, suggests they are bohemian marginals. With Max Ernst cast as their leader and Pierre Prévert pulling the cord, they could be the surrealist group itself, with Buñuel mischievously hinting that artists make ineffectual revolutionaries. (And how appropriate that Ernst, the inventor of surrealist collage, should play the chief in a film where collage is the presiding formal principle.) Whatever one's preferred reading, the outcome is certain. The exhausted bandits stumble and fall before even engaging with the 'Majorcans'/bishops.[13] The first men, (for want of a super-ego?) succumb. Victory goes to the church and repression, even as the ecclesiastics' own flesh rots beneath their robes. Only putrefaction and piles of bones are left lying on the inhospitable shore.

12. Linda Williams has noted a key shift in Buñuel from a use of mainly metaphoric figures in *Un Chien Andalou* (the chain of matching dissolves from ant-infested hand to severed hand in the street, for instance) towards techniques of metonymic displacement in *L'Age d'Or*. This shift helps account for the clearer legibility of the second film's narrative. (Linda Williams, op.cit., pp.138–139).

Max Ernst as the bandit leader.

13. Paul Hammond informs us that, for Buñuel and Dalí in 1930, 'Mallorca connoted all that was feudal, god-fearing, reactionary' (op.cit., p.18).

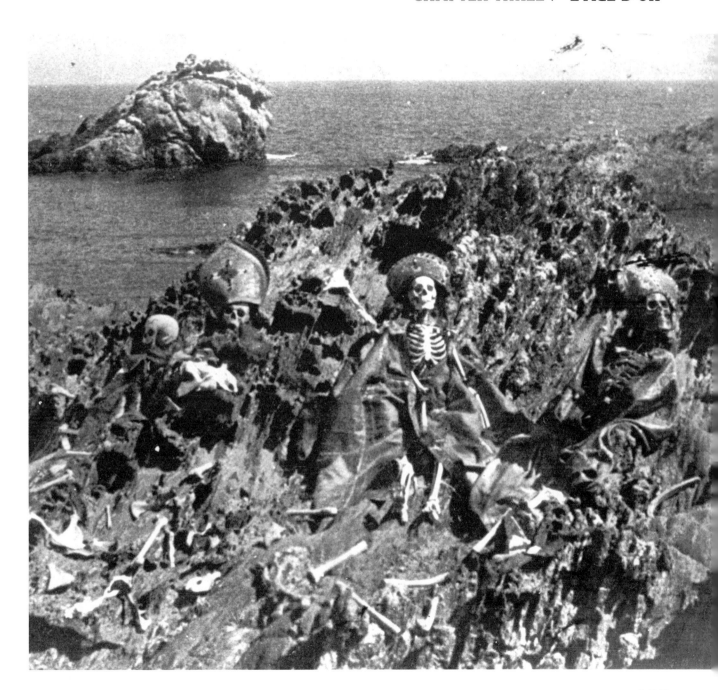

Like the scorpions – and like Buñuel after the prologue to *Un Chien Andalou* – the bandits disappear from the film. In their place arrives a flotilla of little boats which deposit on a tiny quay among the rocks a representative selection of contemporary establishment figures – politicos, captains of industry, army officers, priests, nuns, the obligatory rich American... In their turn, the assorted dignitaries clamber, insect-like, over the jagged terrain. Their mission, we learn, is to celebrate the memory of the dead pontiffs by founding the Imperial City on the site of their remains. The diminutive, moustachioed 'governor' clears his throat. But his inaugural speech has not begun before a woman's cries from the edge of the assembled crowd bring formal proceedings to a halt. A man and a woman – they are to be the film's main protagonists – are making frenzied love in the dirt. The narrative proper of *L'Age d'Or* thus begins where *Un Chien Andalou* left off: with a couple locked together in an unfriendly landscape by the sea. It is a wild embrace. What with the mud, the ambiguous cries and the wrestling, it could be mistaken for a rape, although the script has it that the woman 'is letting the man do what he likes, an expression of infinite tenderness in her eyes, like a mother allowing her child to kiss her'[14]. Individual passion can't be allowed to disrupt the collective order guaranteed by civilisation. Therefore, the couple are pulled apart and the woman led away by two nuns. His face and clothes besmirched with the dirt he's still lying in, but alone now, the man envisions his lover on the lavatory; a toilet roll burns; to the sound of flushing, a torrent of bubbling excremental lava fills the screen. Long close-up shot of the man's face, filled with lustful yearning. As he in turn is dragged off, by a pair of plain-clothes police, he manages to vent his frustration by kicking a little white dog in the air and crushing a beetle underfoot. The governor's interrupted address resumes. It is a babble. But we catch the odd phrase like 'the primal substances themselves...' (the words were apparently cribbed from a recent ministerial speech about agriculture). Then he portentously trowels a turd-like pat of cement – the two

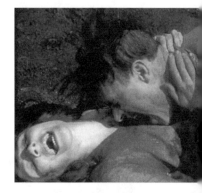

14. Script of *L'Age d'Or* trans. Marianne Alexandre, in *L'Age d'Or And Un Chien Andalou* (Lorrimer, 1968) p.28. Dalí's advice to Buñuel for this scene had been very different: 'When they're in the mud she screams as if they were slitting her throat' (Letter from Salvador Dalí to Luis Buñuel in the Filmoteca Nacional, Madrid, document R, 308, quoted by Ian Gibson, op.cit., p.248).

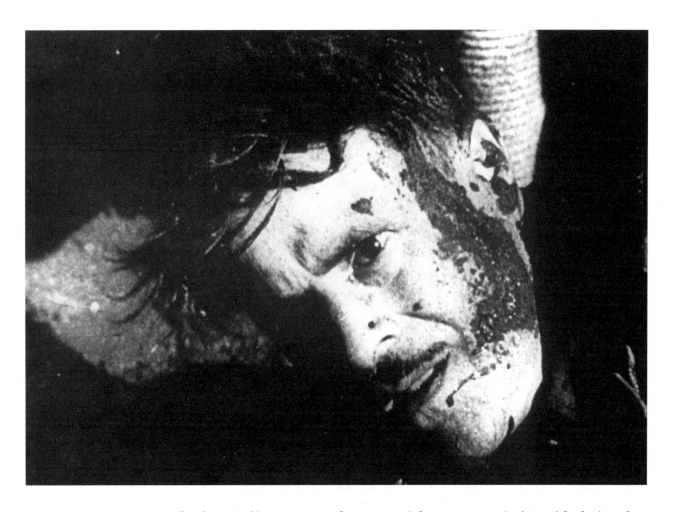

'fundaments' in one – onto the ceremonial cornerstone. An intertitle designed like a plaque reads: 'In the Year of Grace 1930, on the site ['les lieux' in the French is a polite word for the toilets] occupied by the remains of the Mallorquins, has been placed the foundation stone of the city of....' It appears that sublimation (the founding of Rome) and perversion (the orgy in the mud) go together. The origin of desire coincides with the origin of civilisation and blocked sexual satisfaction.[15]

15. Freddie Buache, *Luis Buñuel,* (Editions L'Age d'Homme, 1970) p.19.

The shameful/shameless entry of the couple and their forcible separation introduces the central and longest section of *L'Age d'Or,* which is to be their love story. As in *Un Chien Andalou,* they are anonymous, emblematic and archetypal. But their place in society is more clearly established. Both are from the ruling class. For a film that generations of surrealists have trumpeted as the supreme screen statement of 'amour fou', the characters who exhibit this overwhelming passion are presented in a surprisingly unsympathetic, even jaundiced, light. Necessarily so, because no one is exempt from social determinism. Modot is the victim/ product of the prevailing order of things. He is not so much an individual as the embodiment of collective discontents and frustrations. This anti-hero is uninspiring, antipathetic and clownish, a high functionary in whom it just happens that the crust of the super ego has been broken open by desire. Spectator identification with characters on the screen is a major feature of the realist illusion that Buñuel challenged. Like *Un Chien Andalou,* this is a story that is told in ways that evoke but mock the narrative conventions of classical cinema. The spectator gives up on identification in *L'Age d'Or* not only because the foundations of the narrative are persistently undermined, but also because the protagonists are so unpleasant. If the scorpions sequence invites as to view what follows with a dispassionate eye, so too, though in its different way, does the acting. The bitten lips, the rolling eyes, the explosive body language – these are all so mannered and exaggerated that they impose a distance between the action and the spectator that rules out even a smidgen of sympathy. And the ham acting is only partly accounted for by Buñuel's and Dalí's affection for Hollywood melodramas. Sentiment is as minor an ingredient in a Buñuel movie as the Martini portion in his recipe for a dry gin cocktail.

The intertitle, 'Imperial Rome', and the marvel of editing, transport us forward in the instant of a cut from the 'dawn of culture' to 1930, and from a wild shoreline to a throbbing metropolis. Like the transformation into a

spaceship of the bone thrown skywards by the primeval apes at the start of Kubrick's *2001,* Buñuel's ellipsis gives us achievement instantaneous upon volition. His film celebrates the exhilarating power of the imagination to abolish dull time even as it rubs our noses in our abjection and denial. There follows a montage of stock footage and cod-documentary shots of life in a modern city: the Vatican and its environs disorientatingly intercut with scenes from Paris's Left Bank. No city symphony this, the signs of urban chaos are everywhere. The traffic is in snarl-up. The Pope has mortgaged Saint Peter's. A bourgeois emerges from a café, his suit encrusted with dirt. Another stamps on a violin. 'Sometimes on Sundays', a row of buildings explodes and collapses into the street. A gent walks through a park with a stone perched on his hat, passing a statue with the same. Now our hero is

back in frame still handcuffed to his minders, still being forcibly jostled along, and still enraged by the interruption of his coitus. Distracted by passing sandwich board adverts and shop-window displays – a brief excursion here into the realm of Surrealism's urban 'merveilleux quotidien' – he enjoys a succession of hallucinations. A cosmetics advertisement showing a woman's hand reaching towards a 'Leda' powder-puff prompts him to imagine his lover's finger probing onanistically into a twitching tress of hair. He next becomes fixated on a large photo in a bookshop window of a seated woman – she bears a close resemblance to his mistress – with her head thrown voluptuously back. His desiring imagination transforms these images from the public street into private signals of love. By some mysterious exchange of psychic energy, they bring him into contact with his absent beloved. [16] A dissolve with graphic match on the photo of the woman in glamour pose conjures up the lover herself who is revealed by the backtracking camera, lying on a sofa, her dress in disarray, her hand on her crotch, her ring-finger equivocally bandaged, shuddering with pleasure.

16. Paul Sandro, op.cit., pp.56–57.

There follows a curious conversation between the woman and her mother, the Marquise of X. Lya Lys makes quite a speech in this pioneer sound film and its subject is, precisely, sound. We're in the noble family's mansion and plans are being made for the coming evening's reception and concert. Wouldn't positioning the musicians close to the microphone, muses Lys, compensate for their small numbers and achieve the same effect as a large orchestra placed further away? It's a piece of dialogue that looks forward to post-war 'theatre of the absurd'. But it also draws explicit attention to the new technology of sound, and, according to Marsha Kinder, produces 'a juxtaposition that surprisingly links (the woman's) erotic desire to the new fetishized apparatus that controls the soundtrack'.[17] Buñuel's use of sound in *L'Age d'Or* gave the lie to champions of the avant-garde like Benjamin Fondane who had pessimistically foretold that the coming of sound would spell the death of poetry in film. And most surrealists initially

17. Marsha Kinder, 'The Nomadic Discourse Of Luis Buñuel' in Marsha Kinder ed., *Luis Buñuel's 'The Discreet Charm Of The Bourgeoisie'*, (Cambridge University Press, 1999), p.7.

shared Fondane's dislike of the 'talkies'. But Buñuel understood the surrealist potential of sound. Not for him a soundtrack that redundantly coincides with the image according to mainstream cinema's canons of verisimilitude. Instead, he sets up a dissonance between the two tracks as a means of expressing the surrealists' (and Freud's) notion of the self divided between the desiring unconscious and the orderly ego. In *L'Age d'Or,* as we shall see, he explored a gamut of acoustic possibilities: for interior monologue and interior 'dialogue'; for linking venues and people far apart; for the contrasting effects of diegetic and extra-diegetic music, for valorising the silences in between, for using music and other sounds alternately to reinforce (with parodic redundancy) and to contradict the meaning of the image track. We watch the scorpions' world of pure instinct to the strains of Mendelssohn; and the killing of a son by his father to Schubert.

Going into her bedroom, Lys is unphased at finding a huge cow ensconced on her bed. The placid animal rises to its feet with its hindquarters towering over her, and she gently shepherds it into an adjoining room, the cowbell round its neck tinkling all the while. This cow gag, which has become an icon for the film, is a famous piece of surrealist incongruity. Is the cow another obstacle in the path of desire? Certainly, its presence seems to relate to that play between word and image that we found at punning work in *Un Chien Andalou.* The 'vache' of this notorious cow-on-the-bed sequence opens up a vista of potential correspondences: with the girl herself whose performance some have called 'bovine', with her mother, and with the police still holding the man…. Elsewhere in the film, equivocal images are similarly generated by verbal associations: – Modot's fantasy of the powder-puff that turns into quivering hair is an enfiguring of the double-meaning of 'la houppe' as both 'powder-puff' and 'curls'. Fingers are bandaged because 'bander' also means 'to feel randy'. The girl's ring finger bandaged alternates with the same unbandaged: horniness with detumescence.

Study shot of the cow on the bed, with a crouching Manuel Angeles Ortiz (who played the gamekeeper).

The sequence that comes next resumes the lyrical communion previously established between the lovers, still parted by circumstance. It has been hailed by surrealists as the ultimate screen representation of the power of 'l'amour fou', the potential for subversive and reciprocated desire to overcome all obstacles. It attains a poignant sense of consummation in a movie which otherwise chronicles – comically and desperately by turns – the repeated frustration of such desire.[18] The woman is now sitting at her

18. But it has to be admitted that it is the triumph of love over adversity at the spiritual level only, leaving physical desire still unsatisfied. See Wendy Everett, op.cit., p.147–8.

boudoir mirror, apparently dreaming of the lover from whom she has been so officiously separated. Shots of her buffing her nails are inter-cut with shots of Modot still being bundled along by the two policemen. The mirror plays its traditional metaphorical role in poetry as an agent of magical mediation. A complex soundtrack merging noises from the two unrelated locations proclaims inter-subjective desire's triumph over adversity. There is the ringing of a cowbell which belongs to the woman's space; we have just seen her shoo off the cow and we assume it is still close by. Mingling with this is the angry barking of a dog, running along behind the railings of a park, excited by the passage of Modot and his minders. Finally, there is the noise of a high wind which appears to blow from the mirror itself, as if it were a window onto a blustery day. The woman's hair is ruffled by the wind – the very gust of desire. The man and the woman appear to exchange a tender regard, their eyes filled with tears. The communicability of such desire is expressed with a persuasiveness that owes much to the perceived mimetic status of the soundtrack – then so novel and so innocent – to enhance the film's realism. Yet, at the same time, the *mise-en-scène* defies the canons of realism. A close-up of the mirror reveals, not the woman's reflection, but passing clouds. With perverse inconsistency, however, the mirror <u>does</u> reflect the perfume bottles in front of her on the dressing table. The two contradictory representations of the mirror are held in suspense to the end of the sequence when Lys rests her cheek against its surface and turns her gaze towards us, while the wind blowing through the glass continues to ruffle her hair.

At last, having had enough of all the harassment, our hero reveals his true identity to his captors, producing an official-looking document which identifies him, not as the trouble-maker we have got to know, but as a high-ranking public servant on an important philanthropic mission. A flashback showing the august ceremony of his appointment authenticates this and satisfies the police. No sooner released, however, Modot confounds

expectations of his humanitarian role with a gratuitous act of violence. He spots a blind war veteran dithering on the opposite kerb and twitching his white stick. The enraged Modot has already hailed a taxi but puts off his departure until he has crossed the road and administered a mighty kick to the old man who falls to the ground.

We now cut to the fifth of the film's segments: the elegant soirée given by the Marquises of X, the parents of our heroine, at their imposing residence outside Rome – though by this time there is little pretence that we are not really in France. Will this be the opportunity for the yearning couple to get together for real, or will social formalities once again conspire against the private affair? A bourgeois reception demands self-control and sublimation, the ideal catalyst for intensifying the couple's compulsion to outrage. There is little charm, discreet or otherwise, about this upper crust gathering. The flies that the Marquis keeps trying to swat from his face are an index of this society's 'putrefaction'. Once again what belongs with the 'base' – if we follow Georges Bataille – settles on the highest part. And where there's putrefaction, religion won't be far away. The guests include some of the Majorcans of the inauguration ceremony, not least the diminutive governor, accompanied now by his giant of a wife.[19] A limousine arrives and a footman takes out a monstrance, (a receptacle for the Communion host, or, to the surrealists, for 'Holy Excrement'). It is stood on the ground until the well-heeled guests (literally heeled, for we only see their feet) have alighted.

Unlike a realist film, *L'Age d'Or* does not try to show the consequences of a class system, dominated by a 'triumphant bourgeoisie', in poverty and injustice. Its target is rather the forms of social intercourse which underpin oppression. According to Sanchez Vidal, for Buñuel, 'good breeding is a form of behaviour that guarantees the survival of the oppressive system. A change of these forms is a revolutionary change'.[20] Jean-Luc Godard later concurred: 'I believe the most difficult thing to change

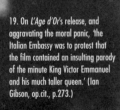

19. On *L'Age d'Or's* release, and aggravating the moral panic, 'the Italian Embassy was to protest that the film contained an insulting parody of the minute King Victor Emmanuel and his much taller queen.' (Ian Gibson, op.cit., p.273.)

20. Agustin Sanchez Vidal, *Luis Buñuel*, (Editorial Catedra, Madrid, 1991) p.25.

125

is not the essence, but the form... *L'Age d'Or* might be classified as a political film because it certainly addresses changes in detail, to change those forms that we know as the most powerful, which are merely social relations or good behaviour..... And real changes only happen when those forms change.'[21] And, as we have said, what goes for convention as theme in *L'Age d'Or* also goes for form; subversive love and its frustrations in the story is matched by the subversion of form which frustrates <u>our</u> consumption of the film.

The ruling class in *L'Age d'Or* is stereotypical, not unlike its caricatural representation by Eisenstein. The social structure that Buñuel

21. Jean-Luc Godard, *Introduction À Une Véritable Histoire Du Cinéma*, quoted by Juan Roberto Mora Catllet in Marsha Kinder ed., *Luis Buñuel's 'The Discreet Charm Of The Bourgeoisie'*, (Cambridge University Press, 1999) p.44.

depicts is starkly divided between the dominant class and the rest – a duality that is more anarchist than Marxist. The images of power in *L'Age d'Or,* and the highlighting of religion's part in upholding these power relations, refer back to the anti-clerical cartoons in the anarchist press of the 1900s, such as *L'Assiette Au Beurre.* The film dates, after all, from the time when the surrealists were militating in the PCF's 'Lutte antireligieuse'. But the target: 'l'alliance du sabre et du goupillon' (sword and incense-burner), would have been familiar to good republicans a century before, rallying to Gambetta's cry: 'Le cléricalisme: voilà l'ennemi!' Nothing mitigates Buñuel's 1930 assault on this bourgeoisie, least of all the insouciant charm he concedes to it in his later films. At the same time, he does not conceal the fact that the poor also can be horrid. The oppressors have a good conscience; the dispossessed ape their masters. No one is spared the film's cruel regard; certainly not the victims of the prevailing (dis)order. The exploited hardly rise to the revolutionary task assigned them by Marx and the PCF. They turn away from the plight of their comrades and collude with their oppressors. Paul Hammond notes that 'the higher-up lackeys unconsciously mimic the body language of their paymasters'[22] While the edgy Lys strokes her unbandaged ring-finger, a dissolve superimposes a butler energetically buffing a smeared decanter.

It is left to the lovers, themselves spoiled offspring of the privileged class, but driven into revolt by subversive desire, to upset the composure of the establishment – armour plated as it is in myopic self-satisfaction. As Jean Renoir was to suggest in *La Règle Du Jeu* of 1939, – a film which owes a lot more than has usually been acknowledged to *L'Age d'Or* – it takes a very particular breach of the 'the rules of the game' to perturb the frozen social rituals of the bourgeoisie at leisure. More than the horse and farm cart (echoes of the tumbril and the guillotine) driven by two wine-swilling peasants that rolls noisily through the ballroom. More than the screaming maid, her pinnie on fire, fleeing from an explosion in the kitchen. More even,

22. Paul Hammond, op.cit., pp.41–42.

in a crescendo of iniquities, than a gamekeeper shooting down his own son.

On the lawn in front of the château, Buñuel's gamekeeper comes back from hunting to be met jubilantly by his young son. They hug. It is a moment of idyllic 'quality time'. Then the boy oversteps the mark and playfully knocks his father's roll-up cigarette to the ground. The father's smile turns into a look of rage. He seizes his shotgun and with great deliberation shoots down his son like a rabbit, not just once but twice – to be completely sure. We, the audience, are shocked both by the killing itself and by the disproportion between the act and its trivial pretext. But still more appalling is the lack of remorse on the part of the filicide, and by the readiness of his work-mates, who have come on the scene, – and of the house-party guests who, alerted by the gunfire, have issued out onto the balcony, – to excuse the killing as conduct in the line of duty. All the gamekeeper has to do is to mime in front of the assembled company the events that led to the shooting. It's as if the acting out – the spin – is sufficient in itself to restore the peace of mind of the filicide – and that of his employers.[23]

23. See Charles Tesson, *Luis Buñuel*, (Cahiers Du Cinéma, 1995) pp.84–87.

The dark, disproportionality gag doesn't even end there: the company's heedlessness at the death of the boy is almost immediately followed by their barely containable outrage at a simple slap. For, in the meantime, Modot has arrived at the party 'accompanied' by a woman's dress which he trails behind him. When he throws it over a chair and joins the gathering, a lap dissolve has the dress 'fill' with its wearer. It is his lover waiting for him excitedly, biting her lip and playing with her ring-finger. But Modot is cautious, as if torn between lustful recklessness and respect for the rules of the game. Crossing the room towards her – (though this is all suggested by exchanges of looks; we never see the couple in the same shot) – Modot is waylaid by her mother, Madame la Marquise. When, compounding his irritation, she accidentally spills a drink over him, he slaps her violently on the cheek. As one, the company rounds on him in angry consternation. The contrast between their unconcern at the murder of the child and their

outrage at a mere slap is blatant. It's a reprise of the couple's earlier challenge to decorum with their primal scene love-making the 'founding of Rome'. Forcible ejection by good society is again the price they have to pay. Is it a case of wilful denial and hypocritical inconsistency on the part of the bourgeoisie? Do they react so strongly because they see it as a slap in the face of the very institution of family – for surrealists, the foyer of hypocrisy and repression? Is the class responding mindfully to a more insidious, fifth-column-type challenge from within? As for the lessons to be drawn from all this, Buñuel does not let on. The surrealists had always said that revolution would best be started by those 'within the seraglio', who knew their way around. Certainly the slap is a release of sorts for Modot – and the audience. It's an emblematic climax to a litany of frustrations that has been a long time building.

Thrown out of the party, our hero hangs about undeterred by disapproving glances. He lurks by the French windows until he catches his mistress's eye and makes a sign for her to meet him outside. While the main body of the guests take their seats on the patio for the concert, the lovers retreat deeper into the garden to make love undisturbed. Parallel editing thereafter inter-cuts the two fields of action. The going for the lovers continues to be rough. They try sitting down but find the chairs uncomfortable. They bump heads and overbalance. They struggle on the gravel path. The first bar of the music – the 'Liebestod' again – ambient sound from the social space of the concert – makes them jump. But the aching motif from Wagner's *Tristan and Isolde* also serves to fuel their desire. Thereafter, the intensity of their love-making rises and falls in tune with the music. Modot takes Lys's fingers in his mouth. The fingers of his own hand are momentarily seen to be amputated and he caresses her cheek with the stumps. No sooner have they managed a deep embrace, than the man gets distracted by the naked foot of a nearby marble statue of Venus who presides over the comedy of their clumsy amorous manoeuvrings. He

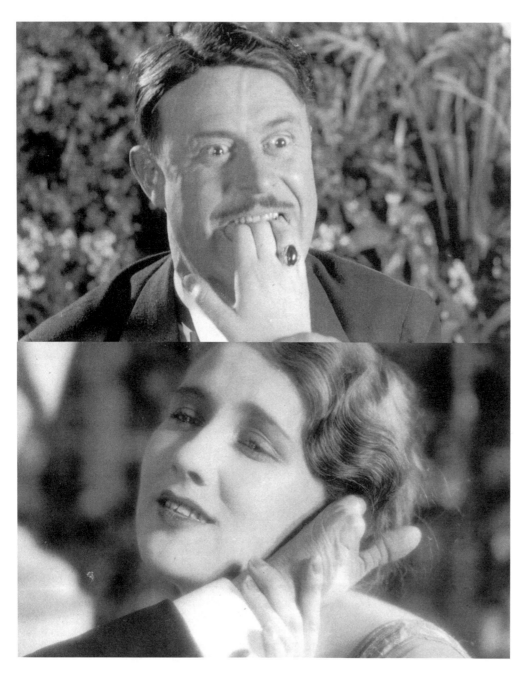

stares at it fixedly. The fetish/simulacrum wins out over the real thing.

The frustrating work of inhibition is once again complemented by prohibition. A servant appears calling Modot to the telephone where an irate Minister of the Interior is on the line. Alone again, Lya finds solace sucking on Venus's big toe (Bataille's 'basest' member, always stepping in the *merde*.

But in this case it's the abject part of a high culture icon!). She fantasises about her father. Buñuel's and Dalí's chain of perverse substitutions stretches on relentlessly: fetishism, scatology, incest. The Minister, toying with a pistol on his bureau, shouts down the phone that our hero has betrayed his mission. By his negligence (diverted by love) he's to blame for a spate of humanitarian disasters. These are illustrated with miscellaneous archive footage of catastrophes across the world, natural and man-made, including crowds milling about and children fleeing from a fire. And to confound it all, he's brought disgrace on the Minister himself. 'You disturb me just for that! To hell with your brats!', bellows Modot in his turn, and hurls the receiver against the wall. We hear a shot and the camera pans up

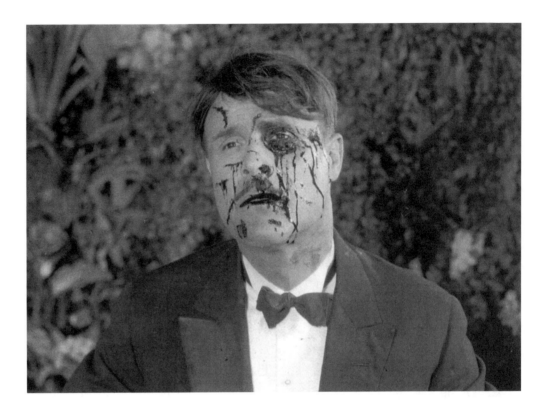

from the Minister's empty shoes on the blood-stained floor to the ceiling to which his body has miraculously risen – a mischievous reversal of the adage that it is the soul that goes heavenwards after death while the body remains earthbound.

The demise of the Minister of the Interior – Mr Super-Ego, after all – ought to ease the path of love. Indeed, the would-be lovemaking does resume. But fulfilment is as elusive as ever. Modot goes through the motions but his heart is no longer in it. Conjugal tenderness replaces the erotic urge, with the couple seemingly imagining themselves together thirty years on. But the cues are contradictory. The lovers' antics are poignant and derisory, tender and frenzied by turns. No wonder spectators are divided over whether

or not the lovers finally reach their goal. Domesticity alternates with murderous fantasy as the Wagner from the concert reaches its climax: 'What joy to have murdered our children!', cries out the inner voice of Lya Lys. Modot's face is scratched and torn. Blood bubbles from his mouth as his voice-over (it's that of Paul Eluard) murmurs: 'Mon amour, mon amour!' Does this shared interior dialogue underline their absolute union? Or is it another projection of private illusions? Modot kneels before her, takes her by the knees and spreads her legs. The folds of her dress palpitate suggestively between her open thighs. Surely this must be 'it'.

Over at the concert, the conductor, as if somehow confounded by the intensity of the couple's real desire which outdoes the sublimated passion of the Wagner, throws away his baton, clutches his head with both hands, leaves the podium, and crunches his way across the gravel towards the lovers' retreat. In an instant, the girl's attentions are transferred to the old conductor. She abandons Modot and passionately embraces the bearded patriarch. The jilted lover stands up in a fury and bangs his head violently on a hanging basket. Mimicking the gestures of the conductor a moment earlier, he sets off back to the mansion, aching head in hands, to the relentless beating of drums. This drumming was recorded from the Holy Week rituals in Buñuel's native Aragonese village of Calanda. It will not let up until the last moments of the movie.[24]

A furious exorcism now ensues as Modot, tell-tale fly-button poking out of his trousers, storms into his mistress's bedroom. He sets about the wholesale destruction of its heteroclyte furnishings – items, surely, from symbolic order that has conspired against him. Like the Bolshevik breaking into the Tzarina's bedroom after the invasion of the Winter Palace in Eisenstein's *October,* he tears up the pillow – the pillow from the same bed that the cow had commandeered earlier on. He pulls out handfuls of feathers and crushes them between his fingers. He picks up and drops a bust of a Roman senator. Ineffectually, he swings an archaic wooden plough about.

24. In his memoirs, Buñuel recalled the hypnotic power of this drumming as 'a secret rhythm in the outside world [which] produces a real physical shiver that defies the rational mind' (Luis Buñuel, op.cit., p.20). He used these drum rolls again on the soundtrack of later films, so that they became a kind of Buñuelian acoustic signature.

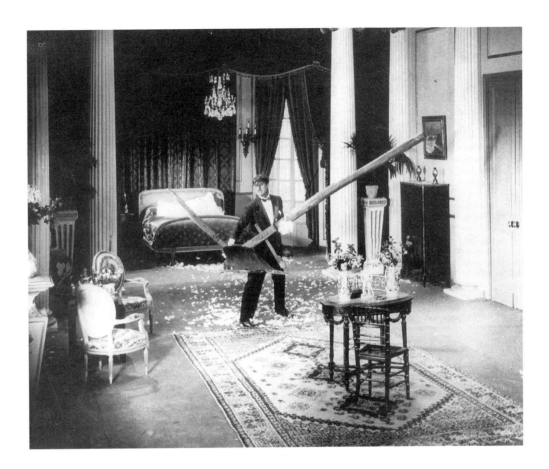

Finally, he throws this and a succession of other phallic forms – a giraffe, a flaming pine tree, a mitred, live archbishop complete with crosier – out of the high window. So many objects standing in for one or another of the causes of our discontents: family, religion, work, even nature itself – here defenestrated in series but together adding up to something not unlike the assemblage of pianos and Marists that held back the hero of *Un Chien Andalou*. Is this going to be any less futile an exorcism? Or is it a truly cathartic rage? We can never tell because Buñuel abandons his hero at this point. His film – via a perfunctory tilt and a graphic match between feathers

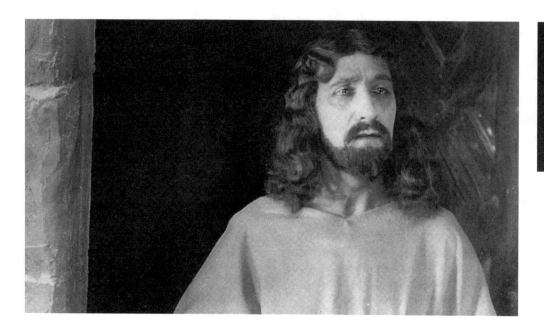

Voici maintenant la sortie
du Château de Selliny
des survivants
des criminelles orgies.
Le premier et principal
des quatre organisateurs
Le Duc de Blangis.

and snow, and the cheeky caption 'At that very moment' – takes off into another unforeseen time and space

We've reached the anticipated 'poison sac' in the sixth and final articulation of this scorpion's tail of a film. It's also a bookend epilogue to match the entomology essay at the start.[25] But, for the finale, we're in pornography mode; not documentary.[26] We're below the snow-wrapped, gothic fortress of the Duc de Blangis, de Sade's monster of libertinage from *Les Cent-Vingt Jours De Sodôme,* of which this scene dramatises the final episode.[27] There is a logic to this apparently arbitrary leap from 'Rome 1930' to a Sade castle in that Modot's final eruption of rage finds its match in the unrestrained aggression of a Sadean libertine. (Hammond suggests that the de Sade episode may also have been Buñuel's way of paying 'a pretty compliment' to his patrons. Not only was Marie-Laure a descendant of the author; she had only the year before acquired the manuscript scroll of *The 120 Days* at auction.)[28] A lengthy, pseudo-moralistic intertitle scrolls up to

25. Paul Sandro (op.cit., p.67) suggests that this epilogue changes the status of the love story, bracketing it around so that we are encouraged to read the whole film as a drama of cosmic proportions— a universal epic struggle between the forces of anarchic desire and the forces of order.

26. Dali's letters, for example, attest to his urge to essay pornography. Hostile critics wanted the film banned, not just as fifth column Bolshevism, but as pornography. Yet we must remember that very little is shown in *L'Age d'Or.* Everything is inferred. And most often it is inferred by something after the event; by the bandaged finger, or by the exposed fly-button. Buñuel uses parallel editing, not to relate different actions simultaneously, but to comment on and inflect our reading of the previous shot.

27. When taxed in an interview that some people thought Sade justified *a priori* crimes against humanity like the Nazi concentration camps, Buñuel replied: 'But these are different things, for goodness sake. Sade only committed his crimes in his imagination, as a way of freeing himself from his murderous impulses. The imagination can permit itself any liberty. But to move on to the act is another matter. The imagination is free; man is not' (in Turrent and de la Colina, op.cit., p.43). Nevertheless, the Sadean epilogue to *'L'Age d'Or* has caused nervousness among some surrealist apologists. *Vide* Ado Kyrou, op.cit., pp.160–161 and J H Matthews, *Surrealism And Film* (University of Michigan Press, 1971, pp.102–105). The surrealists handled de Sade with kid gloves. It was the libertarian as victim of repression, rather than the prophet of unfettered sexual aggression, that Breton venerated. Breton's ideal of desire was hardly Sadean, valorising rather the Platonic myth of the original androgyne and an elective love that restored the original unity between partners in a heterosexual couple. It needed Bataille to remind the surrealists of the uncomfortable truth that in de Sade's philosophy, freedom of desire leads us beyond good and evil and is inseparable from vicious egotism and primordial violence.

28. Paul Hammond, op.cit., p.56.

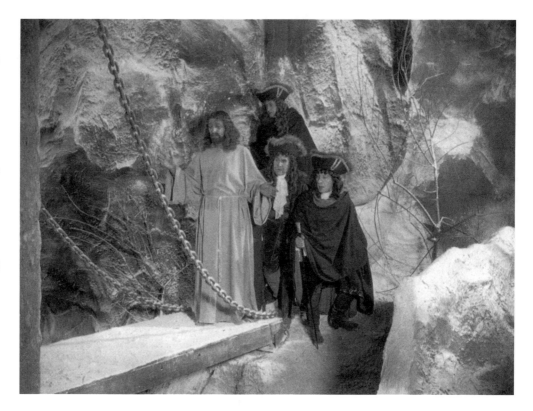

warn us to expect the appearance of the castle's depraved aristocratic residents, debauched by weeks spent inflicting sexual cruelty. But when the castle door opens, it is the bearded figure of Jesus Christ who is the first to emerge. The lechers who follow him out are as exhausted as he, brothers in their decrepitude to the earlier bandits. Their departure is delayed by the unwelcome emergence of one of their hapless girl victims ('suffer the little children!') who has somehow survived their deadly abuse. Christ/Blangis's maintains his inanely angelic expression throughout, whether his face is bearded or, disconcertingly, in the following shot, clean shaven. He goes back into the castle to finish off the bleeding girl. Her dying shriek echoes Lya Lys's earlier cry of passion from the fundamental dirt. The implications of

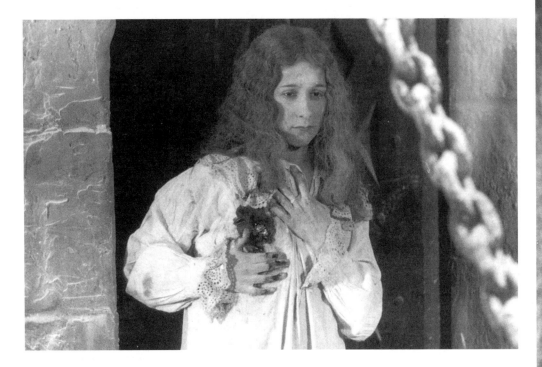

doubling Our Saviour with a serial killer are dizzying. It takes provocation to the limit. But there's yet another twist in store.

In an ultimate pirouette, the castle view dissolves to a snow-covered crucifix in close up. The Calanda drumming gives way to a sprightly *paso doble*, 'Gallito'. From the wooden cross dangle half a dozen apparently female scalps – certainly those of the Duke's/Jesus's victims – swinging in the wind.[29] Is Buñuel suggesting that Christ/Blangis are at one in holding that expiation/orgasm can be achieved only by suffering visited upon the innocent? Would he have us believe that, because repressive self-denial breeds violence, the self-proclaimed religion of love has always really been an infernal machine of female sacrifice? Or are they so many more swatches of women's hair that reprise yet again the primordial and irresolvable Eros/Thanatos dialectic that has ricocheted throughout the film? *Fin*!

29. Buñuel was unhappy with the crucifix shot, rightly thinking that the trailing scraps of hair were not easily recognisable as women's scalps and needed an explanatory caption. In Turrent and de la Colina op.cit, p.41.

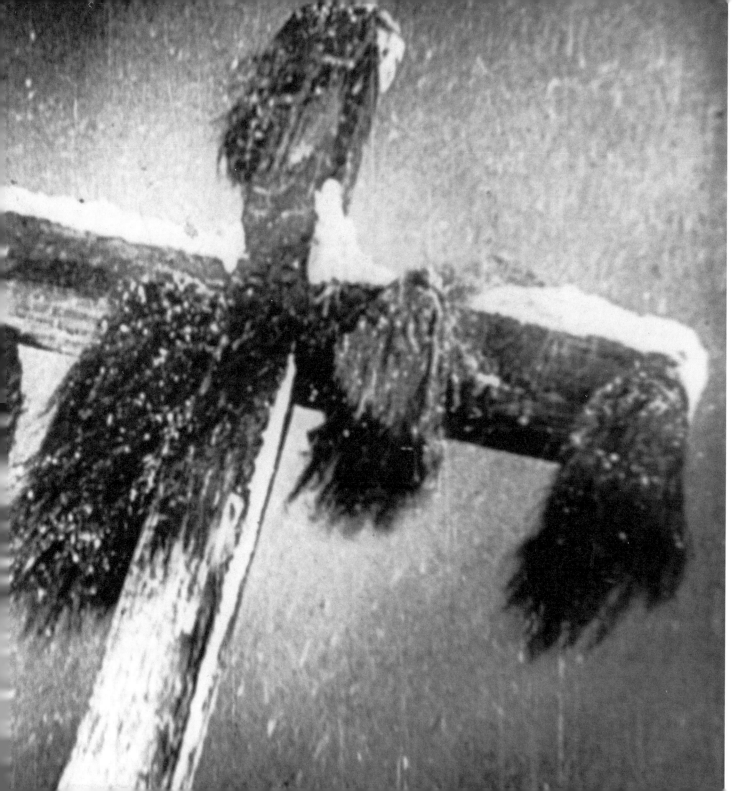

Front cover of the Studio 28
programme for *L'Age d'Or.*

Foyer of Studio 28 after the riot of December 3rd.

30. The film also had its champions, many of them very perceptive. Louis Chavance saw it as an attempt to translate the surrealist technique of collage into cinematographic terms. In the Communist daily *L'Humanité*, Léon Moussinac wrote: 'We experience without difficulty the direct violence of most of the images, images which cannot be paraphrased.' Jean-Paul Dreyfus, another highly respected critic saluted the originality of its subtle, anguished humour, noting that since its title clearly identified it as a surrealist film, it should not be judged as anything else. (For these and other positive responses, see Ian Gibson, op.cit., pp.272–3.) According to *L'Ami Du Peuple*, it should have been titled *L'Age d'Ordure* and its 'métèque' producers thrown out of the country. (Bouhours & Schoeller eds., op.cit., p.176.)

31. Gaetan Sanvoisin, *Le Figaro*, December 11th, 1930.

No résumé of the *L'Age d'Or* experience can resist the lure of interpretation. In the above account of the unfolding of the film, I have tried to avoid pinning it down to a single reading and to emphasise its suggestive ambivalence. Let's now look at the film's reception by divers audiences over the passage of time.

Among the well-heeled entourage of the Noailles, the initial response to the film in the autumn of 1930 was muted and slightly embarrassed, even 'icy'. It excited none of the breathless enthusiasm of its predecessor. But the effectiveness of its bite was speedily confirmed when it reached the public screen – again, at Jean Mauclaire's Studio 28 in Montmartre – at the end of November. Word of mouth in extreme Right circles soon put it about that here was a film by two shameless 'métèques' that brazenly insulted religion, patriotism, the family – in short, all things dear to right-thinking Frenchmen – and this at a time when political argument was settled with walking sticks and fisticuffs on the streets. Militants from the Ligue des Patriotes and the Ligue Anti-Juive broke up the performance on December 3rd. Choosing the moment when the monstrance is removed from a limousine and dumped on the ground, they began shouting: 'We'll show you that there are still Christians in France!' and 'Death to the Jews!' They then threw ink over the screen, let off smoke-bombs to drive out the audience, and trashed an exhibition of surrealist paintings in the foyer. In the following days, *L'Age d'Or* became a *cause célébre*, an 'affaire' in the tradition of the Dreyfus Affair. The entire Paris press rushed to take sides. Dalí and Buñuel became household names. On the right, the newspaper campaign took up the civil disorder as a pretext for banning the film.[30] Powering the outcry against *L'Age d'Or* – and this was after all the same year Eisenstein's *The General Line* was banned – was the claim that it was Communist propaganda. Typical was Gaetan Sanvoisin in *Le Figaro:* 'There's no denying the political intent. This is a very special kind of Bolshevik effort – yes, really special – that is out to rot our moral fibre.'[31] Gaston le Provost de Launay,

municipal councillor for the Champs Elysées district, demanded action from Jean Chiappe, the notoriously partisan Prefect of Police for the Seine. Mauclaire agreed to cut the most offending sequences of the film. But it was banned nevertheless by the Censorship Commission – the same body that had earlier given it a visa – and an order was issued for the seizure of all copies. Noailles, who managed to safeguard the negative, was blackballed from the Jockey Club. There was even talk of his excommunication.[32] The companion film he had commissioned back-to-back with *L'Age d'Or,* Jean Cocteau's *Le Sang d'Un Poète,* had its release delayed several years because of the fracas. Noailles had learned his lesson and, though he continued to behave loyally towards Buñuel, never bankrolled another film.

If the scale of the uproar provoked by *L'Age d'Or* unnerved Dalí,[33] it left Buñuel in a dilemma. Certainly, unlike *Un Chien Andalou,* there was no poetic or dream alibi. The moral panic provoked was gratifying and proof that a surrealist film could deliver revolutionary clout. But while the first film fell under surrealist suspicion because it was so successful; the banning of the second proved that a surrealist film that pulled no punches couldn't be shown to the public. As a filmmaker, where was he to turn next? A twenty-minute version designed for screening at Communist Party meetings was apparently re-cut by Buñuel with Noailles's agreement in 1932. It went under a new title, *In The Icy Waters Of Egoistical Calculation,* a phrase borrowed from *The Communist Manifesto.* But records of its career are scanty. Until 1980 when it was finally authorised for public exhibition, rare and clandestine showings of the complete film in France, London, Madrid and New York were restricted to cine-clubs.

The surrealists played the scandal for all they were worth. Sixteen signatories launched a protest-questionnaire addressed to fellow intellectuals declaring that the abuse of police power was at once a sign of the advancing 'fascisation' of France and a demonstration that Surrealism itself was incompatible with bourgeois society.[34] The establishment's

32. Throughout all this drama, Buñuel had taken himself off to Hollywood, fulfilling what turned out to be an unrewarding contract with MGM. As for Dali, he remained in the thick of things and seriously feared repatriation. The banning of the film also dashed his hopes that good box-office receipts would turn round his financial affairs.

33. See Ian Gibson, op.cit., pp.270–274.

34. 'L'affaire De L'Age d'Or' in José Pierre, ed. *Tracts Surréalistes Et Declarations Collectives: Tome I, (1922–1939),* (Eric Losfeld, 1980) pp.188–193.

reaction nevertheless exposed a persistent ambiguity about surrealist revolutionary effect. When Surrealism's action was deemed harmless, it was shown the patronising tolerance reserved for any artistic avant-garde But when confronted with a work that was truly subversive, the powers that be chose to play down its surrealist origin and instead identify it directly with the threat they really feared: Communism. For all the delicious offence provoked by Buñuel's film – and despite its being championed, once banned, in Communist party newspapers – in the long term it did not help the surrealists achieve their goal of reconciling the roles of artist and revolutionary.

The surrealist line on *L'Age d'Or* has long had it that, besides being 'an indispensable compliment to stock exchange panics', it is also a paean to the power of love. Breton hailed it in *L'Amour Fou* (1937) as 'the only enterprise ever in the exaltation of total love' as he understood it, and went on 'Never will the stupidity, hypocrisy and routine of life be able to prevent a work like this from seeing the light of day or contradict the fact that on the screen a man and a woman inflict the spectacle of an exemplary love on the whole world mobilised against them. Such a love contains within it the embryo of a potential Golden Age that is a complete breakaway from the age of mud which Europe is going through and offers an inexhaustible wealth of future possibilities'.[35] Likewise, for Jacques Brunius, *L'Age d'Or* was 'a moral rather than a poetic film' which 'clearly sets out to attack the whole ethos of our civilisation and our society, and in its place advocates a great and formidable love'.[36] And Ado Kyrou: 'The passage from love to revolt is accomplished without harm to the lovers, for love is itself revolt and kills only its enemies….. There are two camps: the lovers and the others.'[37]

From today's perspective, it is hard to read *L'Age d'Or* in such a utopian light.

Even on the most superficial level, Buñuel's black humour is miserly with hope. His hero is an abject loser. Modot's irascibility looks like childish

35. André Breton, *L'Amour Fou,* (Gallimard, 1937) p.111–112.

36. Jacques Brunius, *En Marge Du Cinéma Français* (Arcanes, 1954), p.141.

37. Ado Kyrou, *Buñuel: An Introduction* (Simon & Schuster, 1953), quoted in Joan Mellen ed., *The World Of Luis Buñuel,* (Oxford University Press, 1978) p.156.

petulance. Like his homologue in *Un Chien Andalou*, he loses his beloved to another man. By the same token, women are shown to be fickle. Men are anxious and get humbled; women get scalped. This is hardly a scenario for the redemption of the world by the Party of Eros.

For all Buñuel's claims as to the straightforwardness of his second film, ironic ambivalence reigns. Take the fetish objects deployed across the film. Divers strands in western culture unexpectedly concur on the meaning of the fetish as the truth's opposite. For Christian missionaries, the fetish belonged with the false gods, blood sacrifice and all the superstitions of dark continents. For Marx, it was bound up with the mystificatory substitution, in bourgeois ideology, of exchange value for use value in the matter of commodities. For Freud, it meant the neurotic investment of libidinal energy, which ought healthily to be directed towards the opposite sex, in some arbitrary replacement like a shoe or a lock of hair; the fetishist preferring his fetish fantasy because he couldn't cope with the anxiety caused by acknowledging the reality of sexual difference. We get locks of hair in *L'Age d'Or,* and if we don't find shoes, we do get a statue's big toe. Lya Lys's seeking solace with the marble toe corresponds closely to Freud's notion of the fetish as a regressive displacement. But what a lock of hair might signify seems to take us in opposite directions. The one depicted on the billboard that seizes Modot's attention fuels his desire for the 'real thing' rather than diverting it. Whereas the hair of the scalps hanging on the crucifix reverses the missionaries' sense of the fetish while exploiting it.

For Paul Hammond, *L'Age d'Or* is less about 'mad love' than 'love which maddens': 'The problematic of desire can be exercised, not exorcised. Desire is impossible, desire is. The theme of the film is frustration. The form of the film mirrors its theme. There's no resolution, only deferral, qualification, blurring. False starts and false endings. Pessimism writ large. A belt in the teeth.'[38] Hammond finds a key to the film in *Tristan And Isolde*, and in particular the meaning ascribed to this tragic romance by Denis de

38. Paul Hammond, op.cit., p.57.

39. Ibid., p.46.

40. Allen Weiss, 'Between The Sign Of The Scorpion And The Sign Of The Cross', in Rudolf E. Kuenzli ed. *Dada And Surrealist Film* (Willis Locker and Owens, 1987), p.165.

41. Georges Bataille, *L'Érotisme* (Union Générale d'Éditions, 1957) p.57, quoted by Paul Sandro, op.cit., p.45.

42. See *My Last Breath*, p.48. If his repressed upbringing had fuelled Buñuel's concupiscence, he took a jaundiced view of the sex act itself: 'For me, fornication has something terrible about it. Coupling, considered objectively, seems ludicrous to me, and even tragic. It resembles dying: eyes blank, spasms, dribbling. And fornication is diabolical; I always see the devil in it.' quoted by Peter William Evans, *The Films Of Luis Buñuel: Subjectivity And Desire* (Clarendon Press, 1995), footnote p.7.

43. Paul Sandro, op.cit., p.45.

44. Paul Sandro (ibid., p.46) paraphrasing Jacques Lacan, 'L'Instance De La Lettre Dans l'Inconscient Ou La Raison Depuis Freud', in *Ecrits*, (Seuil, 1966).

Rougemont in *Love In The Western World* (1956) where Rougemont argues that 'what the lovers love is less each other than the fact of loving. Each loves the other not as they really are but as a mirroring of their personal desire for oneness. Driven by nostalgic narcissism, the lovers' passion can subsist only by placing obstacles in its path. The absolute obstacle, and thus passion's true object, is death itself.'[39] For Allen Weiss: 'the substitute gratifications and continual coitus interruptus which determine the course of the narrative must not be taken simply as the result of societal interference or disapproval; but rather as an integral aspect of the logic of perversion.'[40]

Recent readings like these offer a take on *L'Age d'Or* that is closer to the desublimatory line of the dissident surrealist, Georges Bataille, than to the sublimatory, redemptive vision of Breton. For Bataille, desire and the forbidden are interdependent: there is 'a profound complicity between the law and its violation; transgression does not negate the interdiction, but transcends it and completes it.'[41] This conviction certainly tallies with what Buñuel recalled about his adolescent sexuality, quoted earlier.[42] Like Weiss above, Paul Sandro also sees the films of Buñuel and Dalí through the lens of Bataille. What Sandro says of the protagonists of *Un Chien Andalou* applies equally well to *L'Age d'Or:* 'The man and the woman are alternately repelled and attracted by the tensions built into civilised love….. (They) need the very limits that they are trying to overcome, for it is the condition of the possibility of desire…..It is only during rare moments of ecstacy or rage …that the characters see their way out of the web of perversions that restrain them.'[43] Further on, Sandro presents the same double bind in Lacanian terms. The ones we love and the other things we desire are only metaphors for the lost state of totality in the mirror phase (of our psychic development): 'The self seeks to possess the other absolutely, but it cannot because the other, the object of desire, is a metaphor for the self's own lack-in-being.'[44]

It is only very recently that gender-grounded treatments of the

Buñuel/Dalí films have begun to appear. This is surprising given that Surrealism at large has been the target of extensive criticism by feminist writers since Xavière Gauthier's pioneer *Surréalisme Et Sexualité* in 1971.[45] My approach has by and large toed the surrealist line by taking desire to be gender-neutral, and the 'couple' – in *L'Age d'Or* anyway – to be sharing a 'reciprocal love'. Yet, even if the women in the two films are far from passive, it is the men who initiate the action and go on the rampage. And the eyes behind the camera are male. So it interesting that recent work that has addressed the gender issues has focused less on masculine domination in the films than on masculine anxiety. Thus for Peter William Evans, Buñuel's males are 'simultaneously the victims and aggressors of desire, blinded not only by their own gestures of self-mortification, but also by a failure to interrogate the causes and motivations of their repetitive and ultimately self-destructive passions.'[46] Phil Powrie has argued that the instability of the Batcheff character in *Un Chien Andalou* is 'not so much a figuration of desire..... (as) a symptom of masculinity in crisis. Relating the two films to the crisis that the surrealist group itself was going through at the time, Powrie reads them as expressions of male masochism rather than of a radical aesthetic! '[47]

All this said and done, claims that the surrealists 'only incompletely understood (*L'Age d'Or*)'[48] seem to reflect the resignation of our own dispirited present for which the received wisdom is that history has come to an end and 'there is no alternative'. They risk anachronism when applied to the meanings of the film as they were perceived in the intensely conflicted, not to say totalitarian, 'age of ideology' that was the inter-wars. For all the rhetoric of their tracts and declarations, the surrealists were not dupes of ideology. They knew that they were doomed to remain 'revolutionaries without a revolution' in a period when power in French politics belonged securely to the Right. They were no strangers to 'revolutionary defeatism'. If the Age of Gold was ultimately a will o' the wisp, that was no reason for

45. Xavière Gauthier, *Surréalisme Et Sexualité* (Gallimard, 1971).

46. Peter William Evans, *The Films Of Luis Buñuel: Subjectivity And Desire* op.cit., p.97.

47. Phil Powrie, 'Masculinity In The Shadow Of The Slashed Eye: Surrealist Film Criticism At The Crossroads', in *Screen*, Volume 39, no.2, Summer 1998, pp.153–163. Alan Rees concurs: 'They encode post-Freudianism in ways which cannot be reduced to a triumphalist or uncritical masculinity. Images that evoke castration and loss are central to all the surrealists' classic films which resist any notion of (male) narrative pleasure.' (op.cit., pp.44–45).Their rueful take on male sexuality, coupled with their distancing and self-reflexive features, spare them from the charge of objectifying women that Laura Mulvey and other feminist critics have made so forcefully against mainstream cinema. (See Laura Mulvey, 'Visual Pleasure And Narrative Cinema', *Screen*, Vol.16, no.3, Autumn 1975, pp.6–18.)

48. Paul Hammond, op.cit., p.42.

submission before prevailing iniquities. *L'Age d'Or* is itself deliberately elusive, striking a precarious balance between different registers. It is not Socialist Realist propaganda for uncomplicated love in a Communist paradise. If *L'Age d'Or* is 'in the service of the revolution', it is a revolution that had to give as much space to de Sade – the great negator, and scourge of the Enlightenment's good conscience – as to Lenin.

Now that we have looked closely at both *Un Chien Andalou* and *L'Age d'Or*, at the filmic strategies in play and at the variety of readings the films have prompted, we are in a better position to address a final aspect of Sanchez Vidal's 'endless enigma' – the vexed question of the films' contested authorship. What were the contributions respectively of Buñuel and of Dalí? In the end, whose films are these, Buñuel's or Dalí's?

For decades, the authoritative literature gave the principal credit to Buñuel. Francisco Aranda in his pioneering critical biography of Buñuel (1969) contradicts those who have sought to attribute either film to Dalí, saying: 'When *Un Chien Andalou* is compared with the later and separate works of Buñuel and Dalí, we see that not only the cinematographic quality but also the positive values of the film are those of Buñuel.'[49] For Ado Kyrou, author of *Le Surréalisme Et Le Cinéma,* writing within the Breton camp: 'Everything that seems to us today to facile, superficially surrealist, everything that resembles the dream sequence that Dalí did later for Hitchcock's ultra-commercial film *Spellbound,* everything which is simply symbolist (Batcheff's dispute with his double; schoolbooks changing into revolvers etc.), everything that comes out of Hermès shop window displays – is certainly down to Dalí, who, being already a very talented painter, already also displayed an inclination towards the lucrative business of the showroom and psychoanalysis for old American ladies.' [50]

What accounts for the stubborn tendency to prioritise the role of Buñuel at the expense of Dalí in their creative partnership?

One reason must be that Buñuel would go on to become a prolific and

49. Francisco Aranda, op.cit., p.60.

50. Ado Kyrou, op.cit., p.17. Buñuel, for his part, was more generous, stating that *Un Chien Andalou* was 50% Dalí, 50% himself.

celebrated filmmaker – even if, after *Las Hurdes* (1932), there was a fifteen-year long intermission – in a career that extended into the 1970s. Although Dalí continued to work on his scenario *Babaouo* for some years after his definitive quarrel with Buñuel, he never found another collaborator to direct it. It was, of course, as a painter that Dalí was to affirm himself. Given the way the arts and the media get compartmentalised, it was perhaps inevitable that their two films found themselves assimilated into Buñuel's oeuvre rather than Dalí's.

Another reason why Buñuel rather than Dalí gets the credit is film studies' predilection for valuing the work of the director, the man behind the camera, higher than that of the writer of the scenario, however obediently that script may appear to have been rendered into images by the filmmaker. For forty years or so, especially since the French new wave's vigorously pursued 'politique des auteurs', there has been a predisposition – not least regarding the institution of 'art cinema' – to favour the director as the real 'auteur' over anyone else involved. And, by and large, French avant-garde cinema in the silent era was already an 'auteur' cinema. Buñuel certainly thought of it that way – whether self-servingly or not. In his 1929 essay on 'découpage' – a tricky French word meaning roughly the translation of script into film – he prioritised découpage as the crucial operation (that of the hands-on filmmaker) in which: 'the script or group of written visual ideas abandons literature and becomes cinema'.[51]

The politics of Surrealism have also played their part in exaggerating Buñuel's entitlement to the two films over Dalí's. Despite Buñuel's break with the group in 1932, he remained persona grata with Breton and there was little resentment on either side. Buñuel sided with Aragon and the surrealist political hardliners in the schism within the group provoked by Aragon's propaganda poem 'Front rouge'. Even as he broke away, Buñuel wrote regretfully to Breton confessing his belief that his 'potential would be much more advantageously employed with

51. Quoted by Paul Ilie ed., *Documents Of The Spanish Vanguard*, Studies In Romance Languages And Literatures 78 (University of North Carolina Press, 1969), p.449.

52. Letter from Buñuel to Breton of 1932, quoted by Marguérite Bonnet ed., *André Breton, Oeuvres Complètes* (Gallimard, Bibliothèque de la Pléiade, 1988) volume 2, p.1302. In an autobiographical sketch he wrote for the Museum of Modern Art, New York, in the early forties, however, Buñuel recalled that he had no longer felt at ease with 'that kind of intellectual aristocracy, with its moral and artistic extremisms that cut us off from the world …. The surrealists considered the majority of humankind to be stupid and despicable'. (Quoted by Maurice Drouzy, *Luis Buñuel: Architecte De Rêve* [Lherminier, 1978], p.84.) The full text of these recollections was published in French by *Positif*, Nos. 146 & 147 in January and February 1973.

Surrealism'.[52] Until the end of his life, Buñuel repeatedly acknowledged his debt to the movement and proclaimed his continuing loyalty to its moral principles. Salvador Dalí, on the other hand, became Surrealism's most notorious renegade, loathed and despised all the more because of his persistent claims to be the 'only true' surrealist. His excommunication from the group was a long and bitter process. Eluard stuck up for him. Breton was reluctant to lose an adherent with such effervescent gifts. But from 1936, Dalí had become a supporter of Franco's fallangists in the Spanish Civil War against the Popular Front republican government, championed by the surrealists. He returned to Holy Mother Church and declared himself a royalist. Driven by Gala, his ambitious and mercenary partner, Dalí became a flamboyant showman – perhaps the prototypical 'artist-as-media-personality' – and earned himself Breton's anagrammatical putdown: 'Avida dollars'.

Of course, in many respects, it is otiose even to begin the attempt to disentangle what Dalí and Buñuel brought to what was, while it lasted, a very intimate collaboration. Nor is it in the proper spirit of Surrealism to try to allocate individual credit because, right from the start, the surrealists debunked the romantic notions of 'genius' and the gift of privileged inspiration. This was partly what their cult of automatism was about. In their early collaboration on automatic writing, *Les Champs Magnétiques* (1919), Breton and Philippe Soupault took great pains to disguise their respective inputs. Rather than a creation that redounded to the credit of its maker, an artwork was seen by the surrealists as an involuntary product of the unconscious, at most a trace left behind in the course of a free, surrealist life, the surviving evidence of an existential adventure. Hadn't their nineteenth-century adopted mentor, Isidore Ducasse, the self-styled Comte de Lautréamont, proclaimed not only that 'poetry should be made by all' but that the lifeblood of art was plagiarism, the pirating and re-use of the ideas

of others?

An extra handicap in the game of attribution is the unreliability and contradictoriness of the accounts given by the two protagonists themselves over the years. Dalí's memoirs are self-evidently fantastical myth-mongering. His repeated claim that he had already written the scenario of *Un Chien Andalou* prior to getting together with Buñuel at Cadaques that famous week in January 1929 has never been substantiated. No trace of such a scenario has ever been found. Buñuel's memory too could be self-serving – Sanchez Vidal has caught him out antedating some of his mid-twenties writings, for instance. Yet in Buñuel's account, the kind of semi-automatic 'brainstorming' he says went on between him and Dalí in the invention of the film's 'gags' – the *trouvailles* of the one provoking the imagination or calling up the dream memories of the other – was already very much the creative method he was to employ later when working with his 1960s and 1970s co-scenarist, Jean-Claude Carrière.

In the case of *L'Age d'Or,* Dalí himself was as responsible as anyone else if the part he played was disregarded. In his later anxiety to rebut any charge that he might once have been complicit with a Surrealism that had leftist, revolutionary goals – and prudently guarding his back in an America where McCarthyist witch-hunts were imminent – he went out of his way to disassociate himself from the film, declaring in his 1942 memoirs*:* 'Buñuel had just finished *L'Age d'Or.* I was terribly disappointed, for it was but a caricature of my ideas. The 'Catholic' side of it had become crudely anti-clerical, and without the biological poetry that I had desired.'[53] Blaming the influence of Buñuel's 'Marxist friends', Dalí elaborated the same complaints thirty years later: 'Buñuel had betrayed me by selecting to express himself in images that reduced the Himalaya of my ideas to little folded paper dolls. *L'Age d'Or* had become an anti-clerical, irreligious picture. Buñuel had taken over the most primitive meanings of my way-out ideas, transforming them into associations of stuttering images without any of the violent poesy that

53. Salvador Dali, *The Secret Life Of Salvador Dali* (Dial Press, 1942) p.282.

is the salt of my genius. All that came to the surface here and there out of my butchered scenario were a few sequences he had been unable not to bring off since my stage directions had been so detailed.' [54]

54. Salvador Dali, *The Unspeakable Confessions Of Salvador Dali* (William Morrow, 1976) p.108.

The letters Dalí wrote to Buñuel shortly after the completion of *L'Age d'Or* tell rather a very different story, however. In May 1934, incensed that his name was being omitted from the credits of both the films (at clandestine showings of the later banned film and at re-runs of the earlier one) he wrote to Buñuel: 'I hope you will help my lawsuit if need be, you know better than anyone that neither *Le Chien Andalou* nor *L'Age d'Or* which was its continuation would ever have existed without me. This incomprehensible removal of my involvement is disgraceful. I will take things to their final conclusion.... Basically, you want unconsciously to diminish my participation in the two films and you are trying consciously to justify this with all sorts of childish and ridiculous excuses. Your confusion and the use of "author" in an exclusive sense rather than "author-director", since I also am the "author" – you should check the meaning of that word, which you use in such a strange way – is symptomatic.' [55]

55. Salvador Dali, undated letter, probably of May 1934, quoted in Agustin Sanchez Vidal, 'The Andalusian Beasts', in Ian Gibson et al. eds, *Salvador Dali: The Early Years* (South Bank Centre, 1994) p. 203.

Our account in the preceding chapter of the background to *Un Chien Andalou* showed how close the two men had been in the late 1920s. According to Haim Finkelstein, 'They thought so much alike in many respects that it would be quite impossible at times to establish precedence.'[56] The evidence for this can be found not only at the level of obsessive images, and surrealist 'gags', but also at the level of formal strategies. I've argued that the structuring frameworks that shape the Buñuel/Dalí films are more important than specific motifs in distinguishing them from the films of the rest of the avant-garde and in accounting for their specificity as the first truly surrealist movies. It is significant that we find formal and narrative precedents for these filmic strategies for disrupting the referential frame in the writings of both men, that is in the poetry and prose of both Dalí and Buñuel in the year prior to the making of *Un Chien*

56. Haim Finkelstein, 'Dali And *Un Chien Andalou*: The Nature Of A Collaboration', in Rudolf Kuenzli ed., *Dada And Surrealist Film* (Willis Locker & Owens, 1987), pp.128–141.

Andalou. In Dalínian texts such as 'Two Prose Pieces', 'Christmas In Brussels: An Antique Tale' and 'My Girlfriend And The Beach' and in Buñuel's 'The Comfortable Watchword Of Saint Huesca' – all from late 1928 – we find the same initial recourse to some conventional form and its subsequent undermining via the introduction of all manner of incongruities. And these subversions are done in a deadpan manner that is similar in the writing of both men – with the absurdities and horrors they evoke, treated with the same matter-of-fact, and cruel, serenity. [57]

The same cross-referencing between the two men can be found at the level of specific figures, further problematising the issue of attribution. Buñuel, for example, claimed as his idea the notorious eyeball-slicing scene that opens *Un Chien Andalou*. If we look for corroborating evidence from his earlier writings, we do indeed find this passage in his poem 'Palace Of Ice': 'When Napoleon's soldiers entered Saragoza, VILE SARAGOZA, all they found was the wind in the deserted streets. Only in one puddle did they come across the croaking eyes of Luis Buñuel. Napoleon's soldiers finished them off with their bayonets'. But then again in Dalí's récit, 'My Girlfriend And The Beach', we read: 'My girlfriend likes the sleepy delicacies of lavatories, and the softness of an extremely fine scalpel cuts on the curved pupil which is dilated for the extraction of a cataract'. And both equally could have been inspired by lines from 'The Aromas Of Love' by Benjamin Péret, whose poetry they idolised: 'What greater pleasure / than to make love / the body wrapped in cries / the eyes shut by razors'.[58]

The evidence of the poetry and critical writings of Buñuel and Dalí demonstrates that they shared in these years a mental space furnished with very similar décor along with similar ideas about both the workings of the psychic mechanism and the surrealist potential of cinema. This equivalence makes the pursuit of exclusive attribution of this or that feature to one or the other of the two authors something of a will o'the wisp. In the absence of the original filmscripts, it often comes down to hunch. That said, there remains

57. Examples of these affinities are examined exhaustively in Haim Finkelstein, *Salvador Dalí's Art And Writing, 1927–1942: The Metamorphosis Of Narcissus* (Cambridge University Press, 1996), chapter 6.

58. Benjamin Péret, in *Le Grand Jeu* (Gallimard, 1928), quoted by Agustin Sanchez Vidal, 'The Andalusian Beasts', op.cit., p.194.

59. As for the filmscripts Buñuel was toying with prior to *Un Chien Andalou*, they were hardly prophetic of the radical originality of what he was to produce with Dalí.

60. Haim Finkelstein, op.cit., p.115.

61. Ado Kyrou, op.cit., p.21.

62. Luis Buñuel, op.cit., p.116.

63. Jean-Michel Bouhours and Natalie Schoeller eds., *L'Age d'Or Correspondance Luis Buñuel – Charles De Noailles; Lettres Et Documents (1929–1976)*, Hors-Série/Archives, Cahiers Du Musée National d'Art Moderne (Centre Georges Pompidou, 1993). Dalí's letters were first published in Agustin Sanches Vidal, op.cit., pp.237–244. Ian Gibson quotes a selection in English in *The Shameful Life… op.cit.*, pp. 245–249. Buñuel's half of this correspondence is unknown.

64. See particularly Bouhours and Schoeller eds., op.cit., pp.49–55.

65. This is convincingly demonstrated by Petr Krals in his article, '*L'Age d'Or* Aujourd'hui', *Positif* no.247, October 1981, pp.44–50. See also Paul Hammond, op.cit., passim.

the compelling evidence of Dalí's art. And there is nothing to compare with this on Buñuel's side since he was not a painter.[59] The pictorial evidence for Dalí's pervasive input into *Un Chien Andalou* is unarguable. Stemming directly from his most recent paintings such as *The Lugubrious Game*, 'it is in the scatalogical and masturbatory dimension of the film that Dalí's presence is most meaningfully felt', notes Haim Finkelstein.[60] The spirit of such paintings and the film are in perfect accord.

The most significant revision of the received view of the Dalí/Buñuel partnership concerns their second film. At the very least, recent studies refute the summary verdict of Ado Kyrou to the effect that: '*L'Age d'Or* is a film by Buñuel without Dalí, and if the name of the latter is still there among the credits, this is purely thanks to the generosity of Buñuel who kept just one of Dalí's gags: the gent who walks along with a large stone on his head.'[61] In *My Last Breath*, Buñuel recalls: 'Dalí sent me several ideas, and one of them at least found its way into the film: A man with a rock on his head is walking in a public garden. He passes a statue. The statue also has a rock on its head!'[62] Thanks principally to research by Spanish scholars such as Agustin Sanchez Vidal in his 1988 book, *Buñuel, Lorca, Dalí: El Enigma Sin Fin* and the publication of the correspondence between Buñuel, Dalí and Noailles, a more balanced estimate is now possible.[63] From his retreat at Carry-le-Rouet, Dalí wrote several times to Buñuel between January and the start of shooting in March. From added notes and ideas in pencil on the script of Buñuel's working copy – which has survived – it can be seen that Buñuel adopted a number of the ideas that Dalí posted to him.[64] These letters also show that Dalí was fully apprised of the project down to many of the fine details, and was obsessively concerned by the climactic love scene. The protruding fly-button on Modot's trousers is a literal rendering of a gag proposed in one of Dalí's letters, as is Modot's bloodied face. Likewise, it is now more generously acknowledged just how much the pictorial imagery of Dalí suffused the later film.[65] The fetishisation of thumbs and toes, for

instance, had a history in Dalí's pictures going back to *Bather* (1928) and *The Wounded Bird* (1926). Given Dalí's numerous treatments of the William Tell theme, it can be assumed that the sequence where the gamekeeper shoots his son bears his hallmark. The documentary opening featuring the scorpions met Dalí's demand for 'real facts'. [66] The onanistic ritual in the bandits' shack where Péman's rope is tugged through the tines of a pitchfork animates a protoypical 'symbolically functioning object', whose wholesale fabrication by the surrealists Dalí was soon to champion.

This said, perhaps just as significant as Dalí's suggestions were Buñuel's mixed responses to them in the finished film. If it is only belated justice to Dalí to accord him greater credit for *L'Age d'Or* than was for so long allowed, it also has to be said that Buñuel rejected most of his proposals, and this despite Dalí's urgent insistence. Out went most of Dalí's primary scatological gags: 'we must hear someone pissing'; 'a personage touches a corpse and on the table fingers sink into putty'; 'a woman gets up from her chair with a bloodied bottom'... Dalí sent a drawing of the man kissing the tips of the woman's fingers and ripping out her nails with his teeth ('afterwards everything will continue as normal'). In his judgement 'this element of horror' would be 'much stronger than the severed eye [in *Un Chien Andalou*].' As we've seen, Buñuel replaced the ripping out of nails with an amputee's hand, missing fingers compensated by phallic thumb. Buñuel likewise rejected Dalí's idea of representing a cunt for the first time on the screen. In parallel with the paranoiac double images he was experimenting with in such paintings as *Invisible Sleeper, Horse, Lion* and *The Invisible Man*, Dalí proposed (complete with illustrative drawing) superimposing the image of a mouth shot vertically onto a woman's cleavage with a feather boa round it. Fearful of the censor, but also arguably with greater subtlety, Buñuel achieved a similar effect by filming the folds of Lys's dress quivering between her parted thighs.

Assessing the overall impact of *L'Age d'Or*, it is understandable that

66. Haim Finkelstein, op.cit p.115.

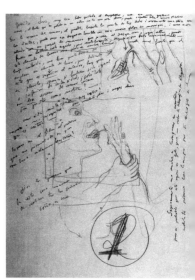

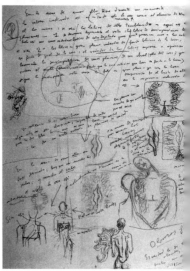

Illustrated letters from Dalí to Buñuel.

67. Paul Hammond, op.cit., p. 42.

68. 'Even Buñuel's "most anarchic texts have a firm foundation of eroticism, religion and violence" and "his intransigence requires a greater communicability'. Qv. Haim Finkelstein, op.cit.", p.88.

69. '(Un Chien Andalou) revealed to him the rich vein of possibilities inherent in the depiction of human characters as vehicles of meaning through the combination of human action and symbolic representation. The discourse of the film, partaking in particular of chains of metaphoric associations, based at times, on formal similarities, pointed to an analogous 'virtual' movement between the constituent elements of painting.' Haim Finkelstein, ibid., p.95.

70. In late 1929, with Breton's encouragement, he wrote the scenario of a five-minute documentary designed to explain Surrealism to a general audience. The surrealists' recourse to the subconscious was to be represented by their descent into the metro, accompanied by automata and a half-naked woman, raising their umbrellas as they went underground. It was never made (Robert Radford, Dalí, [Phaidon, 1997] p.102 and Ian Gibson [op.cit.] p.243. Another film project that Dalí had entertained about this time was a documentary about Cadaques that would record everything from the toenails of the fishermen to the rocks of Cape Creus (Salvador Dali, Oui, 1, op.cit., p.145). It seems certain that these two films were part of and hastened two major shifts in the orientation of surrealist creativity discernible at the end of the twenties. One such shift saw the practitioners of the visual image taking over from the poets as the front-runners of Surrealism. The other saw the growing internationalising of the movement and the partial eclipse of its French adherents by foreigners.

it presaged the parting of the ways for Dalí and Buñuel. Without backing unreservedly Paul Hammond's hunch that the social gags in *L'Age d'Or* are Buñuel's and the sexual ones Dalí's,[67] it is very likely that the polemical thrust of the second film is so much stronger than the first because it is much more Buñuel's. It has been suggested that the tone of Buñuel's writings in the late twenties was consistently more violent and aggressive than Dalí's and more clearly focused on religion and anti-religious symbolism, features that gave Buñuel's writing its sense of direction and drive, while Dalí's writing was less focused and more lightly amusing.[68] And this matched the orientation in the early thirties of Surrealism itself – now 'au service de la révolution' – a direction which Buñuel espoused much more whole-heartedly than Dalí.

As for Dalí, his involvement in filmmaking caused a decisive shift in his painting, opening up new pictorial vistas for him, not least in the area of double images and 'critical paranoia'. Among other innovations, it led him to introduce fully-fledged human presences into the psycho-spaces of his pictures, replacing or augmenting the mutilated, fetishistic fragments of before.[69] Perhaps the filmic requirement to place psychic visual material in some kind of perspectival space also contributed – along with the influence of the oneiric landscapes of De Chirico and Ernst – to the development of the exaggerated, photographic perspectives of Dalí's subsequent paintings. An assemblage such as the donkey/pianos looks forward to his symbolically functioning objects. Finkelstein argues that Dalí had no need to make any more films since what he had learned from the experience of co-authoring the films had rescued him from the creative impasse that his painting had fallen into during the winter of 1928/1929. That Dalí did not make the effort to participate in the shooting of *L'Age d'Or* suggests that he had lost much of his earlier enthusiasm for film. He tacitly admitted that Buñuel was the film's principal 'auteur' and thereafter made his own pitch among the surrealists as a painter and man of ideas.[70]

CODA

Buñuel's and Dalí's falling out over *L'Age d'Or* signalled the end of their film partnership. It also brought to an end the very brief 'golden age' of surrealist cinema.

Unchallengeably, it was Luis Buñuel – as Georges Sadoul affirmed – who carried the torch for surrealist cinema with the greatest efficacy and éclat in a long and prolific career – despite interruptions caused by wars and exile – that gained fresh momentum right up to his last film, *Cet Obscur Objet Du Désir*, in 1977. Despite formally breaking with the group in 1932, he repeatedly acknowledged its formative impact and proclaimed his lifelong fidelity to its ethical stance – the latter always being the key consideration for 'orthodox'surrealists.[71] Two years after *L'Age d'Or*, he made *Las Hurdes*, a harrowing, twenty-seven minute documentary about the inhabitants of a dispossessed region of rural Spain[72]. *Las Hurdes* is often seen as the third volet of his surrealist triptych. Fellow former surrealist Pierre Unik co-wrote the script. Eli Lotar, whose documentary photographs figured in Georges Bataille's review *Documents*, was the cinematographer. *Las Hurdes* (*Land Without Bread*) earned the peculiar distinction of being banned successively by both the Republican government and by Franco's Fallangists, on account of its unforgiving exposure of the effects of social injustice in Spain. Its Surrealism lies in the incongruity between the imagery and the soundtrack, both the ironic voice-over and the background music. The commentary is freezingly detached – its authoritative, scientific tone confounded by its obvious powerlessness in the face of the conditions that confront it. Correspondingly, Brahms's *Fourth Symphony* is absurdly and intolerably grandiose in the context of visuals focusing on extremes of poverty and disease. *Las Hurdes* damningly unmasks the complacency and bad faith of mainstream, colonialist, ethnographic filmmaking of the time. Nor was there anything paradoxical about the notion of a surrealist documentary. The

71. In the sixties, the decade of Breton's death and the formal dissolution of the Paris movement, Buñuel was still declaring himself an unrepentant surrealist revolutionary. Swapping 'filmmaker' for 'novelist', he took for himself the words of Friedrich Engels: 'The (filmmaker) has done his job honourably when, in the course of faithfully depicting authentic social relations, he destroys the conventional picture of these relations, shatters the optimism of the bourgeois world, and obliges the reader to doubt the perennial nature of the existing order, even if he does not propound any conclusion, even if he does not directly take sides'. (Ado Kyrou, *Luis Buñuel*, (Editions Seghers, 1962) p.98.

72. Although some may consider the recently-discovered, 2-minute *Eating Sea Urchins* (1930) to be his next "film" chronologically.

Opposite: *Las Hurdes*

scorpions sequence in *L'Age d'Or* was a forerunner. As Romane Fotiade has commented, documentary could be made to serve the surrealists' aim to explode realist boundaries from within, by infiltrating an accurate account of events with a sense of the arbitrary, the inexplicable, the absurd: 'The pitiless immobility of the camera in front of horrifying images achieves 'the shock to the eye' theorised by surrealist writings on film, while pushing the ciné-vérité or documentary genre far beyond conventional limits.'[73] In this sense, *Las Hurdes* did for the documentary genre what *Un Chien Andalou* had done for melodrama.

The May 1933 number of *Le Surréalisme Au Service De La Révolution* included a curious text by Buñuel entitled 'Une Girafe'. It describes an elaborate surrealist object in the form of the silhouette in wood of a life-size giraffe. Each of the twenty painted spots on the animal's hide was attached by a wooden hinge which, when lifted by the spectator, revealed a surrealist scene or object.[74] Buñuel recalls that the enormous giraffe was actually made and installed in the foyer of the Noailles' mansion. Visitors had to climb a stepladder to discover what lay beneath the higher spots. Many of these 'spots' proved to have in them the germs of later films or at least of one or another of their defining gags. Like *L'Age d'Or* itself, the 'Giraffe' proved to be a kind of 'attic trunk' of material for a whole oeuvre eventually to follow.

If *Un Chien Andalou* and *L'Age d'Or* still stand as privileged object lessons in what surrealist cinema can be, that spirit persists in almost all Buñuel's films after *Los Olvidados*, which was made in Mexico, won the Grand Prix at Cannes in 1950, and, for Europeans at least, signalled the maestro's return from oblivion. The two intervening decades, if better described as marking time than as oblivion, had been difficult ones for Buñuel and his family. At the end of the Spanish Civil War, he had taken refuge in the USA, earning a living as best he could as archivist, film editor and scriptwriter in New York. Between 1945 and 1955, like many Spanish

73. Ramona Fotiade 1998 'The Slit Eye, The Scorpion And The Sign Of The Cross: Surrealist Film Theory And Practice Revisited' in *Screen*, Vol.39, no.2, Summer 1998, pp.123.

74. Luis Buñuel, 'Une Girafe', *Le Surréalisme Au Service De La Révolution*, Nos. 5–6, May 1933, pp.34–36. Aranda includes the text in translation op.cit., pp.262–264. Paul Hammond is sceptical about the actual construction of Buñuel's concept: 'Introduction to *Luis Buñuel: Una Jirafa* (Libros Portico, Zaragoza, 1997).

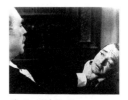

The Beast With Five Fingers

Among Buñuel's unrealized film projects during his time in the USA were *The Sewer Of Los Angeles* with Man Ray in 1944, and the horror film *The Beast With Five Fingers*, eventually directed by Robert Florey in 1945. Legend persists that Buñuel did direct the special effects sequences of a crawling severed hand in the latter film, a rumour doubtless stemming from the severed hand motif in *Un Chien Andalou*.

The Criminal Life Of Archiboldo De La Cruz

Los Olvidados

Cet Obscur Objet Du Désir

75. But if this style is pared down, the 'patte' of its author is nevertheless instantly recognisable. According to Michael Wood: 'Buñuel's camera is not a prowler or a neutral observer, it behaves like someone who has been tipped off. It is like a spy with good informants; a spy in a hurry. It waits for the action, shows us what there is, and moves on.' (Michael Wood, Belle De Jour, [BFI, 2000] pp.8–16).

intellectuals who refused to bow to Franco, he settled in Mexico and took Mexican citizenship. Box office constraints imposed serious concessions in the fifteen or so films that he made during that decade. They have been rarely shown in Europe. With the notable exceptions of *Los Olvidados* (1950), *El* (1952) and *The Criminal Life Of Archiboldo De La Cruz* (1955), Surrealism simmered only intermittently in these commercial potboilers. Set among juvenile delinquents in the slums of Mexico City, *Los Olvidados* was identified as 'neo-realist' by European critics. Buñuel vehemently rejected the label, insisting that no true realism could ever omit the hallucinatory, unconscious dimension of experience. The latter is present in spades in *Los Olvidados*, even if Pedro's harrowing nightmare sequence is conventionally cued as a dream within a socially realistic context.

After 1955, while continuing to live – and for some years also, to film, in Mexico – Buñuel returned more and more regularly to Europe to make his movies. From *Viridiana* (1961) to *Cet Obscur Objet Du Désir* (1977), Buñuel's ten last movies were commercial films which were exhibited worldwide under the banner of 'European art cinema'. On the back of the formal breakthrough achieved by the French 'nouvelle vague', and the relaxation of censorship, particularly in Anglo-Saxon countries, Buñuel was now able to take creative liberties that had previously been the exclusive province of marginal, experimental cinema. With substantial budgets at his disposal, he could cast Europe's best-known actors, employ the finest cinematographers, and generally enhance his films' production values. A refined, unassertive camera style now smoothed away the earlier ragged, avant-garde edges. Eschewing both the beautiful and the distractingly non-conformist, Buñuel aimed at austerity in the visuals and the soundtrack – an invisible, economical, even 'impatient' style.[75] If the surface texture of the later Eastmancolour films is deceptively conventional, the latent content, and the shaping structure, remain unsettlingly surrealist. The comedy of *Le Fantôme De La Liberté* (1974), for example, is predicated on the relativity of

all values. But it has to be admitted that such films were so popular because much of the sting of Buñuel's original strategies had been removed by the 1960s. The 'theatre of the absurd', had accustomed audiences to simple figures of reversal such as those employed in *Le Fantôme....*: tourist-site-views-read-guiltily-as-'dirty postcards'; monks gambling at cards; eating-in-private-while-shitting-in-public.... These gags had already been superseded in terms of viciousness and shock in the cinema of Buñuelian 'disciples' such as Alejandro Jodorowsky (*Fando And Lis*, *El Topo*) and Fernando Arrabal (*Vive La Muerte!*).

For all that the knowingness of the times diluted the surrealist venom, Buñuel remained true both to its moral impetus and to its faith in unconscious inspiration. His cinematic Surrealism persists in the dream imagery, the psychic processes, the centrality of sexual desire, the black humour, and the ways in which all four wreak havoc with conventional story telling. Buñuel's astringency as a director still derives from erecting the structures of apparent verisimilitude before letting loose the irrational to destroy them.[76] From *Belle De Jour* (1967) onwards, his films deliberately confuse the signals that normally permit the spectator to distinguish between dream, daydream and waking life; between the diegesis and all manner of parentheses, such as stories within stories. It was the possibility of introducing two levels of reality into his adaption of *Belle De Jour*, Joseph Kessel's original 1920s novel, in which there is only one, that led Buñuel to accept the invitation to film it from the producers, Robert and Raymond Hakim, in the first place.

Alone among the surrealists, Buñuel succeeded in elaborating and refining the specific means of cinema without betraying the unconscious impulse. In an interview at the time of the opening of *Le Charme Discret De La Bourgeoisie* (1972), he explained: 'An image strikes me, I keep it; I don't analyse it, I don't ask why it has made such an impression on me, or if its springs from an association of ideas, or from an emotion, or a dream, or a

Le Fantôme De La Liberté.

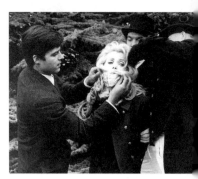

Belle De Jour

76. In retrospect, it looks as if it was Buñuel's good fortune to have joined Surrealism after the so-called 'heroic' period was over – that is after the early and middle 1920s in which 'pure psychic automatism', solipsism and a primary subjectivism associated with Artaud, held sway. The dialectical turning that Surrealism took at the end of the twenties suited Buñuel better. The power of his cinema derives from the generosity of his tribute to reality.

77. Quoted by Yves Baby '*Le Charme Discret De La Bourgeoisie*' in *Le Monde*, 14 September 1972.

The key Buñuelian motif of physical mutilation and deformity, linked to Sadean cruelty, which began with the eye-slitting and hand-severing of *Un Chien Andalou*, and the fingerless hand and assaulted blind man of *L'Age d'Or*, continued throughout his later films. In *Los Olvidados*, a legless man is viciously hurled from his cart and a blind paedophile stoned by a mob.

Los Olvidados

In *Tristana*, the stump of a woman's amputated leg becomes the focus of a fetishistic 'amour fou'.

Tristana

Dwarfs and cripples figure in *Viridiana*, *Nazarin* (1959), and *Simon Of The Desert*, while *The Exterminating Angel* (1962) features the severed hand again (as well as the familiar placement of farm animals in a domestic setting).

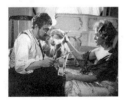

The Exterminating Angel

memory. We surrealists let images overrun us like this. I have never used symbols on purpose.'[77] The brainstorming sessions over cocktails with co-scenarist Jean-Claude Carrière, batting ideas for potential 'gags' back and forth, recall the exchanges of 'dreams' between Buñuel and Dalí at the inception of *Un Chien Andalou*. Such imaginative availability no doubt accounts for many of the stunning *trouvailles* in these later films: those contrary objects, straight out of the surrealist game of 'l'un dans l'autre ('the one in the other'), for instance. There's the little crucifix, found by the engineer Jorge among his dead uncle's effects in *Viridiana*, which opens up to become a knife – an object/oxymoron to set beside the chaplin's falling crucifix in Eisenstein's *Battleship Potemkin* which thuds quivering into the deck like an axe. There's the revolver hidden in a fruit bowl; and the grand piano, crawling with red insects, employed by the police as an instrument for the torture of student militants, in *Le Charme Discret De La Bourgeoisie*...

While tonically committed to liberty, and losing nothing of their critical acerbity, even cruelty, Buñuel's later films are open-ended, multi-layered and multi-connotative. Anger gives way to ambiguity and to an ironic detachment. The obsessions persist but are placed at a distance. Paradox reigns in the domains of both emotions and values. Rather than any mellowing on the old master's part, this new lightness of touch reflects profound social and cultural change between the ideologically Manichean interwar conflict of totalitarianisms and the confident, consumer capitalism of the 1960s. In the films of the twenties, the bourgeoisie is caricatured in the style of anarchist cartoons from the fin-de-siècle, given a new lease of life by post-1917 Bolshevism. Buñuel's bourgeoisie in the later films is very much more of its time, or perhaps of its time as the dominant ideology and the advertising industry would have it represented. Buñuel mischievously colludes with a self-image of a sixties/seventies privileged class – glamorous, comfortable, self-assured – all the better to expose the barbarism on which its fragile civility rests. Close in spirit to Godard here, Buñuel's world is not

the real world but a parody of that world mediated by complacent, self-serving media 'spin'. The gags are red-hot-topical in *Le Charme Discret De La Bourgeoisie*, which followed on the heels of the events of 1968. Even the title seems to allude to the climate of 'repressive tolerance' theorised at the time by the popular Marxist-revisionist philosopher, Herbert Marcuse. There is the ambassador who smuggles cocaine in his diplomatic bag (Fernando Rey, who had just played the drug baron in William Friedkin's *The French Connection* [1970]). There is the gardener-bishop (on union rates), the dipsomaniac feminist, the peacetime army on manoeuvres that gets itself invited to dinner, and the police campaign to get the public to love them.

The Buñuel of later years – unlike the Buñuel of *L'Age d'Or* – came to confess contradictory feelings towards both his characters and their milieu. If love was the solution for Breton, for Buñuel it remains a big part of the problem. For example, *Abismos De Pasion*, his 1953 version of *Wuthering Heights* – itself an iconic text for Surrealism – is a black rather than a rosy testament to 'amour fou'. Nor are the peregrinations of desire, often comically absurd in their complexity, crudely reducible to the Oedipus complex or to reflexes of sado-masochism, however large both of these may loom. Fascinated though he was by both, he displays in his later films a more sympathetic understanding for – even a covert complicity with – the compulsive urges of his protagonists. Nor are women positioned exclusively as the objects of masculine desire. From the Mexican *Susana* (1950) to *Tristana* (1970) via *Journal d'Une Femme De Chambre* (1964) and, most famously, *Belle De Jour*, Buñuel assumes the viewpoint of woman trying to understand what men want and using their sexuality to fight the submissive destiny prescribed them by society. *Simon Of The Desert* (1965), perched high on his column, is only one of many Buñuelian heroes around whom the woman literally runs rings. As victims alike of traumatised childhoods, both female and male protagonists become victimisers in their turn. Buñuel made no bones about the multiple contradictions among which he contrived to

Buñuel's devotion to the Marquis de Sade also remained true. As well as a general reverence to de Sade's tenets, there are also more specific instances. For example, the protagonist of *El* resolves to sew up his wife's vagina, just as Eugenie does to her mother in de Sade's *Philosophy In The Boudoir*. And in *La Voie Lactée* (1969), de Sade is actually portrayed by Michel Piccoli, and the script quotes from the Marquis liberally.

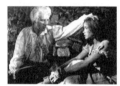

Sade portrayed in *La Voie Lactée.*

Abismos De Pasion

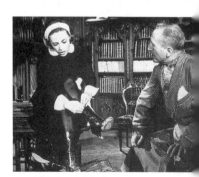

Journal d'Une Femme De Chambre

Simon Of The Desert

78. Quoted by Michael Wood, op.cit, p70. Wood puts the new lightness down to Buñuel's ever closer collaboration with fellow script writer Jean-Claude Carriere, whose work for other directors displays a similar tone.

79. Michael Wood, op.cit, pp.73 and 75.

forge his own life: 'They're part of me and part of the fundamental ambiguity of all things, which I cherish.'

Many critics of Buñuel's late films discern a mellowing, even an approaching serenity in the ageing surrealist master. Jean-Claude Carrière, Buñuel's co-writer on all but one of the last eight films, noted: 'It struck me very often that the first shot ever shot by Buñuel was a razor.... breaking an eye. His last shot was a woman's hand... mending a slit.... in a piece of linen. As if he was at the end of his life repairing the wound he made at the beginning.'[78] But I concur with Michael Wood that, rather than entering some 'state of grace' in the autumn of his years, the ironically detached tone and lightness of his last films, (*Tristana*, co-authored with Julio Alejandro, and made in Spain, is an exception), are Buñuel's thoughtful response to a changed cultural climate. The elites of high capitalism 'not only skate....on thin ice but mistake the thinness of the ice for high culture. There is a serenity inBuñuel's late films. But it is not his. It is the false and fragile serenity of the society he pictures. It is a confection of denial, and it can't last, Buñuel wants to suggest. Unless of course it lasts for ever.'[79] Buñuel's late films guarded their enigmas and continued to catch audiences unawares. Refractory and elusive to the end, his cinema has resisted the 'museumification' that was the fate of so much Surrealism in other domains.

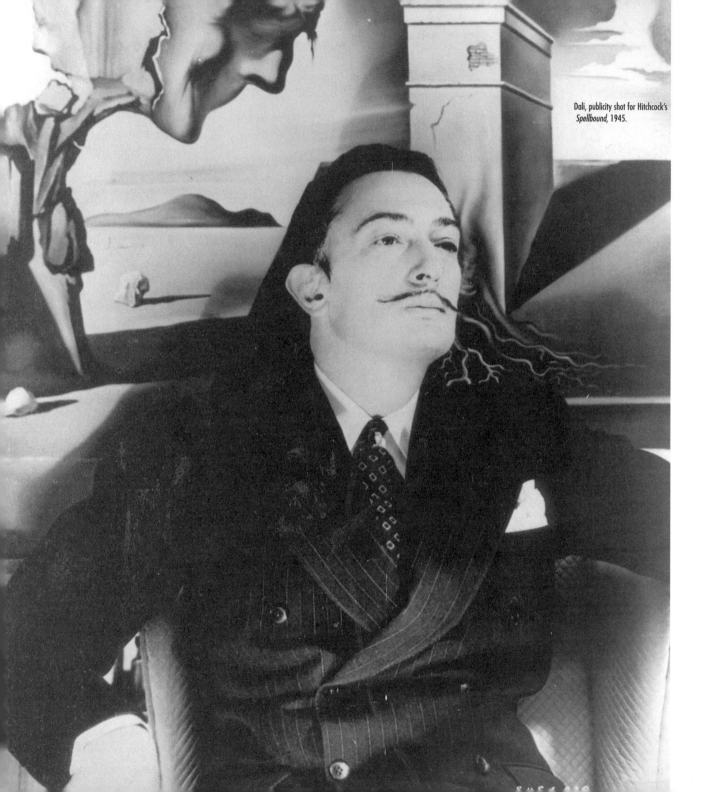

In the years following *Un Chien Andalou* and *L'Age d'Or*, Salvador Dalí's fascination with cinema remained undiminished, with his activities in that domain reaching a peak in the 1940s and early 1950s; unlike Buñuel, however, Dalí would almost never see any of his projects reach fruition.

In 1930, Dalí – who in his 1927 essay "Art Film, Anti-Artistic Film" wrote that "the best cinema is the kind that can be seen with your eyes closed" – was toying with an idea for "tactile cinema" – "feelies" as the logical progression from "talkies". The idea was that cinema-goers had a kind of tray in front of them over which various materials passed at appropriate times, so that they could directly experience what the characters on screen were doing – touching skin, for example. Later that same year Dalí would start to develop a new film scenario, entitled *Le Chèvre Sanitaire* ("The Hygienic Goat"), also the name of an essay from his collection of writings *La Femme Visible*. Only a rough draft of *Le Chèvre Sanitaire* survives, a mêlée of various ideas that hark back to *L'Age d'Or* as well as looking forward to a putative template for "paranoiac-critical cinema". Dalí's key description for the film was "gratuitous", and amongst its episodes was a reconstruction of his 1929 drawing *The Butterfly Hunt*, an incestuous and potentially pornographic tableau. A blueprint for what might have been the ultimate Surrealist film to date, with its promise of "dreams and hynagogic images" alongside convulsive Freudian mechanisms and outrages, it was only the first of many intriguing projects that failed to see the light of day.

Study for "tactile cinema", 1930.

In 1931 and 1932 Dalí began to develop two more film ideas, this time for a pair of divergent documentaries: *Cinq Minutes à propos du Surréalisme* and *Contre la Famille*. *Cinq Minutes à propos du Surréalisme*, which exists as an illustrated typescript, was intended to be a visual record of the whole Surrealist movement, complete with explanations of Surrealist works, activities and techniques. The script is divided into three sections, "words", "images", and "sounds", which include dreams, automatic writing, collages, the sub-conscious, laughter, death screams, Freudian terminologies, and Dalí's own trademark "paranoiac" imagery. *Cinq Minutes à propos du Surréalisme* is the fascinating endo-structure of a complex provocation, a charter of war against the rational emblazoned with the warning: "WATCH OUT for the poisonous and FATAL images of SURREALISM".

Contre la Famille dates from 1932 and, as the title suggests, was designed as a polemic against patriarchy, inspired both by Dalí's own Oedipal conflicts and by a Marxist vision of social reform. The short scenario that exists of the project makes reference to both Freud and Engels in this context, and contains only brief references to the intended structure of the film itself; one scene again refers to Dalí's *Butterfly Hunt*. The remainder of the text consists of psychoanalytical dissections of familial relationships, assaults on existing social constructs and ideologies, and other ideas which in all likelihood would have never successfully translated to the screen.

1932 also saw the publication of Dalí's essay "A Short Critical History Of The Cinema", the preface to another unrealised scenario, *Babaouo*.[1] Here Dalí sang the praises of comic actors like Harry Langdon and the Marx Brothers, as well as the "extraordinary" serial *Mysteries of New York*,[2] and it was this type of milieu – one of slapstick sur-reality – in which the script of *Babaouo* unfurls. Set two years ahead in 1934, in an unspecified European country during times of civil war, *Babaouo* contains such trademark Dalí motifs as soft watches, swarming ants, giant stones or

Script page from *Cinq Minutes à propos du Surréalisme.*

1. Salvador Dalí, *Babaouo, Scénario Inédit* (Editions des Cahiers Libres, 1932).

2. *Les Mystères de New York* was the French title for the serial *The Exploits Of Elaine* (1914) starring Pearl White; it ran for 14 episodes, including "The Poisoned Room", "The Vampire", "The Blood Crystals" and "The Devil Worshippers", and was a seminal influence on French director Louis Feuillade.

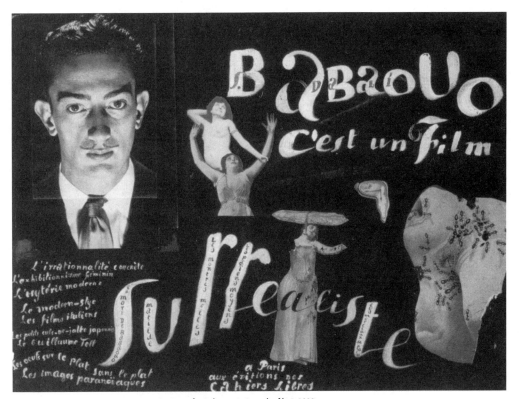

Poster for *Babaouo*, "a Surrealist film", 1932

loaves balanced on cyclists' heads, fried eggs, shrouded figures and intimations of putrefaction, but these only serve to punctuate what boils down to a relatively straightforward narrative concerning the eponymous hero and his lover, Mathilde Ibañez, who suffer a car crash whilst fleeing the scene of some indescribable horror. The woman dies but Babaouo slowly recovers in a seaside village, only to be gunned down in the script's Epilogue. One of Dalí's most complete scenarios in terms of both narrative and visual detail, *Babaouo* was intended to be a true "film-spectacle" that would dictate the future direction of cinema, a populist blend of comedic violence and Surrealist iconography[3].

3. The scenario for *Babaouo* was finally filmed in 1998, by Manuel Cússo-Ferrer.

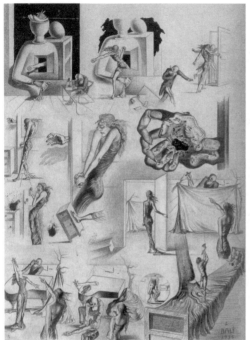

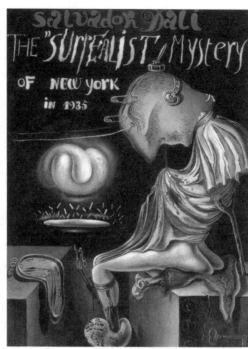

Drawing accompanying the scenario for
The Surrealist Mystery Of New York, 1935

Poster design for
The Surrealist Mystery Of New York, 1935

Increasingly drawn towards the USA and its commercial and cultural possibilities, Dalí arrived in New York for his first exhibition in November 1934[4]. In the early part of 1935, he produced a film scenario entitled *The Surrealist Mystery Of New York*, evidently harking back to the pulp serials with which he, Breton and the other Surrealists were so enamoured. With locations ranging from Harlem to Fifth Avenue, the fragmentary text contains scenes with titles like "Lovers of the New Fear" and "The Cannibalism Of American Cinema", and involves a covert agency spreading the seeds of Surrealist enigma throughout the metropolis. With its notions of autophagy and "unconscious necrophilia", *The Surrealist Mystery Of New York* suggests a dark undercurrent of latent madness and violence.

4. Dalí apparently arrived in New York with the already conceived idea for a film that would feature Richard Wagner, Ludvig II of Bavaria, and novelist Sacher-Masoch. This later materialised as the ballet *Bacchanale* (1939), for which Dalí designed sets and costumes.

Paintings such as 1934's *Mae West's Face Which Can Be Used As A Surrealist Apartment* were indicative of Dalí's continuing and growing attraction towards Hollywood and, especially, its "American Surrealists" the Marx Brothers and Walt Disney (whose *Silly Symphonies* Dalí regarded as sublime). In 1936, he and Gala were invited to Hollywood by Harpo Marx, and duly arrived in January 1937. Dalí engendered much publicity by painting Harpo's portrait, and the two became very close. It was during this period that Dalí conceived his most deranged film script of all, the notorious *Giraffes On Horseback Salad*.[5] The blueprint for a Surrealist Marx Brothers movie, *Giraffes* would have been the ideal conduit through which Dalí's erotic delirium and paranoiac-critical carnage could have spread like a virus to mainstream audiences; some idea of the film's potential scope can be

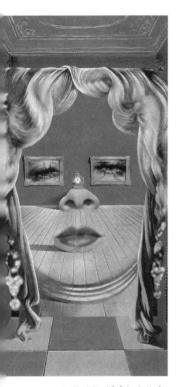

Mae West's Face Which Can Be Used As A Surrealist Apartment, 1934.

5. The script survives in two distinct versions, one shorter and bearing the title *The Surrealist Woman*.

Dali sketching Harpo Marx, 1937.

Script page from *Giraffes On Horseback Salad*, 1937 (above); sketch for *Giraffes On Horseback Salad*, 1937 (above right).

glimpsed in the dozen sketches which Dalí made to accompany the script, which have titles such as "Dinner In The Desert Illuminated By Giraffes On Fire", "Surrealist Dinner On A Bed With Dwarfs", and "Surrealist Gondola Above Blazing Bicycles". Using visual elements from the earlier *Babaouo*, Dalí here adds the central motif of exploding and stampeding giraffes on fire to embellish the story of a man who, bored with his conventional fiancée, is lured into a sexual frenzy by the mysterious Surrealist Woman. It has been suggested that Groucho Marx finally vetoed production of Dalí's film; either way, it is much to be regretted that this rabid cinematic project never materialised. Dalí's love affair with Hollywood – and Harpo – continued nonetheless, and in his 1937 essay "Surrealism In Hollywood", he not only declared that "Cecil de Mille is surrealist in his sadism and fantasy", but moreover that "Harpo Marx is surrealist in everything" – surely the highest accolade he could bestow.

Dalí's next Hollywood project, in 1941, would be to design a "nightmare sequence" for the film *Moontide*, slated to be directed by Fritz Lang. Dalí's outline for the alcoholic delirium of the film's protagonist was duly delivered in the form of a four-page scenario with several accompanying drawings, but eventually his ideas – possibly too savage and unsettling for the mainstream – were never used.

In 1944 came a similar, but much more promising commission: to create oneiric sequences for Alfred Hitchcock's Freudian thriller, *Spellbound*. Here he had to create the sense of a dream experienced by the hero (Gregory Peck), who had lost his memory and stood accused of murder. Dalí produced a series of studies, and also two set designs with desolate and distorted landscapes which successfully created the desired mood of disquiet. The film's producer, David O Selznik, believed that Hitchcock had chosen Dalí because of the surrealist's publicity value. But Hitchcock explained that it was for Dalí's psychoanalytical understanding and, above all, for the hallucinatory, sharply defined way that Dalí presented dreams – the deep

Design for *Moontide*, 1941.

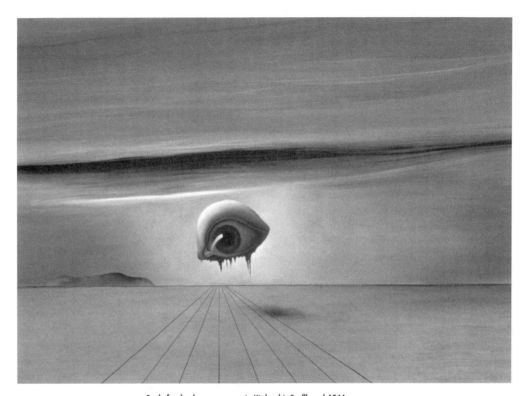

Study for the dream sequence in Hitchcock's *Spellbound*, 1944.

Dalí surveys a set curtain for
Spellbound, 1945.

perspectives, saturated dark shadows and solid imagery – so different from the blurred forms of filmic cliché, which commonly travestied the dream experience. In one of the sequences, a woman with a giant pair of scissors cuts up a hanging painted with huge eyes, reprising the opening of *Un Chien Andalou*. Unfortunately for Dalí, his most extravagant imaginings, such as fifteen grand pianos hanging from the ceiling over silhouettes of dancing couples – a bizarre attempt to recreate the desired effect using scale models and dwarfs was abandoned – were vetoed on grounds of the cost. The sequence was also somewhat diluted due to last-minute tampering, but remains Dalí's one and only lasting Hollywood achievement.

Dalí's next project was conceived with one of the film-makers he most admired, Walt Disney; *Destino* (1946) was a six-minute animation project into which Dalí vowed to pour his complete arsenal of surreal objects, configurations and hallucinations. His storyboards and studies for the film seem to bear that out, showing a series of metamorphoses with fantastic shapes and shifts. Dalí himself described the project as "an effort intended to initiate the public into Surrealism" – something he had been intent upon for the previous decade. Although Dalí worked on the film for several months over two separate periods, it seems that less than twenty seconds were actually made before Disney, for reasons unknown, shelved production[6]. The better news for fans of Surrealism and cinema, however, is that Dalí's storyboards, sketches, and paintings were preserved, and *Destino* was finally and unexpectedly completed by Disney in 2003.

Dalí's interest in cinema continued into the 1950s. His motifs were used in the dream sequence for Vincente Minnelli's *Father Of The Bride* in 1950, although apparently without any direct involvement; and in 1952 he was credited as set and costume designer on Alejandro Perla's *Don Juan Tenario*, while continuing to work on successive versions of a script for a film entitled *The Flesh Wheelbarrow*, about a woman who "eroticizes" and falls in love with her barrow, in which he envisaged the actress Anna Magnani taking the lead role. Dalí described the project at some length, and in spectacular detail, in his 1954 article "My Cinematic Secrets".[7] Also designated by Dalí as his first "neomystical film", its basis seems to be in stunning the viewer whilst creating multiple meanings within a single frame. Once again, *The Flesh Wheelbarrow* was never filmed.

In 1950 Dalí was also contemplating a documentary film project entitled *Le Sang Catalan* ("Catalan Blood"). The scenario for this idea indicates a desire by Dalí to make a film glorifying his native Catalonia, its folklore and rituals, its "desolate and savage" landscapes and, above all, its ineluctable heritage of bloodshed and violence.

Designs of double-images from the abortive *Destino* project (1946-47).

6. Dali and Disney remained in touch; ten years later Disney visited Dali's home, and the pair discussed a film project of *Don Quixote*, although once again this came to nothing – as had earlier proposals of a film of the life of El Cid (pitched to Errol Flynn), and a film of Dali's book *50 Secrets Of Magic Craftsmanship* (pitched to Jack Warner).

7. "My next film will be exactly the opposite of an experimental avant-garde film, and especially of what is nowadays called `creative', which means nothing but a servile subordination to all the commonplaces of our wretched modern art. I shall tell the true story of a paranoid woman in love with a wheelbarrow which successively takes on all the attributes of the beloved whose dead body has served as a means of transport. In the end, the wheelbarrow is reincarnated and becomes flesh. That is why my film will be called *The Flesh Wheelbarrow...* [viewers] will see five white swans explode one after the other in a series of minutely slow images that develop according to the most rigorous archangelic eurythmics. The swans will be stuffed with real pomegranates that have been filled in advance with explosives, so that it will be possible to observe with all due precision the explosion of the birds' entrails and the fan-shaped burst of pomegranate seeds which will hit the cloud of feathers as one might imagine the corpuscles of light bump into each other, so that, in my experiment, the seeds will have the same realism as in the paintings of Mantegna, and the feathers the flowing vagueness which made the painter Eugène Carrière famous. In my film there will also be a scene representing the Trevi fountain in Rome. The windows of the houses round the square will open, and six rhinoceroses will fall into the water one after the other. After each rhinoceros falls, a black umbrella will rise open, from the bottom of the fountain." ("My Cinematic Secrets", 1954; reprinted in *Diary Of A Genius*, Solar Books, 2007, pp87–90).

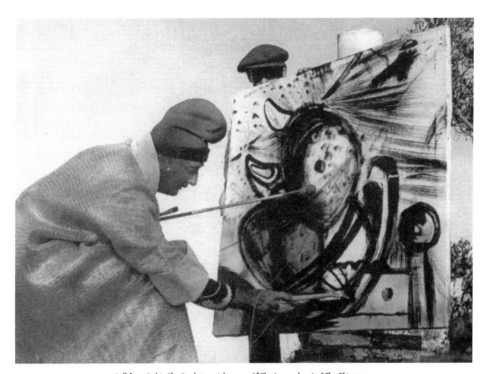

Still from Dali's *The Prodigious Adventure Of The Lacemaker And The Rhinoceros.*

In 1954 Dalí began a collaboration with Robert Descharnes, *The Prodigious Adventure Of The Lacemaker And The Rhinoceros*, a cinematic exploration of his previous revelations concerning Vermeer's masterpiece and its hidden 'rhinocerontic' morphology. This encompasses Dalí's visits to the Louvre, the creation of his painting *Paranoaic-Critical Study Of Vermeer's 'Lacemaker'* (including sessions in the rhino pen at Vincennes zoo), and various scenes of Dalí and Gala at home in the Cap de Creus. With logarhythmic forms as its central subject, *The Prodigious Adventure* is also a vast visual diary of disparate threads and situations. Shooting went on sporadically until 1962, but although apparently all the scheduled scenes were shot, a finished film has yet to be edited from this rarely-seen footage.

Dalí, who by 1960 had tried in vain for thirty years to complete his various cinematic projects, now turned to different media – video and television – to finally accomplish something concrete in the domain of the filmed image. The most successfully realised of these late flourishes were *Chaos And Creation* (1960), *Soft Self-Portrait of Salvador Dalí* (1967), and *Impressions Of Outer Mongolia* (1975). *Chaos And Creation* is a record of Dalí making an abstract painting in New York with the use of two scantily-clad females, several pigs, a motorcycle, various liquids and a handful of meal-worms. Orchestrated by Dalí, it was shot on videotape and is possibly the first example of video performance art.

Soft Self-Portrait, directed by Jean-Christophe Averty and Robert Descharnes, is a 55-minute television documentary. Narrated by Orson Welles, it provides a glimpse into the seemingly anarchic, but actually well-choreographed madness of Dalí's day-to-day life. Dalí's own creative stamp is clearly all over the film, which combines trick photography, strobic effects and temporal/spatial distortions with Dalí's natural showmanship to dazzle the viewer.

Impressions of Outer Mongolia, ostensibly inspired by the Raymond Roussel novel *New Impressions of Africa*, was directed by José Montes-Baquer for television. Its central imagery comes from close-ups of metal ballpoint pens over which Dalí had been urinating for several months; in the resulting corrosion, Dalí claimed to see infinite visions which, in the film, he links to the ingestion of psychedelic mushrooms in Mongolia. Dalí's involvement with this film was such that he is sometimes credited as co-director.

Dalí's interest in film persisted until his final years; in 1982, it seems he attempted a last-ditch reconciliation with Buñuel by inviting his estranged friend to collaborate on a project to be called *The Little Demon*. Sadly, Buñuel was forced to decline through ill health; he died within the year, and Dalí followed him in 1989.

Shooting *Chaos And Creation* (1960); photograph by Philippe Halsman.

1. Georges Sadoul, quoted by Alain & Odette Virmaux in Adam Biro & René Passeron eds', *Dictionnaire Général Du Surréalisme Et De Ses Environs* (Presses Universitaires de France, 1982) p.94.

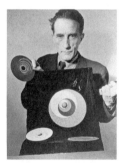

Marcel Duchamp in Hans Richter's *Dreams That Money Can Buy*, a film of seven distinct "dream" episodes. Marcel Duchamp is featured with his "roto-reliefs", Man Ray contributes "Ruth, Roses, And Revolvers", while Max Ernst recreates a scene from his surrealist collage-novel *Une Semaine De La Bonté*. Alexander Calder and the Cubist Fernand Léger both contribute animation sequences.

Richter's next film was *8X8* (1957), a contemplation around chess.

According to the noted film historian and one-time surrealist, Georges Sadoul, 'it seemed to us that there was no truly surrealist cinema after *Un Chien Andalou,* the films of Buñuel excepted'.[1] Such a hard line speaks as much for the unsparing rigour – more ethical than aesthetic – that prevailed in the surrealist group as for the intrinsic qualities of particular films. We have already seen how hotly contested were attempts to attach the surrealist label to many 1920s 'experimental' films before *Un Chien Andalou.* This went not only for Artaud/Dulac's *La Coquille Et Le Clergyman* but also for *L'Étoile De Mer* (Desnos/ManRay, 1928) and George Hugnet's *La Perle* (1929) in the making of which, Dulac apart, all those involved were card-carrying surrealists at the time. Numerous surrealists made forays into the medium after the banning of *L'Age d'Or*. Jacques Brunius made ten films between 1931 and 1953, including *Records 37,* which had a commentary by Desnos. In New York, Joseph Cornell took a copy of *East Of Borneo* (1931), a run-of-the-mill B-movie melodrama, cut it down to a quarter of an hour, and deliberately 'disordered' it like some modified found object, to produce *Rose Hobart* (1936), a tantalising enigma, redolent with unfocused yearning. A few years later, also in New York, the ex-Dada, Hans Richter, rallied a group of surrealists in exile (Max Ernst, Man Ray, Marcel Duchamp) to make the compilation movie, *Dreams That Money Can Buy* (1944–1947).

The availability of cheaper and more user-friendly film apparatus after the Second World War encouraged a 'new wave' of short movies by

surrealists. J H Matthews argues for the bona fide Surrealism of *Eaten Horizons* (1950) by the Danish artist Wilhelm Freddie and for *L'Imitation Du Cinéma* (1959) by the Belgian fellow-traveller, Marcel Marien. René Magritte enlisted family and friends in Brussels to figure in a series of uniquely droll 'home movies'. And surrealist film historians Ado Kyrou and Robert Benayoun each made several feature-length films in the sixties and early seventies including Kyrou's *The Monk* (1972) – based on Matthew Lewis's gothick novel celebrated by Breton (and translated by Antonin Artaud) – with a scenario by Luis Buñuel and Jean-Claude Carrière.[2]

But it has to be admitted that none of these films even approached *L'Age d'Or*'s ambition, originality or subversive authority. Inevitably most were made on shoestring budgets and got only marginal exhibition. Perhaps because the element of surprise was lacking, none achieved the status of a cause célèbre.

Why was it that, given their passion for the medium, the filmic output of surrealists – Buñuel apart – has been so modest? Despite the many claims that film is the perfect medium for Surrealism, the lack of actual films suggests that it may not after all by 'the royal road to the marvellous'. The most obvious explanation is expense. Film was too costly a means of expression for a groupuscule that barely had the resources to keep going (irregularly at best) a review such as *La Révolution Surréaliste*. Neither Man Ray nor Buñuel went into film to make money. Being non-commercial was the guarantee of sincerity and disinterest. But legacies and windfalls were by their nature episodic. Wealthy patrons like Arthur Wheeler, who picked up the tab for Man Ray's *Emak Bakia,* were rare. Even the long-suffering Noailles pulled the plug after *L'Age d'Or*. The advent of sound quadrupled production costs and put film outside the range of surrealist possibility. The audience for avant-garde cinema melted away, *La Revue Du Cinéma* foundered in 1931, likewise the network of ciné-clubs in Paris and the provinces. All this meant that Surrealism was effectively the last of the

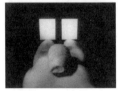

Two images from *Eaten Horizons* (*Spiste Horisonter*) by Wilhelm Freddie. Freddie (1909–95) was a Danish surrealist whose painting and sculpture was largely derivative of Dali, Tanguy, Magritte and others. He made headlines in Denmark with his controversial *Sex-Surreal* show in 1937. His other film was *An Absolute Refusal To The Request For A Kiss* (1949).

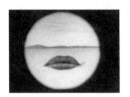

Image from *An Absolute Refusal To The Request For A Kiss* .

Magritte's home movies can be glimpsed in the short documentary *Magritte, ou Le Leçon De Choses* (Luc de Heusch, 1961). Magritte also collaborated on Roger Livet's *Fleurs Meurtries* (1929).

2. Paul Hammond gives a full inventory in *The Shadow And Its Shadow* (Expanded and revised edition, Polygon, 1991) pp.1–48 & pp.229–233. His listings in the original BFI edition of 1978 contain interesting differences.

The surrealists were reputedly less than generous when it came to the filming of one of their cornerstone texts, *Les Chants De Maldoror* by Le Comte de Lautréamont (from whence came their favourite simile, 'as beautiful as the chance meeting on a dissecting-table of an umbrella and a sewing machine'). American underground film-maker Kenneth Anger attempted to film the book in Paris in the 1950s, but gave up after various set-backs including protests from surrealist members – 'they didn't want a Yank messing round with their sacred text'. *Les Chants De Maldoror* is probably unfilmable, but other attempts have included *Marudororu No Uta* (Shuji Terayama, 1974) and *Maldoror* (Karsten Weber, 2000).

Films of books actually written by surrealists have also proved largely impossible, although Jean-Luc Godard's *Alphaville* (1965) was apparently inspired in part by Paul Eluard's *La Capitale De La Douleur*.

Alphaville

The surrealists themselves – including Louis Aragon, Benjamin Péret, Louis Aragon, Philippe Soupault, Paul Eluard and Georges Ribemont-Dessaignes – feature in Tristan Tzara's documentary *Le Coeur À Barbe* (1930), in which they are seen reciting texts and ringing a bell. That same year Salvador Dali appeared in Ernesto Gimenez Caballero's documentary *Noticario De Cine Club*, while Breton, and Max Ernst, appeared in Jean Barral's *La Belle Saison Est Proche* (1959). Ernst co-directed *Maximiliana* with Peter Schamoni in 1966.

filmic avant-gardes until the coming of cheaper technologies in the 1950s, a fate which of which the upside was the assurance of Surrealism's reputation thereafter as the model of filmic subversion.

But shortage of the wherewithal was only part of the story. Fundamental to the mis-match was a confusion between watching films and making films that was never adequately addressed by the surrealists. Just as they sought to reduce, if not deny, the divide between poet and reader, so their impulse was to make an abstraction of the processes of filmmaking. The central drive of their enterprise, after all, was to promote creation by all. Their aim was to demolish the ivory towers and inner sanctums of Art (and Craft) and to restore to all the free play of imagination powered by desire. Their preference was for 'immaculate conceptions', for 'trouvailles' and things produced by chance. Learning and applying techniques was too likely to destroy the wonder. Most of the means of expression they employed were apt for masking or minimising the gap between the sender of a message and its receiver. The mind during the act of automatic writing, for instance, became a 'simple recording machine' of the unconscious murmur; the writer then read message from within as if came from elsewhere. In visual expression, much the same was claimed for techniques such as 'frottage', 'collage', 'decalcomania' and the game of 'exquisite corpse'; and even for the more studied exercises of a Dalí or Delvaux, who reproduced in a state of hyper-lucidity images that had already been registered by the conscious mind but which owed their origin to oneiric activity in the unconscious. The same hand and the same imagination controlled the creative process in all its stages. The thread between inspiration and realisation was unbroken.

Cinema could not be made to work like that. There was an inevitable divorce between the original mind's eye and the image on the screen. As René Clair had early pointed out – challenging Jean Goudal – the camera has its own laws which cannot be set aside. Making films is a craft that requires discipline. It has to take proper account of the mechanical nature of the

medium and reach an accommodation with the machine's own logic. The dream has to take some detours on its route to the screen. There can't be a 'direct imprint'. Even the wildest imagery will only make its full impact if it submits to the codes, the rhythms, the linking devices and shot structure that are proper to the cinema. The complex division of labour, the specialisation, the whole apparatus of décor, actors, rehearsals and sophisticated equipment stood between the surrealist's scenario and the completed work.[3] Was it not, at least in part, Artaud's naiveté, shared by his fellow surrealists, in failing to take all this into account, rather than any crass mishandling of his ideas by the unfortunate Madame Dulac, that explains Artaud's outraged complaint that he did not recognise his *La Coquille Et Le Clergyman* in Dulac's finished film?

The surrealists' instinct was to turn away from such drudgery. Only Buñuel was prepared to 'dirty his hands'.[4] As a practicing filmmaker, he must have found it particularly galling that, as he later put it, 'they fled the work of others'.[5] And, no doubt, their cavalier attitude contributed to his break with the group. The surrealist mindset was inimical to the highly un-spontaneous and disciplined craft habits that are required actually to get films made. Instead they preferred to write scenarios – especially Desnos, Péret, Soupault, Artaud, Masson and Maurice Henry.[6] Filmscripts were a genre 'made by all' like collages and 'exquisite corpses'. They had a regular place as texts in surrealist reviews and often did not differ very much from accompanying accounts of dreams or gobbets of automatic writing. Correspondingly, much surrealist poetry can be read as virtual film material. But what is significant about these projects is how few got made into films. One has the impression that their authors did not expect it. Rather, they were making a point about the potential for the cinema to tell truly poetic stories. That was as far as it went. Man Ray recalls a revealing incident that occurred in 1935. A number of surrealists and their partners were holidaying in the country house of Lise Deharme. Among them were Breton and Eluard

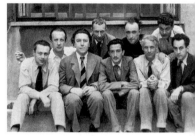

The Surrealist Group in 1930: Tristan Tzara, Paul Eluard, André Breton, Jean Arp, Salvador Dali, Yves Tanguy, Max Ernst, René Crevel, Man Ray.

3. René Clair, 'Cinéma Pur, Cinéma Commercial, Cinéma Et Surréalisme', in *Les Cahiers du mois*, Nos.16–17, pp.89–95 .

4. Dudley Andrew, op.cit., p.45 .

5. Quoted by Maurice Drouzy, *Luis Buñuel : Architecte Du Rêve* (Lherminier, 1978) p.84.

6. See, for instance, Robert Desnos, *Cinéma* (Gallimard, 1966); Philippe Soupault, *Ecrits De Cinéma* (Plon, 1979).

Some unfilmed surrealist scenarios include: Benjamin Péret's 'Pulchérie Veut Une Auto'; Robert Desnos' 'Minuit À Quatorze Heures'; Benjamin Fondane's 'Paupières Mûres' and 'Barre Fixe'; Georges Neveux' 'L'Amazon Des Cimitières'; Georges Ribemont-Dessaignes' 'Le Huitième Jour De La Semaine'; and Louis Aragon's 'Le Troisième Faust'.
Fondane made one experimental film, *Tararira* (1936), but it remains lost.

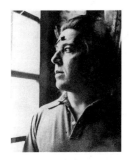

André Breton with dragonfly
(photograph by Man Ray).

7. Man Ray, *Self Portrait* (André
Deutsch, 1963) p.286.

who wrote a scenario titled 'Essai De Simulation Du Délire Cinématographique' and it was decided that Man Ray should film it there and then. But the shooting schedule didn't get beyond the first few takes, seven stills from which were later published in *Cahiers d'Art* (Nos. 5–6, 1935). Man Ray explains: 'In one scene, Breton sat at a window reading, a large dragonfly poised on his forehead. But André was a very bad actor, he lost patience, abandoned the role.... The best part of the shot was the end where he lost his temper.'[7]

Of all the modernist movements, Surrealism was probably the most in love with cinema. But it was as film spectators, not as filmmakers. René Clair was right in the end when he claimed that Surrealism was a good school for filmgoers but a poor one for directors. This was because, of the two, only the spectator can surrender conscious control and give full play to the faculty of free association. The very nature of the surrealists' enthusiasm for the medium was such as to inhibit their use of it for surrealist purposes. They went to the cinema in a spirit of expectant availability waiting on events unfolding on the screen to stimulate their faculties for analogical invention and endless reverie. The last thing they wanted to be concerned with was the formula for the stimulant. For all that they were active spectators – even to the point of delirium of interpretation – they remained spectators just the same, and in this sense, passive. This may help account for the somewhat flippant attitude they showed to film which Maurice

8. Maurice Drouzy, op.cit., pp.84–85.

Drouzy has noted as being the obverse side of their passion for the cinema experience.[8] Dudley Andrew also wonders: 'Toying with the cinema to inspire their painting and their poetry, did Breton, Desnos, Eluard, and Aragon ever really take their proclamations concerning its extraordinary power to

9. Dudley Andrew, op.cit., p.48.

heart?'[9]

If the surrealists had little time for music (too abstract) and for the theatre (too rehearsed), their relationship with film was thus a mixture of love and hate. According to the Virmaux's, they never gave up on a certain

suspicion that the world of film was an impure one.

So what became of that enthusiastic spectatorship with which we started? Sad to say, here too celebration was succeeded by disappointment and resentment. Mainstream cinema was found to be selling short the medium's marvellous potential.'[10] In the manifesto for *'L'Age d'Or'* in 1930, the surrealists consigned to the garbage pail all but a few Mac Sennett comedies, Picabia and Clair's *Entr'acte*, W.S Van Dyke's *White Shadows Over The South Seas*, early Chaplin[11], and *Battleship Potemkin*. Apart from these and Buñuel/Dalí's's two films, 'nothing reaches a level higher than the merely existent'.[12] They reserved a special contempt for mainstream French 'quality' cinema which sought to bring dignity to a medium still stigmatised by its fairground peepshow origins by making it a vehicle for classic novels and boulevard theatre hits. The arrival of sound meant the jettisoning of a self-sufficient film syntax that had been developed over the silent years.[13] More and more, the surrealists saw cinema abandoning invention for mere imitation and confirmation of the world as it was – for what Man Ray called 'keyhole films'. As usual, Breton found the *mots justes* for their disappointment: 'Its wings have been clipped. They've preferred to keep to a theatrical type of action instead of making the mechanism of correspondences operate as far as the eye can see.'[14] But the surrealists understood that technical advance in filmmaking was not itself to blame. To explain what had gone wrong with cinema, they put it in its wider social context. According to Roger Gilbert-Lecomte of the para-surrealist *Grand Jeu* group, cinema was a growth industry within the capitalist system and as such infected with the same evils, such as excessive individualism and private greed. If cinema found itself assigned to derisory roles, this was because, in society as its current form, there were no worthy applications for it.[15] Benjamin Péret in the fifties took a similar line with yet greater vehemence: 'Never has any means of expression engendered such hope as the cinema. With cinema not only is anything possible, but the marvellous

10. As early as 1918, Soupault was already bemoaning film's missed opportunities: 'After (the Lumière brothers), those who worked busily with this extraordinary invention deceived themselves terribly; they made the cinema the colourless mirror and the mute echo of the theatre. No one has stopped making this mistake. (Philippe Soupault, 'Note 1 Sur Le Cinéma', in SIC, no.25, January 1918, translated in Richard Abel, *French Film Theory And Criticism: A History/ Anthology, 1907–1939* (Princeton University Press, 1988) pp.142–3).

White Shadows Over The South Seas.

11. Their dismay at the change in Chaplin's original anarchic screen persona into the later sentimental 'little fellow' didn't stop the surrealists coming to his defence with their 1927 tract, 'Hands Of Love', when Chaplin's wife had him prosecuted for 'unnatural' intimacies..

12. From the 1930 pamphlet, *L'Age d'Or*, in José Pierre ed., op.cit.

13. Being unable to represent the world of appearances realistically, the silent film, argued Benjamin Fondane, had been compelled to devise its own esoteric formal language in order to communicate the whole complex of states of mind. (Benjamin Fondane, in *Les Cahiers Jaunes*, special cinema number 4, 1933).

14. André Breton, 'Comme Dans Un Bois', op.cit.

15. Roger Gilbert-Lecomte, 'L'Alchimie De L'Oeil' in *Les Cahiers Jaunes*, special cinema number, 4, 1933, pp.26–31.

16. Benjamin Péret, 'Contre Le Cinéma Commercial', *L'Age Du Cinéma*, no.1, March 1951, pp.7–8, translated in Paul Hammond, *The Shadow And Its Shadow*, op.cit., pp.62–3.

In 1952 Péret wrote the commentary to Michel Zimbacca's meditation on primitive art, *L'Invention Du Monde*.

17. Paul Hammond, 'Off At A Tangent' in *The Shadow And Its Shadow* (BFI, 1978) pp.1–21.

The Most Dangerous Game.

Dream sequence from *Peter Ibbetson.*

18. André Breton, *L'Amour Fou*, op.cit., p.111, footnote.

itself is placed within reach. And yet never have we seen such a disproportion between the immensity of its possibilities and the mediocrity of its results. ... As well as awakening it is also capable of brutalising and it is this, alas, that we have witnessed as the cinema, a cultural form without precedent, has developed into an industry governed by sordid market forces incapable of distinguishing a work of the mind from a sack of flour.'[16]

It follows that in terms of surrealist appreciation of whole films rather than privileged moments, the roster of commercial films that earned their unqualified respect has been modest. Leaving aside the filmography of Surrealism proper, Paul Hammond has suggested that the kind of films that find favour with surrealists can be divided into three categories: those that are surrealist ethically, those that pursue some of surrealism's predilections and themes, and those that are surrealist by accident.[17] They continued to love the anarchic humour of the Marx Brothers who kept the sight gag going into the sound era, behaved with the liberty of cartoon figures, whose dialogue was as dysfunctional as automatism, and where the lechery of Harpo was as unbound as it was unpredictable. They applauded *King Kong* (1933) as a tale of 'amour fou' whose real meaning undercut the banal misogyny of the concluding morality that it was 'Beauty that killed the Beast'. They cherished Count Zaroff in Schoedsack and Pichel's *The Most Dangerous Game* (1932), especially for Leslie Banks' Sadean Zaroff, who usurps the role of the hunter, Joel McRae, and turns him, along with Fay Wray, into the hunted. Breton and Eluard were among the first to celebrate Henry Hathaway's adaption of George du Maurier's novel, *Peter Ibbetson* (1935) where the plot is advanced by the lovers' shared dream and where the interdict on love makes the fires of desire burn still more hotly.[18] Ado Kyrou and the *L'Age Du Cinéma* team singled out Olsen and Johnson's *Hellzapoppin* (1941) for the degree of its zaniness, daring at the time. Although Surrealism may not have been a direct influence on Charles Laughton in *Night Of The Hunter* (1955), his only film as director, its

atmosphere of inescapable nightmare, its supernatural overtones, and its dark humour won the group's accolades, as did Nico Papatakis's harrowing dramatisation in *Les Abysses* (1963) of the crimes of the Papin sisters.

Given the amount of attention that the surrealists paid to cinema, one is bound to ask what they have contributed to film appreciation, to film theory and to our understanding of the film effect? Oscillating between the psychoanalytical, the lyrical and the moral, the surrealists may have lacked a consistent and coherent conceptual framework. Breton never wrote a *Surrealism And Cinema* to set beside his *Surrealism And Painting,* nor did cinema figure in either of the two *Manifestos*. But beyond enthusiasm, their understanding of the nature of film was perceptive and sophisticated. Wendy Everett goes so far as to claim that, by the number and range of their articles of film criticism from 1919 onwards, they might almost be said to have created the genre.[19]

Eschewing analysis, their response to films initially took the form of verbal equivalents to the visual impressions a film had made on them or the emotions it had evoked, what Soupault called 'critiques sympathiques'. Such parallel readings reflected their belief in the active role of the spectator in creating film meaning. Or they might submit a film to Dalí's 'delirious interpretation', enlarging on its possibilities by teasing out alternative readings, often at odds with the preferred meaning or the intentions of the director. Or they might collectively imagine a series of additional sequences for Sternberg's *The Shanghai Gesture* (1941).[20] Always alert to involuntary Surrealism in otherwise 'straight' films, they elevated to iconic status certain isolated images such as the vision of Marlene Dietrich's thighs in *The Blue Angel* (1930), the worm-infested ship's biscuit in *Battleship Potemkin,* and the intertitle 'Once over the bridge, the phantoms came to greet him' from Murnau's *Nosferatu* (1922). They unearthed surrealist themes in unexpected places: so, just as Breton identified Jonathan Swift as 'surrealist in malice', Gérard Legrand claimed Otto Preminger's *Laura* (1944) as 'surrealist in its

Night Of The Hunter

19. Wendy Everett, 'Screen As Threshold: The Disorientating Topographies Of Surrealist Film', *Screen*, Vol.39, no.2, Summer 1998, pp.141–152.

20. In *L'Age Du Cinéma*, special surrealist number 4, August–November 1951, pp.53–58.

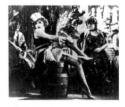

The Blue Angel.

21. Gérard Legrand, 'Elixir De Navets Et Philtres Sans Étiquette', in *L'Age Du Cinéma*, surrealist number, August–November 1951, pp.17–20.

22. See Ado Kyrou, *Le Surréalisme Au Cinéma*, (Le Terrain Vague, 1963) p.278. Many first and second generation surrealists subsequently made careers in and around cinema: Georges Sadoul, Roland Tual, Albert Valentin, the Prévert brothers and Jacques Brunius, among others. Both latter-day surrealists and sympathisers were active in film journalism after the Second World War keeping a Surrealism-alert sensibility very much alive in film culture. *L'Age Du Cinéma* was one such mouthpiece. And in *Positif* in the fifties and sixties, surrealists such as Georges Goldfayn, Robert Benayoun and Gérard Legrand offered a consistent alternative voice – more ethically and politically committed – to *Cahiers Du Cinéma* and the mainstream nouvelle vague.

23. Wendy Everett (1998), op.cit., p.151.

24. Inseparable from the revaluation of Surrealism's contribution to film theory has been the evolution over the years of critical approaches to surrealist cinema itself. The landmarks are identified by Phil Powrie in 'Masculinity In The Shadow Of The Slashed Eye : Surrealist Film Criticism At The Crossroads' in *Screen*, Vol.439, No.2, Summer 1998, pp.153–163).

liquidation of time'.[21] Seizing on certain shining nuggets among the mountainous debris of filmic mediocrity – the moment a flock of doves fly up when the blind man opens his eyes in Korda's *The Thief Of Baghdad* (1940); the moment James Mason in Fregonese's *One Way Street* (1950) is woken from his siesta on the Mexican border by a girl tickling his nose with a salted fish – they have helped rescue many otherwise unexceptional movies from oblivion. We are in debt to them for discovering and valorising a swathe of movies that mainstream film critical history would have otherwise neglected.[22]

According to Wendy Everett: 'Perhaps the surrealists' most important contribution to film theory is their attempt to understand ways in which dream and film function as systems of communication which differ significantly from verbal language.'[23] I hope that this aspect of their legacy is clear from my treatment of the Dalí/Buñuel films. One could go further. In their intuitions about the relation between the visual and the verbal image, in their refusal to allow cinema to be assimilated to literature, in their awareness of the polysemic quality of the film image for all its tangible immediacy, in their preoccupation with the meaning-making role of spectatorship, particularly on the decisive part played by subjective desire (and anxiety) in the reading of films, they anticipated in all sorts of ways much recent thinking about cinema. Extending beyond the field of film, there is a marked surrealist dimension to the wider cultural criticism of, for instance: Rosalind Krauss, Hal Foster, Susan Rubin Suleiman, Christian Metz, Linda Williams…. – especially in so far as this has been filtered through Jacques Lacan's neo-Freudianism or has engaged with perennial surrealist dissident, Georges Bataille, or with Walter Benjamin, who famously called Surrealism 'the last snapshot of the European intelligentsia'.[24]

Finally, what evidence is there for the survival of Surrealism on the

screens of today? The answer is the same as for contemporary life and culture generally. Surrealism in film is both everywhere and nowhere.

Of all the movements of modern art, Surrealism is the most popular, widely known and immediately recognised. No other modernist 'ism' has the same currency. In the sense that Surrealism wanted to build a bridge between art and life, it has partly succeeded because it has changed our sensibility. We apply the term, not just to images but to experience, to odd encounters, to things that disturb the flow of everyday life and perhaps make us laugh, but uneasily. So pervasive is Surrealism in contemporary culture that it has become a commonplace. When applied to art or performance, it has lost most of its original specificity being employed to describe all manner of representation that is strange, unusual, dreamlike, or spectacularly excessive. Breton's call in 1930 for Surrealism's 'occultation' was a lost cause; it was vulgarisation that won out. The market order of capital and consumerism which Surrealism challenged has 'recuperated' the movement. Even before the Second World War, holding the line against the market and the media failed as the products of Surrealist creativity themselves became sought after commodities. Whether it be advertising, fashion, or design — commerce has had no compunction about appropriating the forms, images and techniques of Surrealism for its own purposes. With its art consecrated by retrospective exhibitions in the museums, and its books on HE curriculum reading lists, it has been sanitised, docketed and pigeon-holed.[25] As Surrealism has become more popular, so it has become more trivial. The diverse forms of action that Breton tressed together into a single project have become separated, with the aesthetic and the entertaining elements proving best equipped to survive, while the ethical and revolutionary thrust has fallen away. And this fate of Surrealism generally – curse or vindication? – has also befallen Surrealist cinema.

Being everywhere and nowhere means that Surrealism – in film as in so much else – has lost its specificity. Nevertheless, it is still worthwhile

Most early writing about surrealist cinema was by hagiographers and proselytisers. Their enthusiasm varying only in the degrees of its heat, these could be said to include Ado Kyrou, author of lyrical celebrations of the subject in general and Buñuel in particular; J H Matthews, the very prolific American apologist, (*Surrealism And Film*, University of Michigan, 1971), Michael Gould, *Surrealism And The Cinema* (Barnes/Tantivy, 1976); Steven Kovacs, *From Enchantment To Rage: The Story Of Surrealist Cinema* (Associated University Presses, 1980), Paul Hammond, *The Shadow And Its Shadow*, (British Film Institute, 1978 and subsequent editions), and Alain and Odette Virmaux, *Les Surréalistes Et Le Cinéma* (Seghers, 1976). Several of these sought to extend the surrealist canon beyond the very few made by the surrealists themselves to include both commercial, independent and experimental films that seemed to be imbued with the surrealist spirit, uphold values sympathetic to the surrealist project or include scenes that stood out from the norm. It was not until the 1970s that critical discourse took a more distanced stance towards its object. Crucial here was Philip Drummond's seminal article in *Screen (op.cit)*. Important for placing surrealist film in the wider context of modernism and other avant-gardes was Allen Thiher's *The Cinematic Muse*. In 1981 came Linda Williams' Lacan-inspired *Figures Of Desire* and Paul Sandro's *Diversions Of Pleasure*.(1987). The 1980s also saw a return to history with the work of Robert Abel *French Cinema: The First Wave, 1915–1939* (Princeton University Press, 1984) and *French Film Theory And Criticism, 1907–1939*, two volumes (Princeton University Press, 1988).

25. As Buñuel ruefully commented in his memoirs: 'There's no doubt that Surrealism was a cultural and artistic success; but these were precisely the areas of least importance to most surrealists. Their aim was not to establish a glorious place for themselves in the annals of art and literature, but to change the world, to transform life itself. This was our essential purpose, but one good look around is evidence enough of our failure.' (Luis Buñuel, op.cit., p.123).

26. Dudley Andrew, *Mists Of Regret*, (Princeton University Press, 1995) pp.48–49.

Le Sang d'Un Poète.

Meshes Of The Afternoon.

Les Jeux Des Anges.

identifying some key moments in the filtration process. As might be expected its most direct impact since 'the golden age' has been on 'art cinema', the avant-gardes and marginal genres. Historically the two films of Dalí and Buñuel lay at the intersection between the avant-garde and Impressionist films of the twenties and the poetic realist films of the 1930s as well as marking the transition from silent to sound movies. Dudley Andrew sees the surrealist spirit carried on into 'poetic realism', the classic current of French 'quality' cinema in the thirties. This was thanks in large part to the script-writing of the ubiquitous Jacques Prévert, 'an unmistakable cinematic emissary of Surrealism', even as the darkening pre-war political scene caused his exuberance to yield to resignation.[26] Likewise most of the films of Jean Cocteau from *Le Sang d'Un Poète* (1930) to *Le Testament d'Orphée* (1959) are deeply marked by a surrealist uncanny. During and after the Second World War, the surrealist spirit (via Cocteau) inflected work by 'underground' filmmakers in the USA such as Kenneth Anger and Stan Brakhage. Mother to these independents was Maya Deren, whose dreamlike *Meshes Of The Afternoon* (1943, co-authored by Alexander Hammid) made play with multiple reflections in mirrors and windows in its pursuit of the deeper self.

Surrealist ideas also filtered into the work of film animators, especially in Japan, and in Eastern Europe – Poland, Czechoslovakia and Yugoslavia. Early cartoons by the Polish animator, Walerian Borowczyk, such as *Le Concert De Monsieur Et Madame Kabal* (1962) and *Les Jeux Des Anges* (1964) match Buñuel in their cool precision and satirical bite. And Georges Sadoul, had he lived to see them, would probably have given a place to the films of Czech animator, Jan Svankmajer, without relaxing the rigour of his surrealist criteria. Surrealism in Prague went back to 1934 and is still active today. Often driven into clandestinity, the Czech group survived German occupation and multiple changes of regime, rivalling that of Paris in its staying power. Czech Surrealism is characterised by its critical spirit,

seditious humour, focus on the real and the concrete irrationality of the object, with collage and assemblage as its preferred creative methods. Coincidentally perhaps, 1969, when Jan Svankmajer joined the group, was the same year the Prague surrealists set themselves the project of imagining a series of scenarios meant as sequels to *L'Age d'Or,* then approaching its fortieth anniversary. Svankmajer was already an established graphic artist and animated filmmaker. His trademark is setting in motion and manipulating real objects, especially those which are outmoded, eccentric and useless: fragments of dolls, puppets, clocks, bits of string, broken furniture and household utensils past their sell-by date. In the tradition of Surrealism's symbolically functioning objects, Svankmajer uses analogy to restore magic to the merely utilitarian. He also looks back to Mannerist ancestors of Surrealism such as Archimboldo and Bosch. His densely-stocked domestic interiors are cramped and claustrophobic. Unreliable mirrors and trapdoors make them treacherous places. (Svankmajer was a natural to tackle film versions of Lewis Carroll.) The lurking presence of spies and hidden observers allude to surveillance under the police state. There is a pervasive atmosphere of dreamlike absurdity tinged with menace and eroticism. The games his models play – and in his more recent, feature-length films, his human characters – are often aggressive, even cannibalistic. He greatly influenced the American animators, Stephen and Timothy Quay, who paid due homage to the master in *The Cabinet Of Jan Svankmajer* (1984)[27].

Elsewhere, Robert Benayoun found 'the sumptuous gift of automatism' in the drawn cartoon films of the Canadian Norman McLaren. Then there was the surrealists' influence on most, if not all, of the French 'new wave' generation. The surrealists' precocious enthusiasm for the movie-going experience – more than cinéphiles; cinéphages – looks forward to and is only matched by that of the 'nouvelle vague' critics/directors in the late fifties. Truffaut and Godard repeated the surrealists' call for a free cinema of

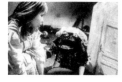

Alice.

27. Svankmajer's best known film is probably *Dimensions Of Dialogue* (1982) featuring the savage behaviour of animated clay models. His two Lewis Carroll films are *Jabberwocky* (1971) and *Alice* (1988). See Peter Hames ed., *Dark Alchemy : The Films Of Jan Svankmajer* (Flicks Books, 1995) for a full filmography up to 1995.

28. Bergman wrote : 'No form of art goes beyond ordinary consciousness as film does', (in *The Magic Lantern*, Penguin, 1988, p.73).

Georges Franju is perhaps the key French director linking the concerns of Surrealist cinema to the present day. His *Le Sang Des Bêtes* (1949) was – like Buñuel's *Las Hurdes* – a hybrid amalgam of documentary and hallucination, set in the Parisian slaughterhouses, and shot in the face of palpable hostility and invective towards the film-maker from the slaughterhouse workers as they slit multiple throats with insouciance. It absorbs both Artaud's concern with the documentary form, and the blood-saturated atmosphere of *The Butcher's Revolt*, as well as evoking Eli Lotar's 1929 surrealist photo câche "Aux Abattoirs de la Villette". Franju's *Les Yeux Sans Visage* (1959), a film of "surgical horror", is renowned for its moments of bizarre visual poetry recalling Cocteau. Franju also resurrected the surrealists' favourite Feuillade hero in a new version of *Judex* (1964), which evoked the collages of Max Ernst in its imagery.

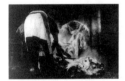

Georges Franju's *Le Sang Des Bêtes.*

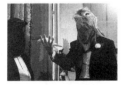

Georges Franju's *Judex.*

Max Ernst's *Une Semaine De Bonté* (1934).

immediacy and, likewise, extolled American film at the same time as they railed against domestic 'quality cinema'. Surrealism and 'new wave' alike used Hollywood as a stick to beat established French 'elders'; and both also 'undid' Hollywood in the process.

Few European 'auteur' directors have not at some time acknowledged their personal debt to the movement. Think of the nightmare sequence that opens Ingmar Bergman's *Wild Strawberries* (1957).[28] Think of the poetic licence and mix of fact and fantasy in the films of Fellini after his break with neo-realism. Think of the endlessly deferred 'amour fou', on the very cusp of the oneiric, endured by the couple – anonymous like Buñuel's and Dalí's – in *L'Année Dernière À Marienbad* (1961) by the two Alain's, Resnais and Robbe-Grillet. Think of Wim Wenders' *Wings Of Desire* (1987) even if they fly perilously close to sentimental whimsy. Recent Latin American cinema also has been particularly susceptible to the surrealist virus (eg. Raul Ruiz, *City Of Pirates* [1983]) deliberately confusing different levels of reality and marrying up formal and political subversions.

Eventually, Surrealism infiltrated the Mecca of entertainment cinema itself, as a regular reference, not just those flashes and accidents lit upon and savoured by the likes of Ado Kyrou. Following the demise Hollywood's vertically integrated studio system, the setting aside of the Hayes Code, and buoyed up by the worldwide appeal of European art cinema, a young 'indie' generation of American commercial filmmakers seized the chance take liberties with narrative, subject matter and film form that had never been claimed before in America outside the avant-gardes. David Lynch is certainly the most forthright about his debt to Surrealism. The cult opening sequence to *Blue Velvet* (1986) introduces us to the suppressed and violent desires lurking under the apparently squeaky clean surface of an American small town, as his camera burrows beneath a manicured lawn down into the pullulating, dirt world of the creepy-crawlies. Like Buñuel and Dalí, Lynch imposes these vertiginous descents into the

unconscious on his audience and makes them our own. In two of his most recent films, *Lost Highway* (1996) and *Mulholland Drive* (2001), on cue from *Un Chien Andalou,* principal characters play 'double and split'. Beside Lynch, there are Terry Gilliam, Spike Jonze, David Cronenberg, Tim Burton and a host of others who feed our appetite for self-reflexivity and black humour – for films that bring out the absurd in everyday situations and situate the imagination at the centre of a character's existence. Mainstream audiences are no longer phased by films that combine the realistic and the poetic, the rational and the irrational, the everyday and the fantastic. We are inured to displacements of the human body by other materials. We no longer flinch before assaults on our spectatorship, wild juxtapositions, the collapsing of time and space – strategies that were once the menacing weaponry of aesthetic and psychological terrorists. Surrealist motifs get recycled with self-congratulatory, postmodernist knowingness.

Perhaps we need to re-see that prologue to *Un Chien Andalou* to feel the *frisson* provoked by the surrealist razor poised before us again as an imminent and very physical threat to the retinal eye. And if Surrealism's gold is now devalued currency, we can take heart from the words engraved on André Breton's tombstone in the Cimetière des Batignolles: 'Je cherche l'or du temps', punningly questing at once for 'time's gold' and for 'l'hors du temps' – 'timelessness' – and maybe try to follow in his footsteps.

Another French director taking cues from Surrealist art was Jean Rollin, a disciple of Georges Franju whose films filled with nude vampire girls and psychedelic cruelty often took inspiration from the paintings of Delvaux, Magritte, and especially Clovis Trouille (paintings such as *Mark Of The Devil, The Orgy,* or *The Raped Girl From The Haunted Ship*).

Clovis Trouille, *Mark Of The Devil.*

Jean Rollin, *The Nude Vampire* (1970).

TABLE OF ILLUSTRATIONS

Abel Richard ed., *French film theory and criticism: a history/anthology, 1907–1939,* two volumes (Princeton University Press, 1988)

Abel Robert, *French cinema: the first wave, 1915–1939* (Princeton University Press, 1984)

Adamowicz Elsa, 'Bodies cut and dissolved : Dada and surrealist film', in J. Williams & A Hughes eds., *Gender and French film* (Berg 2002)

Ades Dawn, *Salvador Dalí* (Thames & Hudson, 1982)

Ades Dawn, *Surrealism and film*, in Jennifer Mundy ed; *Surrealism: Desire unbound* (Tate Publishing, 2001) pp242–3.

Aitken Ian, *European film theory and cinema: a critical introduction,* (Edinburgh University Press, 2001)

Andrew Dudley, *Mists of regret, culture and sensibility in classic French film* (Princeton University Press, 1995)

Aranda Francisco, *Luis Buñuel: a critical biography,* (Secker and Warburg, 1975)

Aub Max, *Luis Buñuel : entretiens avec Max Aub* (Pierre Belfond 1984)

Bataille Georges, *Oeuvres complètes,* I (Gallimard, 1970)

Baxter John, *Buñuel,* (Fourth Estate, 1994)

Biro Adam & René Passeron eds', *Dictionnaire général du surréalisme et de ses environs* (Presses Universitaires de France, 1982)

Bonnet Marguérite, *André Breton: naissance de l'aventure surréaliste* (Librairie José Corti, 1975)

Bouhours Jean-Michel and Natalie Schoeller eds., *L'âge d'or: correspondance Luis Buñuel – Charles de Noailles; lettres et documents (1929–1976)* Hors-Série/Archives, *Cahiers du musée national d'art moderne* (Centre Georges Pompidou, 1993)

Bouhours Jean-Michel, 'La mécanique cinématographique de l'inconscient', in the catalogue for the exhibition, *La révolution surréaliste,* (Centre Pompidou, 2002) pp.381–385

Breton André, *L'amour fou,* (Gallimard, 1937)

Breton André, *Manifestos of Surrealism* (University of Michigan Press, 1969)

Brunius Jacques, *En marge du cinéma français,* (Arcanes, 1954)

Buache Freddie, *Luis Buñuel,* (Editions L'âge d'homme, 1970)

Buñuel Luis & Salvador Dalí, *L'âge d'or and Un chien andalou* translated by Marianne Alexandre, (Lorrimer, 1968)

Buñuel Luis, *My last breath* (Jonathan Cape, 1985)

Buñuel Luis, *An unspeakable betrayal: selected writing of Luis Buñuel,* (University of California Press, 1995)

Cahiers de la cinémathèque, 'Le cinéma des surréalistes', Nos. 30–31, Summer/ Autumn 1980

Cinéma dadaiste et surréaliste, (Centre national d'art et de culture Georges Pompidou, 1976)

'Cinéma et surréalisme', *Le surréalisme: entretiens dirigés par Ferdinand Alquié,* (Mouton, 1968) pp.416–431

Cesarman Fernando, *L'oeil de Buñuel,* (Editions du Dauphin, 1982)

Dalí Salvador, *Oui, 1,* (Denoël, 1971)

Dalí Salvador, *The Secret life of Salvador Dalí* (Dial Press, 1942)

Dalí Salvador, *The Unspeakable confessions of Salvador Dali* (William Morrow, 1976)

Desnos Robert, *Cinéma* (Gallimard, 1966)

Drouzy Maurice, *Luis Buñuel : architecte du rêve,* (Lherminier, 1978)

Drummond Philip, 'Textual space in *Un chien andalou'*, *Screen,* Vol.18, No.3, 1977, pp.55–119

Drummond Philip, 'Domains of cinematic discourse in Buñuel's and Dali's *Un chien andalou'*, a paper presented to 'Buñuel 2000: a centenary conference, Department of Romance Studies, University of London (September 2000)

Dubois Philippe & Edouard Arnoldy eds., 'Un chien andalou: lectures et relectures', special number of *La revue belge du cinéma,* Nos 33–35, 1993

Durgnat Raymond, *Luis Buñuel,* (Studio Vista, 1967)

Edwards Gwynne, *The discreet art of Luis Buñuel,* (Marion Boyars, 1982)

Etherington-Smith Meredith, *Dali,* (Sinclair-Stevenson, 1992)

Etudes cinématographiques, Nos.20–23, special double number: 'Luis Buñuel', (1962–3)

Etudes cinématographiques, Nos. 38–42, special double number: 'Surréalisme au cinéma' (1965)

Evans Peter William, *The films of Luis Buñuel: subjectivity and desire* (Clarendon Press, 1995)

Everett Wendy, 'Screen as threshold – the disorientating topographies of surrealist film', *Screen,* Vol.39, no.3, Summer 1998, pp.141–152

Finkelstein Haim, *Salvador Dali's art & writing, 1927 to 1942 – the metamorphosis of Narcissus* (Cambridge University press, 1996)

Fotiade Ramona, 'The untamed eye: Surrealism and film theory', *Screen,* Vol.36., No.4, Winter 1995, pp.394–407

Fotiade Ramona, 'The slit eye, the scorpion and the sign of the cross: surrealist film theory and practice revisited', *Screen,* Vol.39, no.2, Summer 1998, pp.123

Gale Matthew ed., *Dalí And Film,* (Tate Publishing, 2007)

Gardies René, 'Le cinéma est –il surréaliste?', in *Europe,* Nos.475–476, special number: 'Surréalisme' (1968) pp.145–152

Gibson Ian, *The Shameful life of Salvador Dalí,* (Faber & Faber, 1997)

Goldfayn Georges, 'Le cinéma comme enterprise de transmutation de la vie', in *L'âge du cinéma,* special surrealist number, August–November 1951, pp.21–24

Gould Michael, *Surrealism and the cinema* (A S Barnes & Co, 1976)

Hames Peter ed., *Dark alchemy : the films of Jan Svankmajer* (Flicks Books, 1995)

Hammond Paul ed., *The shadow and its shadow,* (British Film Institute, 1978; expanded and revised edition, Polygon, 1991)

Hammond Paul, *L'âge d'or,* (British Film Institute, 1997)

Ilie Paul ed., *Documents of the Spanish vanguard,* Studies in Romance Languages and Literatures 78, (University of North Carolina Press, 1969)

Kinder Marsha ed., *Luis Buñuel's 'The discreet charm of the bourgeoisie',* (Cambridge University Press, 1999)

Kovacs Steven, *From enchantment to rage: the story of surrealist cinema* (Associated University Presses, 1980)

Kuenzli Rudolf E ed., *Dada and surrealist film* (Willis, Locker & Owens, 1987)

Kyrou Ado, *Luis Buñuel,* (Editions Seghers, 1962)

Kyrou Ado, *Le surréalisme au cinéma* (Le Terrain vague, 1963)

Lefèvre Raymond, *Luis Buñuel,* (Edilig, 1984)

LaFountain Marc J, *Dali and post-modernism* (State University of New York Press, 1997)

Legrand Gérard, 'Elixir de navets et philtres sans étiquette', in *L'âge du cinéma,* surrealist number, August–November, 1951, pp.17–20

Luis Buñuel: el ojo de la libertad, (Publicaciones de la Residencia de Estudiantes, 2000)

Man Ray, *Self-Portrait,* (Little Brown, 1963)

Matthews J H, *Surrealism and film* (University of Michigan, 1971)

Mellen Joan ed., *The world of Luis Buñuel : essays in criticism* (Oxford University Press, New York, 1978)

Murcia Claude, *Un chien andalou, l'âge d'or, Luis Buñuel : étude critique* (Nathan, 1994)

Oms Marcel, *Don Luis Buñuel,* (Les Editions du Cerf, 1985)

Oswald Laura, 'Figure/discourse : configurations of desire in *Un chien andalou',* *Semiotica,* No.33, 1981,pp.105–122

Petr Kral, '*L'âge d'or* aujourd'hui', *Positif,* no.247, October 1981, pp.44–50

Pierre José ed., *Investigating sex: surrealist discussions, 1928–1932,* translated by Malcolm Imrie (Verso, 1992)

Pierre José ed., *Tracts surréalistes et déclarations collectives* Tome 1, 1922–1939 (Eric Losfeld, 1980); Tome 2, 1940–69 (1982)

Powrie Phil, 'Masculinity in the shadow of the slashed eye: surrealist film criticism

at the crossroads', *Screen,* Volume 39, no.2, Summer 1998, pp.153–163

Radford Robert, *Dali,* (Phaidon, 1997)

Rebolledo Carlos, *Buñuel,* (Editions Universitaires, 1964)

Rees A L, *A history of experimental film and video* (BFI, 1999)

Sanchez Vidal Agustin, *Buñuel, Lorca, Dali: el enigma sin fin* (Barcelona, 1988)

Sanchez Vidal Agustin, *Luis Buñuel,* (Editorial Catedra, Madrid, 1991)

Sanchez Vidal Agustin , 'The Andalusian Beasts' in Ian Gibson et al. eds, *Salvador Dali : the early years* (South Bank Centre, 1994), pp.193–208

Sandro Paul, *Diversions of pleasure: Luis Buñuel and the crises of desire* (Ohio State University Press, 1987)

Sanouillet Michel, *Dada à Paris* (Jean Jacques Pauvert, 1965; updated edition, Flammarion, 1993)

Secrest Meryle, *Salvador Dali: a biography* (E P Dutton, 1986)

Short Robert, 'Magritte and the cinema', in Sylvano Levy ed., *Surrealism: surrealist visuality,* (Keele University Press, 1996) pp.95–108

Soupault Philippe, *Ecrits de cinéma* (Plon, 1979)

Stich Sidra, *Anxious visions : surrealist art* (Abbeville Press, 1991)

Talens Jenaro, *The branded eye* (University of Minnesota, 1993)

Taranger Marie-Claude, *Luis Buñuel: le jeu et la loi,* (Presses Universitaires de Vincennes, 1990)

Tesson Charles, *Luis Buñuel,* (Cahiers du cinéma, 1995)

Thiher Allen, *The cinematic muse: critical studies in the history of French cinema* (University of Missouri Press, 1979)

Turrent Tomas Perez & Jose de la Colina eds., *Conversations avec Buñuel* (Cahiers du cinéma, 1993)

Viatte Germain ed., *Peinture, cinéma, peinture,* (Marseille, 1989)

Virmaux Alain & Odette, *Les surréalistes et le cinéma* (Seghers, 1976)

Williams Linda, 'Prologue to *Un chien andalou',* *Screen,* Vol.17, No.4, 1976–7, pp.24–33

Williams Linda, *Figures of desire: a theory and analysis of surrealist film,* (University of Illinois Press, 1981)

Williams Linda, 'An eye for an eye', *Sight and sound,* April 1994, pp. 15–16

Page numbers in italic indicate an illustration. Includes unfilmed projects.

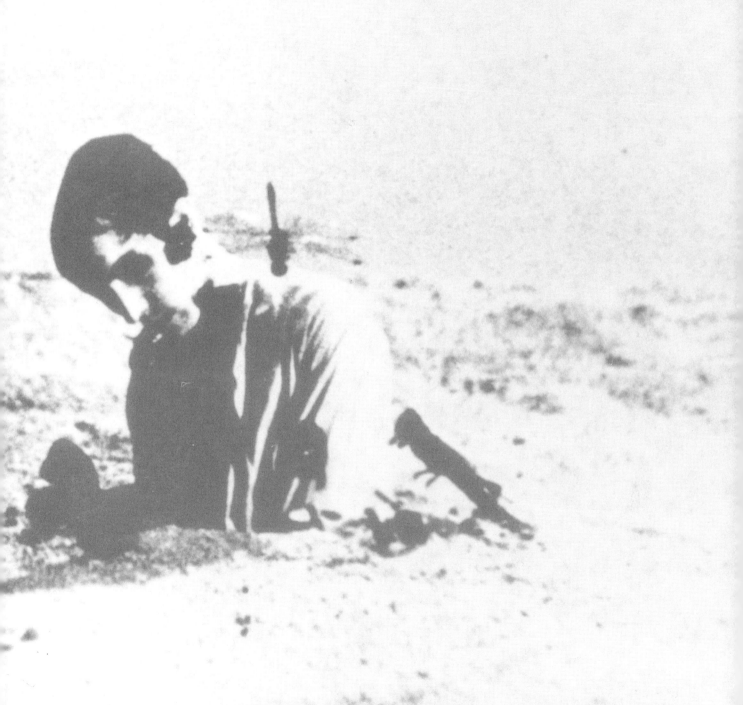